World Photographers Reference Series Volume 5

Bill Brandt

Selected Texts and Bibliography

Anne Hammond & Amy Rule *Series Editors*
Robert G. Neville *Executive Editor*

Volumes in the Series

1 *Frederick H. Evans* edited by Anne Hammond
2 *Imogen Cunningham* edited by Amy Rule
3 *Henry Fox Talbot* edited by Mike Weaver
4 *Carleton Watkins* edited by Amy Rule
5 *Bill Brandt* edited by Nigel Warburton

In Preparation

J. Craig Annan edited by William Buchanan
Edward Steichen edited by Ronald Gedrim

Each volume in **The World Photographers Reference Series** is a bibliographical and documentary study of the work of a photographer who has made an important contribution to the history of the medium. It provides the scholar and the collector with a chronology, a biographical and critical essay, reproductions of the photographer's work, and comprehensive bibliographies, together with a selection of important and often inaccessible texts by and about the photographer.

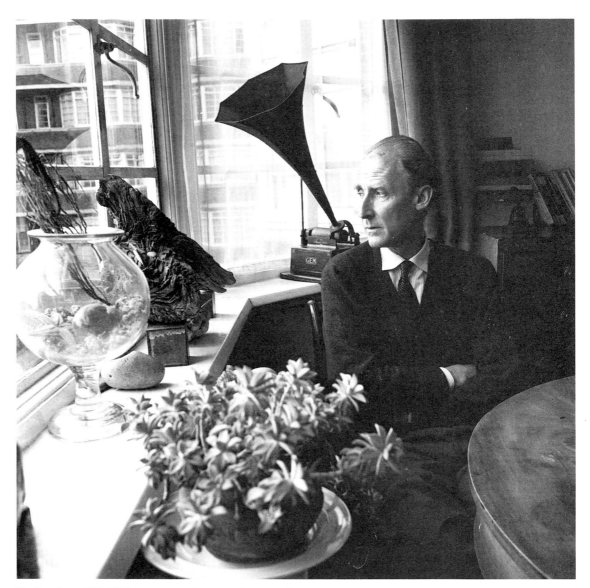

Fig. 1. Roger Hill *Bill Brandt*, 1962. Courtesy of Roger Hill.

Bill Brandt

Selected Texts and Bibliography

Edited by
Nigel Warburton

CLIO PRESS OXFORD, ENGLAND

British Library Cataloguing in Publication Data

Warburton, Nigel
Bill Brandt: Selected Texts and Bibliography – (World Photographers
Reference Series; vol. 5)
I. Title II. Series
799.092

ISBN 1-85109-206-4

Clio Press Ltd.,
55 St. Thomas' Street,
Oxford OX1 1JG, England.

Typeset by Columns Design and Production Services Ltd., Reading, England.
Printed and bound in Great Britain by
Butler and Tanner, Ltd., Frome and London.

Contents

Bibliography

List of Illustrations

Preface and Acknowledgements

This volume of the World Photographers Reference Series presents a documentary and bibliographical study of Bill Brandt, who made distinctive contributions to reportage, landscape, the nude and portrait photography in a photographic career of over fifty years. It includes a contextual chronology, a critical essay which focuses on his pictorialism and the influences of Surrealism on his work, a selection of texts by and about him, and an annotated bibliography.

The documentary texts by Brandt include a summing up of his career made in 1970, and his major statement on photography 'A Photographer's London' as well as two documents which provide detailed information about his working methods, and an account of the experience of photographing Picasso. Two classic photo-stories by Brandt from *Lilliput* and one from *Picture Post* are also included. The writings about Brandt include introductions to his first two books, an account of his working methods and discussions of all the major phases of his career.

The bibliography includes works written by and about Brandt. It also includes a list of major photo-stories by him for *Lilliput* and *Picture Post*. Each bibliographical entry is identified by a bold numeral. Articles which are reprinted in this book as documents are marked in the bibliography with an asterisk (*).

Corrections to or omissions from the bibliography may be sent to Clio Press, 55 St Thomas' Street, Oxford, OX1 1JG, which publishes twice-yearly entries on photographers in its abstracting service entitled *ARTbibliographies Modern*. Essays and further studies on Brandt may be submitted for publication to the journal *History of Photography*, Taylor and Francis, 4 John Street, London WC1N 2ET.

The largest collection of Brandt's photographs – approximately 250 prints – is held at the Victoria and Albert Museum, London. The Hulton Deutsch Collection, London, owns Brandt's prints and negatives from his *Picture Post* assignments; the Imperial War Museum, London has the negatives of his shelter pictures from 1940. The Royal Commission on the Historical Buildings of England has contact prints and negatives of Brandt's photographs of cathedral monuments taken for the National Buildings Record in the early 1940s. Other museums which own works by Brandt include the: Metropolitan Museum of Art, New York; Museum of Modern Art, New York; International Museum of Photography: George Eastman House, Rochester; J. Paul Getty Museum, California; Bibliothèque Nationale, Paris; Art Institute of Chicago; San Francisco Museum of Modern Art; National Gallery of Victoria, Melbourne; and the National Gallery of Canada, Ottawa, Ontario.

I am especially grateful to Anne Hammond for her help, particulary with the illustrations, and to Ian Jeffrey and Mike Weaver, who have contributed in many ways to my research. I also want to thank John Berger, Noya Brandt and John-Paul Kernot, Joanne Buggins of the Imperial War Museum, Edward Robinson of the Museum of Modern Art, Malcolm Daniel of the Metropolitan Museum of Art, Mark Haworth-Booth of the Victoria and Albert Museum, Roger Hill, Brigitte Lardinois and John Hoole of the Barbican Art Gallery, Stephen Lacey of Reed's Wharf Gallery, Adam Lowe, Rupert Martin, Gregory McCulloch, Mike Wells, Anne Woodward of the Royal Commission on the Historical Monuments of England and Edward Woodward. In addition I would like to thank the following who have assisted with this book in a variety of ways: Timothy Auger, Mrs H. Bullock, Jacklyn Burns of The J. Paul Getty Museum, Alida Campbell of *New Stateman and Society*, Stuart Cooke of Argus Specialist Publications, Peter Dixon and Margaret Riley of Focal Press, Edith Golub of Macmillan Publishing Company, Susan Grayson-Ford and Julia Osmond of the Photographers' Gallery, London, Barbara Mary Hampton, Amanda Hopkinson, Bill Jay, Herbert Keppler of *American Popular Photography*, J.R. Lander, Jess Mackta of *Aperture*, Susan Percival and Toby Hopkins of the Hulton Deutsch Collection, Allan Porter, Amy Rule of the Center for Creative Photography, University of Arizona, John Saumarez Smith, Aaron Scharf, Helena Watson of Hamlyn Publishers and Howard Watson. I am grateful for financial assistance for travel and research from Nottingham University and I would also like

to thank Bob Neville and Anne Wilcock of Clio Press for their kind editorial support. Finally, I wish to thank Anna Motz, to whom I dedicate this book, for her patience and helpful discussion.

Contextual Chronology

1900 Sigmund Freud's *The Interpretation of Dreams* is published.

1904 Bill Brandt (Hermann Wilhelm Brandt) is born, 3 May, Hamburg. His father is British, of Russian descent; his mother is German.

1909 Brandt's parents give him the illustrated children's book *Cherry Stones*.

1914 Britain declares war on Germany.

1918 The First World War ends.

1920 Brandt suffers from tuberculosis and is sent to a sanatorium in Davos, Switzerland where he remains for six years. During this time he does some painting and experiments with a Brownie Box Camera.

1921 Man Ray moves to Paris.

1923 Berenice Abbott begins work as Man Ray's assistant.

1924 André Breton publishes *The First Surrealist Manifesto*.

1926 General Strike in Britain. Brandt leaves the sanatorium at Davos.

1927 Brandt travels to Vienna; while there he is psychoanalysed by Wilhelm Stekel. Eugène Atget dies in Paris.

1928 Brandt photographs Ezra Pound. Luis Buñuel and Salvador Dali's film *Un Chien Andalou* is shown in Paris.

1929 Brandt works as Man Ray's assistant in Paris.

1931 Brandt returns to England to work as a freelance photojournalist.

1932 Hunger marches by British unemployed. Brandt's photographs are published in the German magazine *Der Querschnitt*.

1933 Brandt travels to Spain and Hungary. Arts et Métiers Graphiques publishes Brassaï's *Paris de Nuit*.

1934 J.B. Priestley's *English Journey* and Man Ray's *The Age of Light* are published. Brandt contributes to *Weekly Illustrated* and works for the Black Star picture agency. Brandt's photograph of a tailor's dummy appears in *Minotaure* with text by René Crevel.

1935 *The Spirit of London* by Paul Cohen-Portheim is published.

1936 Brandt's first book, *The English at Home*, is published.

1937 George Orwell's *The Road to Wigan Pier* is published. Brandt travels to the Midlands and North of England to photograph life in industrial towns. Stefan Lorant founds *Lilliput*.

1938 Brandt has his first exhibition, Galerie du Chasseur d'Images, Paris. *A Night in London* is published. Brandt begins regular freelance contributions to *Lilliput* and to the newly founded *Picture Post*. He continues to contribute to these magazines for a period of twelve years.

1939 Britain and France declare war on Germany. Brandt's photographs are published in *Verve*.

1940 The Battle of Britain; The London Blitz begins. Henry Moore makes his 'Shelter Drawings'; Brandt makes shelter photographs for the Ministry of Information: a set of these is given to Wendell Wilkie.

1941 Brandt begins work for the National Buildings Record, documenting historic buildings and monuments endangered by Luftwaffe 'Baedeker' raids targeted on ancient cities. Orson Welles' film *Citizen Kane* is released.

1942 Brandt's first published nude, *Lilliput* (August).

1943 Brandt begins working freelance for *Harper's Bazaar*, both British and American editions. His photographs, mostly portraits, appear intermittently in this magazine over a period of more than twenty years.

1945 Brandt buys a Kodak Wide Angle camera in Covent Garden and uses it to photograph nudes. The war ends in Europe.

1948 Brandt's photographs are included in a group exhibition, '4 Photographers', with those of Lisctte Model, Ted Croner and Harry Callahan at the Museum of Modern Art, New York. Focal Press publishes Brandt's *Camera in London* which includes his major statement about photography, 'A Photographer's London'.

1949 Focal Press publishes Brassaï's *Camera in Paris*. Carol Reed's film *The Third Man* is released.

1951 The Festival of Britain takes place in London. Brandt's *Literary Britain* is published and widely reviewed.

1961 Publication of Brandt's *Perspective of Nudes*.

1962 Brandt begins experimenting with colour photography on beaches in Normandy and Southern England.

1963 Brandt's photographs are exhibited at George Eastman House, Rochester, New York (15 April–17 June).

1966 The first edition of Brandt's selection from his work *Shadow of Light* (including 8 colour photographs) is published to great critical acclaim. R.B. Kitaj paints *Screenplay* based on two of Brandt's photographs.

1968 Brandt begins work on his three-dimensional collages, made from beach flotsam displayed in flat perspex boxes.

1969 Brandt has a major retrospective exhibition at the Museum of Modern Art, New York (16 Sept.–30 Nov.).

1970 The Museum of Modern Art exhibition moves to the Hayward Gallery, London (30 April–31 May) – it is the first photography exhibition to be sponsored by the Arts Council of Great Britain.

1974 Brandt's collages are exhibited at the Kinsman Morrison Gallery, London (17 June–12 July). Brandt is awarded the 1974 Society of Industrial Artists and Designers medal.

1975 Brandt selects photographs for 'The Land: 20th Century Landscape Photographs' at the Victoria and Albert Museum, London.

1977 Brandt is made an honorary doctor of the Royal College of Art, London. A revised edition of his *Shadow of Light* is published.

1980 Brandt's *Nudes 1945–1980* is published. He is made an Honorary Member of the Royal Photographic Society.

1981 A major retrospective of Brandt's photography at the Royal Photographic Society, Bath.

1982 Brandt's portrait photographs are exhibited at the National Portrait Gallery, London. *Bill Brandt: Portraits* is published.

1983 Brandt's *London in the Thirties*, a book which reprints some of his earliest work, is published. Two films about Brandt are made. Brandt dies in London, 20 December.

1985 A major retrospective exhibition of Brandt's work, 'Bill Brandt: Behind the Camera, Photographs 1928–1983', Philadelphia Museum of Art (8 June–21 Sept.).

1993 A major retrospective exhibition of Brandt's work at the Barbican Art Gallery, London (30 Sept.–12 Dec.).

Brandt's Pictorialism

Nigel Warburton

The public perception of Bill Brandt is based largely on a few hundred photographs which have been reproduced again and again, principally the images in the second edition of *Shadow of Light* (1977), his personal choice from his photography of the previous 46 years. Through judicious retrospective selection of pictures, most of which had originally been taken for magazines, Brandt controlled the body of work by which he was to be recognized as a photographic artist. Much of his work for a wide range of magazines including *Minotaure*, *Verve*, *Weekly Illustrated*, *Picture Post*, *Lilliput*, *Life* and *Harper's Bazaar*, much of it uncredited, remains hidden in archives[1]. Despite working on a number of fashion assignments for *Picture Post*, for instance, he excluded this aspect of his photography from his artistic portfolio[2]. Similarly the several hundred photographs of church interiors and monuments made for the National Buildings Record during the Second World War are virtually unknown[3]. Even his brief excursion into colour photography, which resulted in the eight colour photographs of beach flotsam and sea-worn rocks in the first edition of *Shadow of Light* (1966) appears to have been edited out of the approved *oeuvre* at a later date. The colour photographs, taken on the beaches of Normandy and East Sussex, bear strong resemblances to his three-dimensional assemblages[4]. These too are little known.

Brandt's career as a photographic artist was constructed, at least at the outset, from his work as a magazine photographer. In this he was typical of twentieth-century photographers. He selectively re-used photographs originally conceived and undertaken for commissions, turning what began as illustrative

1. For information about some of Brandt's major magazine photo-stories, see 'Selected Magazine Photo-Stories by Bill Brandt in *Lilliput* and *Picture Post*' Bibl. **37–112**.

2. For example 'Paris Designs for the Small Purse', *Picture Post,* vol. 45, no. 12 (17 Dec. 1949), p. 39–41, 8 illus.

3. Contact prints and negatives of these photographs are held by the National Buildings Record, Savile Row, London. For further details of this aspect of Brandt's career, see Nigel Warburton. 'Bill Brandt's Cathedral Interiors: Rochester and Canterbury', *History of Photography*, vol 17, no. 3, p. 263–8, 3 illus. (Autumn 1993) and the accompanying portfolio of photographs from Brandt's negatives in the same issue 'Portfolio: Cathedral Interiors', p. 269–76, 7 illus.

4. 32 of these assemblages are known to exist. 31 of them are illustrated in colour in Zelda Cheatle and Adam Lowe, Editors. *Bill Brandt: The Assemblages* (Kyoto, Japan: Kyoto Shoin, 1993). [ArT Random Monograph]. See also Mark Haworth-Booth's review of an exhibition of collages at the Kinsman Morrison Gallery, London (17 June–12 July 1974), *Connoisseur*, vol. 187, no. 751 (Sept. 1974), p. 74, 1 illus., reprinted below (p. 133–5) as a document. The assemblages have also been exhibited at the Zelda Cheatle Gallery, London (30 May– 22 June 1990) and, together with a series of vintage prints that Brandt made of them, at Reed's Wharf Gallery, London (30 Sept.– 30 Oct. 1993). The press release for the exhibition at the Zelda Cheatle Gallery included the following comment by Brandt 'Collages have one thing in common with photography – they are made from real objects that I find as I can find a landscape.'

1

work into personal artistic statement, scrupulously eliminating hack work, frequently revising the pictures by which he wished to be known. He used commissions as an incentive to produce personal pictures. In 1948 he wrote:

> I hardly ever take photographs except on an assignment. It is not that I do not get pleasure from the actual taking of photographs, but rather that the necessity of fulfilling a contract – the sheer *having* to do a job – supplies an incentive, without which the taking of photographs just for fun seems to leave the fun rather flat.[5]

Indeed, with the notable exception of his nude photography, almost all of his best-known photographs were produced on assignment for magazines[6].

Brandt's magazine work is a rich source of information about his working methods and processes of selection. For instance, examination of an early Brandt *Picture Post* photo-story reveals that the dour-faced 'Resident of Putney' (fig. 2) (as she is labelled in *Shadow of Light*[7]), in an image which has frequently been reproduced in other contexts, is actually Brandt's uncle's parlourmaid, Pratt, the subject of a day-in-the-life essay 'The Perfect Parlourmaid'[8]. This fact has eluded commentators since the photograph appeared with an even more misleading caption, 'Putney landlady', in the first edition of *Shadow of Light* (1966)[9]. In *Picture Post* the photograph was captioned :

> Taking Her Afternoon Off
> Every Wednesday Pratt has her 'half day'. She leaves at noon and makes straight for London, whence she visits friends at Putney. She does a little shopping, sees a film and is back again by 10.30.[10]

However, Brandt clearly did not think such information necessary to an appreciation of his photographs as art. In this case there was nothing to be gained by the viewer recognizing that the woman on the left in *Parlourmaid and Under-Parlourmaid Ready to Serve Dinner* (fig. 3) was also the subject of *A Resident of Putney*. From his manner of presenting photographs in books and exhibitions, and from his minimalist style of captioning, it is obvious that they were presented primarily for their visual appeal. Background information about subjects was always kept to a minimum. Indeed, in both editions of *Shadow of Light* the captions were printed separately from the images, as if they might

5. Bill Brandt. 'A Photographer's London', introduction to *Camera in London* (London: Focal Press, 1948), p. 17. The complete text of this essay, Brandt's most important statement about his photography, is reprinted below (p. 84–93) as a document.

6. In fact Brandt received some impetus for even the nudes series from an initial assignment from *The Saturday Book* which was later withdrawn as a result of a purity campaign by the annual's publishers. See Bill Brandt. 'Notes on "Perspective of Nudes"', *Camera* (Lucerne), no. 4 (April 1961), p. 7, which is reprinted below (p. 121–3) as a document.

7. *Shadow of Light*, 2nd rev. ed. (London: Gordon Fraser Ltd, 1977), plate 8.

8. 'The Perfect Parlourmaid', *Picture Post*, vol. 4, no. 4 (29 July 1939), p. 43–7, 21 illus.

9. *Shadow of Light* (London: Bodley Head, 1966), plate 12.

10. 'The Perfect Parlourmaid', p. 46.

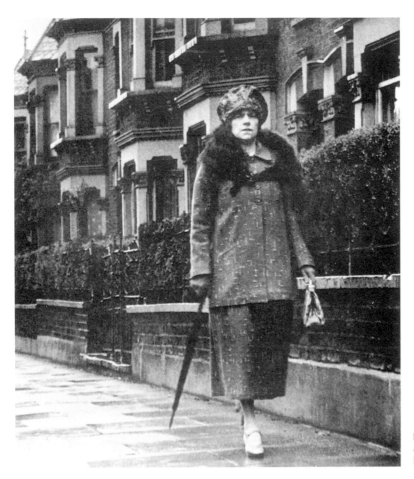

Fig. 2. *A Resident of Putney, c.*1939. Copyright © Noya Brandt.

interfere with the appreciation of the photographs. As works of art, as opposed to magazine illustrations, these pictures were to stand on their own, radically decontextualized, and often transformed and simplified in the printing process. It was for their pictorial and atmospheric qualities that they were to be valued when hung on the gallery wall, or printed in the fine art monograph. It is interesting, in view of this, that Brandt's contemporaries received his first two books as documentary polemics against social injustice and poverty, scarcely mentioning the quality of the photography: they were taken to be windows through which the viewer could peer at the extremes of poverty and wealth in English life. For instance, an anonymous patriotic reviewer complained of *The English at Home* (1936):

In order to emphasize sharp contrasts of social conditions which can scarcely be peculiar to England Mr Brandt has

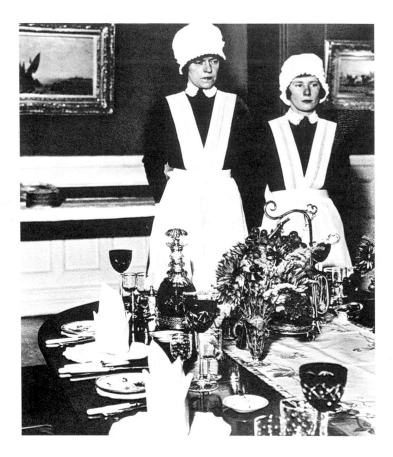

Fig. 3. *Parlourmaid and Under-Parlourmaid Ready to Serve Dinner, c.*1936. Copyright © Noya Brandt.

hammered his point till it is in danger of being blunted, while he has almost ignored the life of maritime and country folk, and of middle-class business people whose week-end search for fresh air and exercise in suburban gardens, on bicycles is surely a feature worth recording.[11]

Raymond Mortimer devoted almost half of his introduction to this book to berating the state of a country in which 'children are less well nourished than our dogs and worse housed than our pigs'[12]; G.W. Stonier, writing in the *New Statesman and Nation* felt that with *A Night in London* (1938), Brandt's second book, the photographer was making a social point:

And, though Mr. Brandt does not underline his sympathies, his book might well be intended as propaganda for socialism. The contrasts it illustrates between wealth and poverty are striking.[13]

The contrasts in both books are indeed striking – the jacket of the *English at Home* juxtaposes the conspicuously rich at Ascot

11. Anon. *The Times Literary Supplement*, no. 1780 (14 March 1936), p. 225.

12. Raymond Mortimer. Introduction to *The English at Home* (London: B.T. Batsford Ltd, 1936), p. 8. The complete text of this introduction is reprinted below (p. 33–6) as a document.

13. G.W. Stonier. 'London Night', *The New Statesman and Nation*, vol. 16, no. 386 new series (16 July 1938).

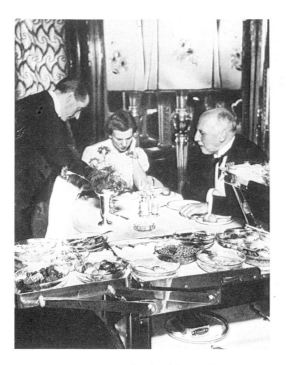 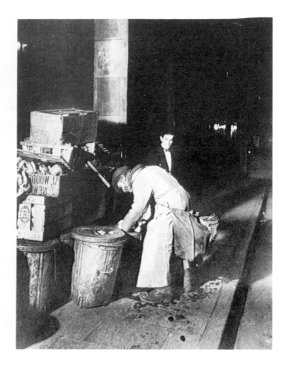

Fig. 4. *Late Supper* and *Behind the Restaurant Where the Waiters Come Out for Fresh Air, c.* 1938, from *A Night in London* (plates 42 and 43). Copyright © Noya Brandt.

racetrack on the front cover with the conspicuously poor family in squalor on the back. In *A Night in London*, the elaborate late dinner of a wealthy couple is alongside a homeless man rifling through the contents of dustbins (fig. 4), the implication being that he is living off their scraps like a dog. The position of the waiter leaning forward to serve in the left-hand picture is echoed formally by the homeless man hunched over the dustbins to scavenge in the right; the backwards writing on a crate of rubbish in the second picture suggests that Brandt had deliberately reversed the negative when printing in order to achieve this visual rhyme and thus emphasize the relation between the two photographs. The *Homeless Girl* sleeping rough on old newspapers on some steps is placed alongside *Footsteps Coming Nearer* in which a man approaches a prostitute (fig. 5) – the French caption *A L'Affût du Client* is more explicit than the English. In the layout of the book the line of the steps is parallel to the diagonal of the kerb in the second picture, making a visual link between the two images and hinting at the homeless girl's inexorable movement towards prostitution.

Both books used such paired photographs to emphasize contrasts or to imply visual narratives and analogies, devices no

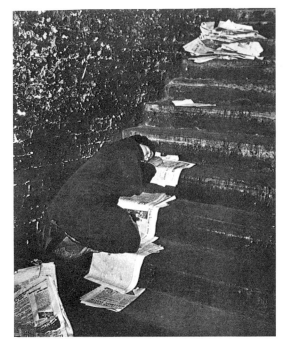

Fig. 5. *Homeless Girl* and *Footsteps Coming Nearer, c.*1938, from *A Night in London* (plates 42 and 43). Copyright © Noya Brandt.

doubt borrowed and adapted from the picture-editing techniques of Stefan Lorant, founder of *Lilliput* and subsequently of *Picture Post*. Lorant usually paired pictures (including some of Brandt's) for humorous or satirical effect; Brandt's photographic pairings were subtler, creating both social and formal contrasts. So many of these paired pictures played on contrasts between rich and poor that it is hardly surprising that Brandt's contemporaries read a political message into them. Moreover, captions in *A Night in London* such as *Dark and Damp are the Houses in Stepney* and *Whole Families Sleep in One Room*[14] seem unambiguously to be challenging the status quo, as do the images they describe. Yet in an article published in 1959 Brandt distanced himself from such a reading:

> I was probably inspired to take these pictures because the social contrast of the 'thirties was visually very exciting for me. I never intended them, as has sometimes been suggested, for political propaganda.[15]

Despite this seeming aestheticism, Brandt's images of the East End were the natural choice to illustrate *Picture Post*'s 'Enough of All This' (1939)[16], an impassioned polemic against the evils of

14. *A Night in London* (London: Arts et Métiers Graphiques, 1938), plates 24 and 25.
15. Bill Brandt. *Photography*, vol. 14, no. 6 (June 1959), p. 32.
16. *Picture Post*, vol. 2, no. 13 (1 April 1939), p. 54–7.

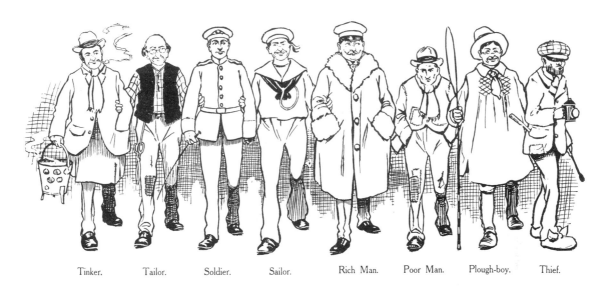

Tinker. Tailor. Soldier. Sailor. Rich Man. Poor Man. Plough-boy. Thief.

Fig. 6. Chas. Crombie. Illustration from *Cherry Stones, c.*1900.

poor housing and poverty in London. Brandt's images of bedraggled children and slum housing provided emotive illustrations of the sorts of conditions of want and squalor which the Beveridge Report would aim to alleviate. Brandt's contribution to a photography exhibition at Marx House in London in 1940 included his disturbing image of a Spanish beggar contorted in his supplication – an image almost certainly inspired by Luis Buñuel's moving documentary about extreme poverty in a Spanish village *Land without Bread* (1932) – and several images of impoverished miners' families. One anonymous reviewer described them as 'photography with a vengeance, in every sense of the word'[17]; it is difficult to imagine that Brandt had not envisaged or even sought such a response.

If Brandt's photojournalism was not intended to have political force, was his interest in these social contrasts *purely* visual? One clue suggesting that it was not, or at least that it was not purely formal, is provided by his well-documented fascination with his childhood book *Cherry Stones*, which illustrated the rhyme 'Tinker, tailor, soldier, sailor, rich man, poor man, plough-boy, thief' (fig. 6) (perhaps some Victorian moralist had thought it necessary to protect children from knowledge of the existence of homelessness, changing the usual 'beggarman' to the innocuous

17. Anon. 'Modern Photography at Marx House', *New Statesman and Nation*, vol. 20, no. 492 (27 July 1940), p. 87–8.

·

'plough-boy')[18]. Here distinct and contrasting social types were identified, named and pictured; the same analytical approach was at play in *The English at Home*. For instance, to take just two examples, there we find *Cambridge Professor* [19] and *Bobby on Point Duty* [20] presented as social types identified by their uniforms, as if Brandt were trying to anatomize English society – or perhaps an outsider's fantasy of English society – by breaking it down into its constituent recognizable categories. Raymond Mortimer's description of Brandt in the introduction to the book as 'not only an artist but an anthropologist'[21] was apt; there is a sense in which Brandt remained aloof from his subjects, viewing them with a dispassionate eye, sharpened by distance. And if Brandt was not the reformer he was sometimes taken to be, that too was consistent with the stance of non-interference popular with the anthropologists of his time: the anthropologist's task was to observe and record, not to moralize about the strange customs and iniquities of the land he or she was studying. Yet if Brandt was a photographic anthropologist, his documentary techniques were unorthodox: at every stage of his career pictorial considerations overrode evidential ones.

That an apparently documentary photographer should have given priority to formal and aesthetic concerns has disconcerted some commentators. The artist David Hockney remarked how horrified he was to discover that Brandt's famous photograph of the house on which *Wuthering Heights* was modelled, *Top Withens* in Yorkshire (fig. 7), was in fact a composite image. The sky was added from a second negative. To disguise the way the photograph was created, Hockney argued, was a kind of subterfuge analogous to Stalin's erasing of discredited individuals from group photographs:

> There's nothing wrong with collage at all, but it should be quite clear that one thing is stuck on top of another. This photograph was not like that and so people would assume that it had been made from a single image. When you can tell that the sky is from another day and yet you pretend that it's not, then I think you can talk about Stalinist photography.[22]

What alerted him to the possibility of this being a composite image was the strangeness of the lighting, a feature which contributes to the mystery and atmosphere of the image: a bright light emanates from the sky, but this is inconsistent with the bright light on the grass. Hockney had concluded that Brandt must have used a flash to achieve this effect until he learned

18. *Cherry Stones* illustrated by Chas. Crombie, verses by Alice M. Raiker (Leeds and London: Alf Cooke Ltd, no date). David Mellor has analysed the significance of this book for Brandt in his introduction to the catalogue of the Royal Photographic Society retrospective exhibition of Brandt's work (1981) and in his essay 'Brandt's Phantasms', in *Bill Brandt: Behind the Camera* (Oxford: Phaidon, 1985).
19. *The English at Home*, plate 42.
20. *The English at Home*, plate 3.
21. Mortimer, p. 4.
22. David Hockney. *Hockney on Photography*. Conversations with Paul Joyce (London: Jonathan Cape Ltd, 1988), p. 45.

Fig. 7. *Top Withens*, 1945. Collection of the J. Paul Getty Museum, Malibu, California. Copyright © Noya Brandt.

23. Quoted in Bill Jay. 'Bill Brandt – The Best From Britain', *Creative Camera Owner*, no. 38 (Aug. 1967), p. 161.

24. This information comes from Mark Haworth-Booth's essays in *Bill Brandt: Behind the Camera* and from Patrick Roegiers' book *Bill Brandt: Essai* (Paris: Belfond, 1990). However, the earliest mention of this aspect of his working methods occurs in Alexander King's article 'One Photographer's Formula: The Story of Bill Brandt "The Super-Optical Night Bird"', *Minicam Photography*, no. 3 (July 1940), p. 52 which includes the following comments: 'He frequently finds some suitable locale and then persuades some friend to dress becomingly for that part of town where the picture is to be made. He never employs professional models because such people have invariably been spoiled by occupational maladies, such as, unnecessary eagerness, a tendency towards slick and obvious posturing.'

25. *A Night in London*, plate 37.

26. *Picture Post*, vol. 2, no. 4 (28 Jan. 1939), p. 34–7. Rolf Brandt's illustrations of Rabelais's *Gargantua and Pantagruel*, published in 1945, were influenced by his brother's experiments with the Kodak Wide Angle camera he used to photograph nudes. See *Apparitions* (London: The South Bank Centre, 1981), a catalogue of an exhibition of Rolf Brandt's illustrations (Main Foyer, Royal Festival Hall, London, 7 March–2 May 1981), especially the introduction 'The Book Illustrations of R.A. Brandt' by John Keir Cross.

27. 'The Perfect Parlourmaid', p. 47.

28. *The English at Home*, plate 62.

that the image had been made from two different negatives.

What Hockney and numerous other viewers of Brandt's photography had failed to appreciate was the extent of the photographer's pictorialism. For Brandt, in every phase of his career, the camera was a picture-making tool; only exceptionally did he use it as a recording device. For him the effect was always more important than how it was achieved. Despite appearances, he was far closer in attitude to Henry Peach Robinson, who thought that absolutely any technique was permissible in photography, than he was to the strictures of the documentarists. As Brandt put it, 'Photography is not a sport.' What is sometimes hard to discern in his early work is unambiguous and forcefully expressed in his writings and interviews: 'I believe there are no rules in photography. A photographer is allowed to do anything, anything, in order to improve his picture.'[23] This attitude to photography affected his practice in at least three ways: in how he directed what went on in front of the lens; in the darkroom processes he used; and in his retouching of prints.

Contrary to appearances, a number of the photographs in Brandt's first three books, *The English at Home* (1936), *A Night in London* (1938) and *Camera in London* (1948), were staged using family and friends as models[24]. Brandt's younger brother Rolf, who became a successful illustrator, and who closely resembled Bill, acted in many of these. He is to be found in a dinner jacket hanging from a taxi in *After the Theatre* (fig. 8), standing with two friends in an East End alleyway in the sinister *Dark Alley-Way* (fig.9) (the policeman at the end of the alley was a piece of serendipity: he walked past as Brandt was setting up the photograph), and also talking with his wife Esther in *Street Scene*[25]. He featured in at least two photo-stories which appeared in *Picture Post*. In 'A Day in the Life of an Artist's Model' he is painting a stylized picture of the model for an advertisement; the caption names him, describing him as a 'surrealist artist'[26]. In 'The Perfect Parlourmaid' Rolf is being served dinner by Pratt, their uncle's parlourmaid[27]. Rolf's wife Esther is the Brighton belle wearing the 'I'm No Angel' hat in *The English at Home*[28]. At least one of the several versions of lovers entwined on the grass in Hyde Park used Rolf and a friend. This approach is worth comparing with Weegee's (Arthur Fellig) use of infra-red film to capture the manoeuvrings of lovers on a dark beach. Weegee's candid photographs were intrusive, unethical, yet undeniably documentary; Brandt's were of a different genre altogether: not candid, but staged; pictorial, not voyeuristic. Brandt's directorial input to his reportage photography went

Fig. 8. *After the Theatre*, 1934, from *The English at Home* (plate 7). Copyright © Noya Brandt.

beyond casting family and friends in various roles: on at least one occasion he carried a glass and china Victorian lamp with him to include in the background of a portrait assignment for *Lilliput* because he had visualized it as complementary to the photograph[29].

What are we to make of this technique of casting actors as characters in the photographs and of using quasi-theatrical props? What difference does it make that, to take a further example, *At Half-Past Ten Mr. and Mrs. Smith Prepare for Bed* (fig. 10) is actually a photograph of a professional female model and a friend of Brandt's rather than of what it purports to be, an elderly London couple getting ready for bed? Presciently, Raymond Mortimer wrote in the introduction to *The English at Home* of the pictures of poverty such as that of the children at a basement window *Their Only Window*, 'These are photographs not of actors in realistic stage-sets, but of people as they are, in

29. This incident is described by Tom Hopkinson in 'A Retrospect', in *Literary Britain*, 2nd rev. ed. (London: Gordon Fraser Gallery Ltd, 1986).

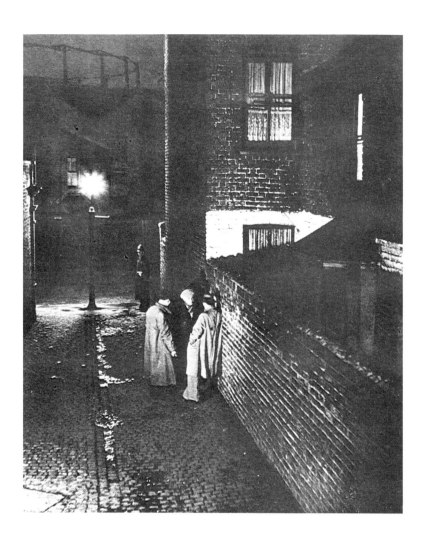

Fig. 9. *Dark Alley-Way,*
*c.*1938, from *A Night in London*
(plate 53). Copyright © Noya
Brandt.

30. Mortimer, op. cit. p. 7.

their real and unescapable surroundings'[30]. This implies that the photographs might lose some of their force had they been cast and staged, and that the fact that these were photographs of real people as they appeared should shame the viewer. If photographs such as these had been staged, we might feel that Hockney's charge of Stalinism had some justification. However, once it is generally recognized that Brandt did indeed stage many of his shots, the documentary force of all his photography of this era is significantly undermined by the possibility that the image in question had been directorially manufactured. This may not matter much in the artistic context where his photography is more likely to be valued for its formal beauty and atmospheric intensity than for its literal accuracy. But knowledge of Brandt's directorial input inevitably changes the viewer's perception of

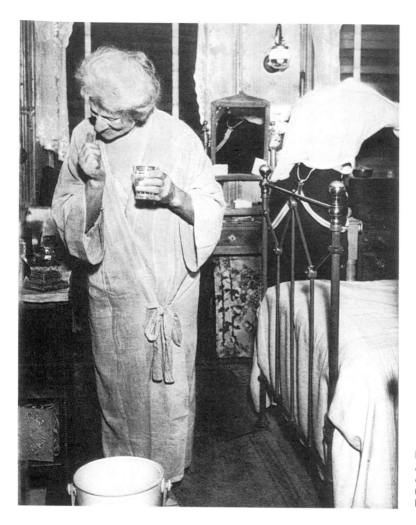

Fig. 10. *At Half-Past Ten Mr. and Mrs. Smith Prepare for Bed, c.*1938 from *A Night in London* (plate 29). Copyright © Noya Brandt.

his photography. As Charles Hagen put it on discovering Brandt's directorial input to his early photography:

> Posed or unposed, Brandt's work can now be seen as explicitly an invention, the fabricated proof of an emotionally urgent inner landscape rather than a simple record of an objective social reality. The essential mystery of his early photographs turns out to be not the Dickensian one of the city in industrial culture, but the Surrealist mystery of the remembering, dreaming self, imposing its emotional needs on the world around it.[31]

Some commentators might want to go so far as to see Brandt as a forerunner of directorial photographers such as Duane Michals

31. Charles Hagen. 'Bill Brandt's Documentary Fiction', *Artforum*, vol. 24, no. 1 (Sept. 1985), p. 112.

or Cindy Sherman. These photographers use themselves (and in Michals' case, his friends) as actors in staged scenes which they photograph in a tradition of pictorialism that dates back to Hippolyte Bayard's *Self-Portrait as a Drowned Man* (1840). But the important difference between Brandt's technique and theirs is that Brandt concealed the fact that he was using actors in some of his apparently documentary photographs; whereas these photographers do not disguise the fact that they are photographing a constructed reality: indeed they advertise it.

More plausibly, Brandt was not particularly interested in using the camera as a simple recording device. Employing family and friends to play the parts of prostitute and client, Eastenders, or lovers in the park was the best way of achieving the effects he desired. Photographing from the flux of life would have involved relinquishing aesthetic control, a sacrifice not worth making for undetectable documentary reliability, particularly if photographing at night when long exposure times were needed. Brandt was certainly not unique among photojournalists in his readiness to stage photographs: Brassaï, for instance almost certainly staged many of his. However, the fact that Brandt's working methods, described by his brother Rolf [32], involved going out to look for suitable scenes which he would then re-stage, sometimes even sketching out his ideas in advance, suggests strongly that this approach to photography was very far from labour-saving.

Another facet of Brandt's pictorialism is evident in his use of photographic materials and especially in his darkroom procedures. Much of his most creative and original photographic work took place after the shutter had fallen, as he commented in 1959:

I can never understand how some photographers send their films out to a processing firm. Much of the powerful effect of William Klein's *New York* was due, I am sure, to his very personal printing which stressed just what he wanted to bring out in the pictures. And imagine what marvels we could have had if Cartier-Bresson had taken an interest in printing during the early days of his career.[33]

Characteristically, he added, 'There are no rules governing how a picture should be printed.' A brief note on his working methods accompanying an article in *Popular Photography* in 1958 described him as spending 'anything from five minutes to one week, or even longer, over printing a single picture, if necessary.'[34]

32. Quoted in *Bill Brandt: Behind The Camera*, p. 83.
33. Bill Brandt. *Photography* (June 1959), p. 32.
34. 'Bill Brandt', *Popular Photography*, vol. 4, no. 10 (July 1958), p. 52.

He did not strive for realistic detail, but rather prized atmospheric effect, 'the spell that charged the commonplace with beauty', as he eloquently described it[35]. Atmosphere for Brandt was not to be achieved by recreating visual experiences; the emotional response was all-important and could be achieved in a variety of ways. This attitude is exemplified by his use of an old Kodak camera with a very wide-angled lens which he used to produce anamorphic nudes reminiscent of Henry Moore's sculpture (see, for example, fig. 17). His approach to colour photography was also symptomatic of his general photographic outlook. He disliked colour portraits on the grounds that 'the results are always too soft, they lack impact', but thought colour could improve a landscape 'particularly when the colours are odd and "incorrect". Colour is so much better when the hues are non-realistic.'[36]

In printing his negatives he would simplify and intensify the elements of the picture so as to arrest the spectator's attention and evoke an emotional response. This is most evident in his later prints with their stark black and white contrasts resulting from use of a hard enlarging paper, often grade 4. This printing style, which he employed from the early 1950s onwards, with its elimination of superfluous detail and arresting chiaroscuro, is immediately recognizable: any photographer using such a technique now appears derivative. Brandt reprinted most of his established *oeuvre* in this style, unifying and reworking the different phases of his career and reaffirming the coherence of his output in the different genres, a process which culminated in the second edition of *Shadow of Light* (1977).

Brandt was no purist about the photographic print, a fact rarely mentioned. He would often add details with a soft pencil, retouch extensively with paint, or even scratch additional details on to the surface of a print, sometimes quite crudely. These alterations are often indetectable in reproduction, but many a Brandt vintage print bears the marks of his attentions and afterthoughts. For instance, some prints of the statue in Barcelona (fig. 11) have had streams of water added by hand in white paint as if running from the statue's umbrella: there is no indication that there was any water coming from the fountain when it was photographed. Brandt has simply painted the detail on to the print. He has added lines of emphasis in soft graphite pencil to some of the vintage prints of nudes. A photograph of a child standing by a window taken on assigment for *Picture Post* (fig. 12), has had a 'smiley' graffito scored into the paper's emulsion, presumably emulating the wall graffiti of Brassaï's

35. 'A Photographer's London', p. 11.

36. Quoted in Bill Jay, op. cit. p. 162.

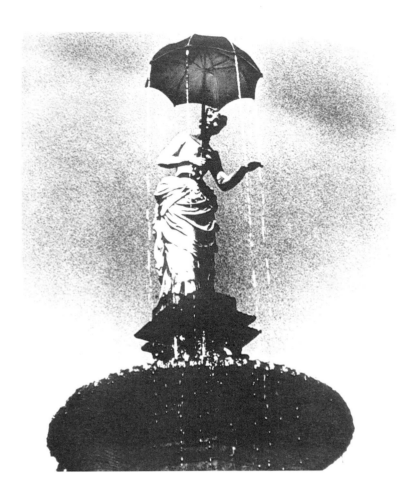

Fig. 11. *Fountain in Barcelona,*
1930. Copyright © Noya Brandt.

famous series. He has painted the outlines of feathers on to at
least one print of the photograph of a crane, *Evening in Kew
Gardens* (fig. 13), a photograph which is in part intended as a
self-caricature in profile. Once again, this willingness to treat the
photograph as raw material for a picture, rather than as
sacrosanct, underlines Brandt's creative attitude to the medium,
an attitude which very probably resulted from his early contact
with Surrealism and in particular with Man Ray's experimental
approach to photographic processes. Like Brandt, Man Ray was
concerned with the end result rather than the means by which it
was achieved.

Brandt's photography is often called Surrealist, though usually
this term is used in a loose sense simply to convey its
strangeness or dream-like quality. But can Brandt legitimately be
labelled a Surrealist in any stricter sense? In the strictest sense,
he was never a Surrealist since he was never officially admitted
to the ranks of the true Surrealists, never ordained by their High

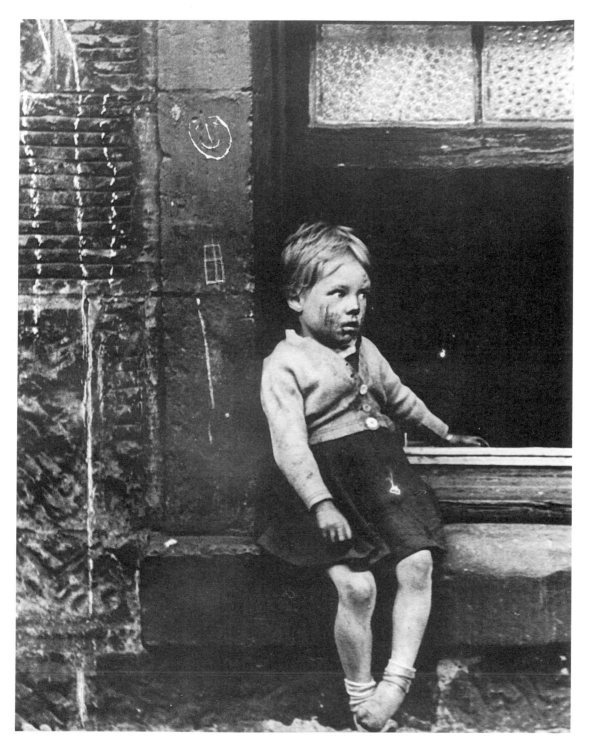

Fig. 12. [Child and Graffiti. Unused photograph taken for the *Picture Post* story 'The Forgotten Gorbals'. 1948].
Copyright © Hulton Deutsch Collection Limited.

Fig. 13. *Evening in Kew Gardens*, c.1938. Courtesy of the Board of Trustees of the V & A. Copyright © Noya Brandt.

Priest, André Breton. Nevertheless, he came into contact with some of the central figures in the Golden Age of the movement in the late 1920s in Paris, a period which Brandt later recalled as having been wonderful. His work ever after bore the marks of this contact. In 1929 he worked for a short period as Man Ray's assistant. Although Man Ray proved a poor teacher because he was so rarely in the studio, Brandt claims to have learnt a great deal simply from looking through all the drawers and files that he would never have dared open had the great man been present. Brandt was not the only significant photographer to emerge from this atelier: Berenice Abbott and Lee Miller both worked as Man Ray's assistants around this time[37], though Brandt did not meet them then. Brandt's work subsequently appeared in the Surrealist magazines *Minotaure* and *Verve*. In the late 1920s and early 1930s he was, then, on the periphery of the official Surrealist movement, a position which allowed him selectively to cultivate the Surrealist sensibility. The effects of this are evident both in his choice and treatment of subject matter.

Surrealist painters, sculptors and film-makers had favourite themes and subject matter to which they frequently returned. Brandt, like many of the Surrealists, including Salvador Dali, Luis Buñuel and Hans Bellmer, was fascinated by mannequins and statues. He photographed them throughout his career – of the 144 images in the second edition of *Shadow of Light* ten feature statues or mannequins of some kind, and many of the nudes have transformed the model into a near mannequin with doll-like features, or else into marble sculptures. One of his first published images, no doubt influenced by Eugène Atget's pictures of dummies in shop windows as well as by Giorgio de Chirico's early paintings, was of a dummy with a tiny head and wide-eyed stare (fig. 14). This was used in *Minotaure* accompanied by a poetic essay by René Crevel, 'La grande mannequin cherche et trouve sa peau'[38]. In this vein Brandt photographed the serene dignity of a stone angel standing knee-deep in shrubs in Highgate Cemetery[39] and the incongruous figurehead in a rock garden in Scilly[40]. When, during the Second World War, Brandt was commissioned by the National Buildings Record to document cathedral monuments threatened by Baedeker raids, he discovered visual equivalents to his flea market dummies in the crypt of Canterbury Cathedral (see, for example, fig. 15).

The eye, too, is a recurrent motif in Surrealist visual art, whether slit by a razor in Buñuel and Dali's *Un Chien Andalou*; or photographed with glass tears, or cut out from a photograph

37. Lee Miller gives an insight into Man Ray's methods in 'I Worked With Man Ray', *Lilliput*, (Oct. 1941).

38. *Minotaure*, no. 5 (1934) p. 18.

39. *Shadow of Light*, 2nd rev. ed., plate 9 *Highgate Cemetery*.

40. *Shadow of Light*, 2nd rev. ed., plate 66 *Figure-head in a garden, Isles of Scilly* (1934).

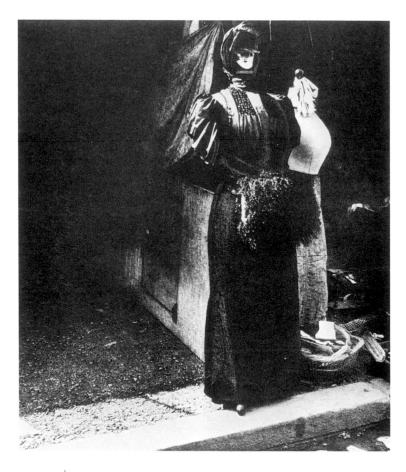

Fig. 14. *Flea Market, Paris,*
*c.*1930. Copyright © Noya Brandt.

and attached to a metronome by Man Ray according to his
instructions for making *Indestructible Object*:

> Cut out the eye from a photograph of one who has been loved
> but is not seen any more. Attach the eye to the pendulum of a
> metronome and regulate the weight to suit the tempo desired.
> Keep going to the limit of endurance. With a hammer well
> aimed, try to destroy the whole with a single blow.[41]

In contrast to these examples of an erotic fascination with a
woman's eyes, Brandt's portrait series of male artists' single
eyes express wisdom and melancholy as well as highlighting the
formal beauty of the weathered landscape of the human face
(see, for example, fig. 16).

It is, perhaps, in his nudes taken with the wide-angle Kodak
camera, particularly those included in *Perspective of Nudes*
(1961) that Brandt came closest to the Surrealist mood (see, for
example, fig. 17). Here we get a glimpse of Breton's 'convulsive

41. Quoted in Roland Penrose.
Man Ray (London: Thames and
Hudson, 1975), p. 109.

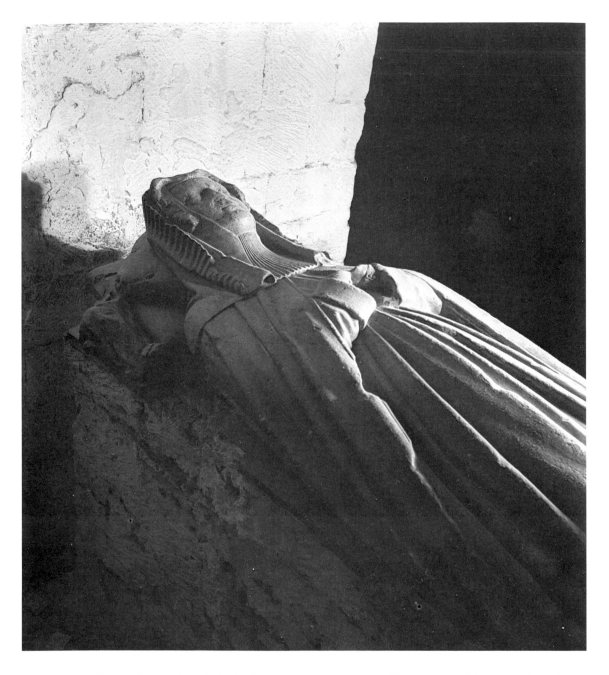

Fig. 15. [*Female Effigy in Canterbury Cathedral Crypt*, Dec. 1941]. Courtesy of the National Buildings Record, London, Commission on the Historical Monuments of England.

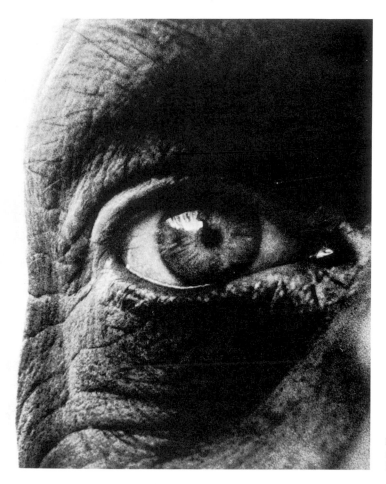

Fig. 16. *Jean Dubuffet's Right Eye,* 1960. Copyright © Noya Brandt.

beauty' in the strangely contorted shapes which are midway between Hans Bellmer's doll and Henry Moore's organic forms. Here too he evinced something of the automatism so praised by Breton: since he could not control precisely how any picture would look when taken with the camera, he had to give himself up to chance, let the camera see for him, finding a visual equivalent to the automatic writing of the early days of Surrealism. Most of these photographs are curiously depersonalized: in Brandt's work, human flesh becomes stone-like and surprisingly unerotic, a world not of passion but of the contemplation of forms.

Dreams and dream-imagery had a special appeal for the Surrealists as manifestations of the unconscious life, of analogical thinking and of the power of the irrational. In his 1924 *Surrealist Manifesto* André Breton wrote of the Surrealist's belief in the 'omnipotence of the dream'. Many of Brandt's photographs have something of the quality of dreams, an effect in part achieved by the simplification resulting from the printing style.

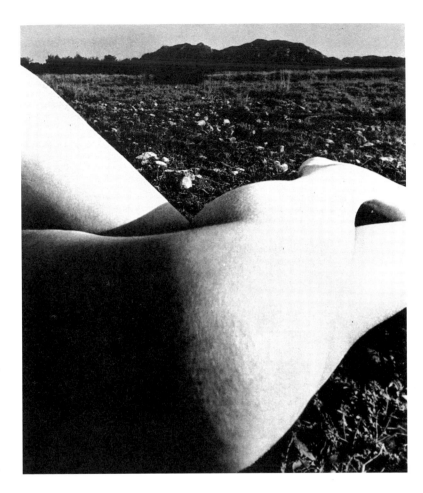

Fig. 17. *Eygalières, France,*
1953. Copyright © Noya Brandt.

42. 'Nightwalk: A Dream
Phantasy in Photographs by Bill
Brandt'. *Coronet* (U.S.) vol. 9, no. 3,
whole no. 51 (Jan. 1941), p. 47–54,
7 illus.

43. They even have a
photograph in common: the image
that was captioned 'Dark and Damp
are the Houses of Stepney' in *A
Night in London* reappears here with
the image of a woman holding a dog
under her arm superimposed. The
woman's hands in the image in
'Nightwalk' of her falling down the
centre of a spiral staircase precisely
match those of the statue, *Shadow of
Light,* 2nd rev. ed., plate 68.

But very few of the images are explicitly photographs of dreams. A notable exception is a little-known sequence of seven photographs produced for the US magazine *Coronet* [42]: 'Nightwalk – a dream phantasy in photographs by Bill Brandt'. In this Brandt has attempted to photograph a woman's dream imagery, including a *Vertigo*-like fall down the centre of a spiral staircase and strange ghost-effects produced by multiple printing, the five dream photographs framed by shots of the woman asleep in bed and of her waking. The nightwalk resembles the narrative of *A Night in London* in its span from dusk to dawn [43]. It is significant that Brandt did not repeat this experiment and did not use these images in his later work. He seemed to have realized the shortcomings of such literal dream photography. It was certainly not in the spirit of Surrealism, for, as Max Ernst pointed out, the aim of Surrealist artists was not to depict the contents of dreamlife: that would be just more 'descriptive naïve naturalism'. What it means to say that Surrealists paint dream-reality, he claimed, was that

they freely, bravely and self-confidently move about in the
borderland between the internal and external worlds which are
still unfamiliar though physically and psychologically quite
real ('sur-real'), registering what they see and experience
there, and intervening where their revolutionary instincts
advise them to do so.[44]

Near-dream imagery recurs in all the phases of Brandt's career,
as, for example in the photograph of the Billingsgate porter with
a huge fish balanced on his head, the nude-like landscapes and
the landscape-like nudes with their disconcerting biomorphic
shapes, the wrinkled eyes of the artists, the unreal cityscapes in
the moonlight, Francis Bacon at dusk on Primrose Hill. By
working in this area between dream and reality, Brandt
displayed a Surrealist sensibility, albeit in milder form than
Dali's or Buñuel's.

This sensibility was also evident in his non-photographic art.
The three-dimensional assemblages which Brandt made in the
1960s and 1970s continued his exploration of the borderland
between the internal and the external (see figs. 18, 19 and 54).
Although composed of fragments of reality – starfish, skulls,
feathers, driftwood, bark, sea-weed, broken glass, bird wings,
shells and rope – they are, paradoxically, the least naturalistic of
all his work. The components are no longer simply what they
were, but have been made unfamiliar by their arrangement: they
have metamorphosed into the limbs and bones of fantastic
animals, elements of bizarre dreamscapes, lines and shapes in
Miro-esque patterns of hieroglyphics. Some, like the evil sprite
created from a dried fish perched in a thicket of driftwood, and
reminiscent of an Arthur Rackham illustration, are figurative.
Others, such as the pattern of brittle-stars (fig. 19), have a
striking formal beauty. Most resist explanation, though many
suggest dream imagery.

Sigmund Freud, whom the Surrealists revered, spoke of
dreams as the 'royal road' to the unconscious: every dream
encodes an unconscious wish in its manifest content. The aim of
psychoanalysis was to uncover the latent content of the dream,
which had been disguised by the mind's censor. Prior to his time
in Paris Brandt had been psychoanalysed in Vienna by Wilhelm
Stekel, a pupil and former analysand of Freud's[45]. Freud
mentions Stekel in *The Interpretation of Dreams*, both praising
him for his intuitive dream interpretation and chiding him for
relying too heavily on his personal sensitivity: the science of
psychoanalysis, Freud felt, could not be constructed on

44. Max Ernst. 'What is
Surrealism?' [p. 134–7] in Lucy R.
Lippard, Editor. *Surrealists on Art*
(Englewood Cliffs, New Jersey:
Prentice-Hall, 1970) p. 135–6.

45. David Mellor has discussed
the possible effects of Brandt's
psychoanalysis by Stekel in
'Brandt's Phantasms' in *Bill Brandt:
Behind the Camera*; Ian Jeffrey also
discusses Stekel in his introduction
to *Bill Brandt Photographs
1929–1983* (London: Thames and
Hudson, 1993). For further
information about Stekel and his
relation to Freud, see Paul Roazen
Freud and His Followers (New
York: Da Capo Press, 1992).

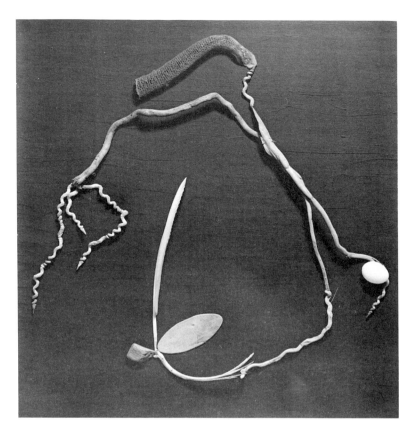

Fig. 18. [*Assemblage Number Sixty*] *c.*1970. Photographed by Edward Woodman. Courtesy of Stephen Lacey and Adam Lowe. Copyright © Edward Woodman.

foundations which required such individual acuity. No doubt during the period of his analysis Brandt would have been required to keep a dream diary and to have dwelt deeply on the imagery of his dreams, aided by Stekel's intuitive interpretations, a process which cannot but have affected his visual imagination and primed him for his encounter with the Surrealists in Paris.

There are strong analogies between Brandt's photographic transformations of reality and the primary processes of the psyche as described by Freud, a fact which might go some way towards explaining the quality of mystery so frequently attributed to Brandt's work. According to Freud, the latent content of a dream, the unconscious wish, is disguised by processes of condensation and produces imagery characterized by an obliviousness to the categories of space and time and a toleration of contradictions; objects in dreams have symbolic significance which the analyst may be able to tease out. The psychoanalyst Charles Rycroft defines condensation as: 'The process by which two (or more) images combine (or can be combined) to form a composite image which is invested with meaning and energy derived from both.'[46] This seems at once to

46. Charles Rycroft. *A Critical Dictionary of Psychoanalysis* (London: Penguin, 1972), p. 22.

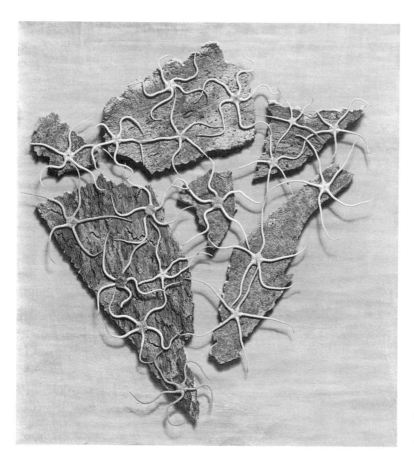

Fig. 19. [*Assemblage Number Nine*]. Photographed by Edward Woodman. Courtesy of Stephen Lacey and Adam Lowe. Copyright © Edward Woodman.

sum up both Brandt's willingness to make composite prints and the way he combined apparently disparate elements and images by juxtaposition, giving a new meaning to both.

Like dreams, Brandt's photographs often seem to stand outside time. This effect was in part achieved by a preference for still subject matter – Brandt was never a photographer of the decisive moment, his images never relied on fast shutter speeds and photography's ability to freeze an instant. In fact, those which do feature movement, such as the famous one of a young girl doing the Lambeth Walk (fig. 52), seem curiously un-Brandtian as a result. More representative are still, empty landscapes, stone-like nudes that could almost be sculptures, deserted streets in the manner of de Chirico. The abstraction of the late printing style exaggerated the formal aspects of these subjects, further removing them from everyday experience. Space and spatial relations too are frequently distorted, particularly in the nudes.

Symbolization was a feature of dreams which particularly

interested Stekel: he was responsible for persuading Freud to devote a section of *The Interpretation of Dreams* to this topic. Dreams are filled with objects which refer outside themselves to other things: this symbolization is part of the censor's disguising of the latent content. The typical objects represented in dreams are, according to Freud, the human body, parents, children, brothers and sisters, birth, death, nakedness and most commonly of all, genitals and sexual intercourse. Freud identified a range of frequently occurring symbols for these things which could almost be an inventory from Brandt's photography. The human body as a whole is frequently represented as a house; nakedness by clothes and uniforms. The male organ finds symbolic substitutes in things that resemble it in shape such as sticks, umbrellas, posts, trees; also in things from which water flows, such as fountains. Erection is represented symbolically by balloons. Among less easily understandable male sexual symbols are fish, hats and overcoats. Rooms, doors, windows and gates are symbols of the female genitals. Freud comments: 'We have earlier referred to *landscapes* as representing the female genitals. *Hills* and *rocks* are symbols of the male organ. *Gardens* are common symbols of the female genitals.'[47]

The viewer's recognition of the familiar contents of the dreamworld in Brandt's photography may contribute to the feeling that it goes beyond everyday reality. In his statement in *Camera in London* he stressed the need for instinctive responses to possible subject matter: 'instinct itself should be a strong enough force to carve its own channel'[48]. This praise of instinct above self-consciousness is a Surrealist stance that surfaces again and again in the little that Brandt wrote about his own photography. The dream symbolism is a direct result of this reliance on emotional rather than purely rational processes – there is no indication that he consciously selected it. And even though many of the symbols are typical ones, there is no precise and simple meaning which can be read off from Brandt's photographs. Like dream imagery, the photographs' latent meaning is opaque to the viewer – as mysterious as the real meaning of a dream to its dreamer.

47. Sigmund Freud. *Introductory Lectures on Psychoanalysis* (London: Penguin, 1973), p. 192.
48. Bill Brandt. 'A Photographer's London', p. 10.

DOCUMENTS

A Statement (1970)
Bill Brandt

I had the good fortune to start my career in Paris in 1929. For any young photographer at that time, Paris was the centre of the world. Those were the exciting early days when the French poets and surrealists recognised the possibilities of photography. One could say that it was now that modern photography was born. Atget's work was at last being published, he had died almost unrecognised, two years before; Brassaï, Kertész and Cartier-Bresson were working in Paris, as well as Man Ray. Man Ray, the most original photographer of them all, had just invented the new techniques of rayographs and solarisation. I was a pupil in his studio, and learned much from his experiments. There were the surrealist publications, *Bifur*, *Variétés*, *Minotaure* and others, the first magazines to choose photographs for their poetic quality; there were the surrealist films such as Buñuel's notorious *Le Chien Andalou* and *L'Age d'Or*, which had a strong effect on photography.

Looking back now, one can see that already two trends were emerging: the poetic school, of which Man Ray and Edward Weston were the leaders, and the documentary moment-of-truth school. I was attracted by both, but when I returned to England in 1931, and for over ten years thereafter, I concentrated entirely on documentary work. The extreme social contrast, during those years before the war, was, visually, very inspiring for me. I started by photographing in London, the West End, the suburbs, the

Bill Brandt. 'Bill Brandt' [Statement], *Album*, no. 2 (1970), p. 46–7, 2 illus. Courtesy of Noya Brandt.

An overview of Brandt's career locating its roots in both the poetic and documentary photographic traditions.

slums. I photographed everything that went on inside the large houses of wealthy families, the servants in the kitchen, formidable parlourmaids laying elaborate dinner-tables, and preparing baths for the family; cocktail-parties in the garden and guests talking and playing bridge in the drawing rooms: a working-class family's home, with several children asleep in one bed, and the mother knitting in a corner of the room. I photographed pubs, common lodging-houses at night, theatres, Turkish baths, prisons and people in their bedrooms. London has changed so much that some of these pictures have now the period charm almost of another century. After several years of working in London, I went to the north of England and photographed the coal-miners during the industrial depression. My most successful picture of the series, probably because it was symbolical of this time of mass unemployment, was a loose-coal searcher in East Durham, going home in the evening. He was pushing his bicycle along a foot-path through a desolate waste-land between Hebburn and Jarrow. Loaded on the crossbar was a sack of small coal, all that he had found after a day's search on the slag-heaps. I also photographed the Northern towns and interiors of miners' cottages, with families having their evening meal, or the miners washing themselves in tin-baths, in front of their kitchen fires.

In 1939, at the beginning of the war, I was back in London photographing the black-out. The darkened town, lit only by moonlight, looked more beautiful than before or since. It was fascinating to walk through the deserted streets and to photograph houses which I knew well, and which no longer looked three-dimensional, but flat like painted stage scenery. When the bombing started I was commissioned to take pictures of Londoners in their improvised air-raid shelters in unused Tube tunnels, East-end wine-cellars, church crypts and the basements of large houses.[†] These pictures were taken for the Ministry of Information, and kept for the Home Office records. A selection of them was later published in *Lilliput* magazine, opposite Henry Moore's Shelter drawings.[††]

Towards the end of the war, my style changed completely. I have often been asked why this happened. I think I gradually lost my enthusiasm for reportage. Documentary photography had become fashionable. Everybody was doing it. Besides, my main theme of the past few years had disappeared; England was no longer a country of marked social contrast. Whatever the reason, the poetic trend of photography, which had already excited me in my early Paris days, began to fascinate me again. it seemed to me that there were wide fields still unexplored. I began to photograph nudes, portraits, and landscapes.

To be able to take pictures of a landscape, I have to become

[†] See, for example, fig. 22, p. 53; fig. 23, p. 55; and fig. 24, p. 58.

[††] 'Shelter Picture by Brandt and Henry Moore', *Lilliput*, vol. 11, no. 6 (Dec. 1942), p. 473–82, 10 illus. [5 by Brandt; 5 by Moore]. See fig. 22, p. 53.

obsessed with a particular scene. Sometimes I feel that I have been to a place long ago, and must try to recapture what I remember. When I have found a landscape which I want to photograph, I wait for the right season, the right weather, and right time of day or night, to get the picture which I know to be there.

One of my favourite pictures of this time is 'Top Withens' on the Yorkshire moors.[†] I was then trying to photograph the country which had inspired Emily Brontë. I went to the West Riding in summer, but there were tourists and it seemed quite the wrong time of the year. I liked it better, misty, rainy and lonely in November. But I was not satisfied until I saw it again in February. I took the picture just after a hailstorm when a high wind was blowing over the moors.

Another picture of that period is the gull's nest in Skye.[††] I had discovered the eggs one sunny afternoon, but as the light was then too flat and the nest looked too pretty for this very wild part of the island, I decided to come back in the evening. It was almost midsummer-night and the pale green twilight started rather late. When I approached the nest on an isolated outpost of rocks, an enormously large gull which had been sitting on the eggs, flew off and circled low around my head barking like a dog. It was windstill, the mountains of the Scottish mainland were reflected in the sea – the light was now just right for the picture.

I always take portraits in my sitter's own surroundings. I concentrate very much on the picture as a whole and leave the sitter rather to himself. I hardly talk and barely look at him. This often seems to make people forget what is going on and any affected or self-conscious expression usually disappears. I try to avoid the fleeting expression and vivacity of a snapshot. A composed expression seems to have a more profound likeness. I think a good portrait ought to tell something of the subject's past and suggest something of his future. Most frequently reproduced of all my photographs, is the portrait of a young girl resting on the floor of her London room. Perhaps it is not really a portrait. Her face fills the foreground and beyond the profile stands a chair and a chest of drawers; seen through two windows are houses on the other side of the street. This picture may have been subconsciously inspired by Orson Welles' film *Citizen Kane*. The technique of this film had a definite influence on my work at the time when I was starting to photograph nudes. Feeling frustrated by modern cameras and lenses which seemed designed to imitate human vision and conventional sight, I was looking everywhere for a camera with a very wide angle. One day in a second-hand shop, near Covent Garden, I found a 70-year-old wooden Kodak. I was delighted. Like nineteenth-century cameras it had no shutter, and the wide-angle lens, with an aperture as minute as a pin-hole, was focused on

† Fig. 7, p. 9.
†† Fig. 53, p. 127.

infinity. In 1926, Edward Weston wrote in his diary, 'The camera sees more than the eye, so why not make use of it?' My new camera saw more and it saw differently. It created a great illusion of space, an unrealistically steep perspective, and it distorted. When I began to photograph nudes, I let myself be guided by this camera, and instead of photographing what I saw, I photographed what the camera was seeing. I interfered very little, and the lens produced anatomical images and shapes which my eyes had never observed. I felt that I understood what Orson Welles meant when he said 'the camera is much more than a recording apparatus. It is a medium via which messages reach us from another world'.

For over fifteen years I was now pre-occupied with photographing nudes. I learned very much from my old Kodak. It taught me how to use acute distortion to convey the weight of a body or the lightness of a movement. In the end, it had also taught me how to use modern cameras in an unorthodox way, and for the last chapter of my book *Perspective of Nudes* which was published in 1961, I discarded the Kodak altogether. These last pictures are close-ups of parts of the body, photographed in the open air, I saw knees and elbows, legs and fists as rocks and pebbles which blended with cliffs and became an imaginary landscape.

When young photographers come to show me their work, they often tell me proudly that they follow all the fashionable rules. They never use electric lamps or flash-light; they never crop a picture in the darkroom, but print from an untrimmed negative; they snap their model while walking about the room. I am not interested in rules and conventions. Photography is not a sport. If I think a picture will look better brilliantly lit, I use lights, or even flash. It is the result that counts, no matter how it was achieved. I find the darkroom work most important, as I can finish the composition of a picture only under the enlarger. I do not understand why this is supposed to interfere with the truth. Photographers should follow their own judgment, and not the fads and dictates of others. Photography is still a very new medium and everything is allowed and everything should be tried. And there are certainly no rules about the printing of a picture. Before 1951, I liked my prints dark and muddy. Now I prefer the very contrasting black-and-white effect. It looks crisper, more dramatic and very different from colour photographs.

It is essential for the photographer to know the effect of his lenses. The lens is his eye, and it makes or ruins his pictures. A feeling for composition is a great asset. I think it is very much a matter of instinct. It can perhaps be developed, but I doubt it can be learned. To achieve his best work, the young photographer must discover what really excites him visually. He must discover his own world.

Introduction to *The English at Home*

Raymond Mortimer

One of the pleasures of being English is to return to this country after a longish time abroad, especially if you come up the Solent in a liner. After the featureless American plains, the uncomfortable African deserts and the cruel mountains of Asia, the Isle of Wight looks unbelievably green and cosy and neat, like something seen through the wrong end of a field-glass. Then comes Southampton, with policeman and postman looking touchingly Victorian, figures from the *Illustrated London News* of seventy years ago; and custom-house officials, who may be ruthless but who at least are polite and have clean hands; and having bought a packet of those Virginian cigarettes which you cannot get in Virginia, and *Punch*, and a cup of stewed station-tea, you subside into your railway-carriage and watch the hedges and steeples and bungalows rush by, murmuring half ironically, half affectionately, a line you learned at your first school – "This is my own, my native land!" Soon familiarity blinds you again, but for an hour or two you have caught a surprising vision of your country and your countrymen: you have noticed a hundred details which are peculiar to England; you have, in fact, been able to look through foreign eyes.

Mr. Bill Brandt is British by birth, but he has spent most of his life abroad, and has thus been able to pick out what makes this country different from others. Whatever rank you may think

Raymond Mortimer, introduction to Bill Brandt. *The English at Home* (London: B.T. Batsford Ltd, 1936), p. 3–8.

Mortimer describes the photographer as an anthropologist as well as an artist, stressing the plight of the poor as they are revealed in Brandt's first book.

Fig. 20. Cover of *The English at Home*, 1936.

photography takes as an art, Mr. Brandt has the eyes and the temperament of an artist. He has the artist's faculty for being surprised and excited by things other people would not notice, the artist's ability to select what is significant, the artist's understanding of the medium in which he is working. Look at the *Circus Boy* in this book, with his ruffled hair against a curiously contrasted background of canvas, or the white-eyed miners in their cage, or the *Billingsgate Porter*, where there is a skilful analogy between the silvery smoothness of the fish and the blank simplicity of the face which shines beneath it, as below some extravagant mediaeval head-dress.

Mr. Brandt shows himself to be not only an artist but an anthropologist. He seems to have wandered about England with the detached curiosity of a man investigating the customs of some remote and unfamiliar tribe. And his illustrated report brings home very amusingly the variety and importance in England of clothes. During the Nineteenth Century one of the questions which roused the most violent feeling here was what clergymen ought to wear in church. Thousands of pounds were spent in litigation, riots broke out, Acts were passed in Parliament, and rather than obey them men of exceptional

goodness went to prison – all on this question of clothes. And the strength of public opinion about clothes (though no longer about clergymen's clothes) is still enormous. It would need great courage not to wear evening clothes at the Savoy for dinner; it would need even greater courage to wear them there for luncheon. In fact I don't believe that you would be allowed to do so, though the men waiting on you would not be allowed not to do so. Imagine trying to explain these customs to an intelligent cannibal from Equatorial Africa! Similarly if you attend a police-court in sporting clothes, the magistrate will abuse you like a pickpocket; if you appear like a guardsman with a bearskin on your head, you will go to prison, and if you dress like a bishop, with a mitre, you will probably find yourself in a lunatic asylum. Mr. Brandt shows us the tall head-dresses reserved for ceremonial occasions; the unbecoming pancakes of straw in which it is the uncomfortable privilege of Harrovians to deck themselves: the dangerously curtailed jackets sported by the smaller boys at Eton; the feathered splendours of the flower-sellers in the streets; the velvet caps which must be used only by those officially engaged in the destruction of deer, otters and foxes. If these insignia were widely misused, the whole fabric of English life would totter. There are tribes where a man who even by mistake sees the face of his mother-in-law is driven by public opinion to suicide. If an Eton boy wore a Harrow hat, if a footballer used the cricketer's methods of protecting his shins, if a don changed caps with a parlour-maid, public opinion in England would be hardly more indulgent.

Nor, of course, is this as unreasonable as it sounds. When one meets people, one likes to know where one is. The subtle difference between the shovel-hat of a prelate and the cockaded hat of a footman provides an invaluable guide to the conversational opening which is appropriate. A black tie with diagonal light blue stripes tells you where you get off. But in foreign countries too often one can't make any good guess at a stranger's occupation or interests. The gentleman at your table in the *wagon-restaurant* looks like a high-class undertaker, and then turns out to be a *maquereau* whose wife's second cousin died last year.

As a description of ourselves this collection of photographs is extremely entertaining. It is also, you will agree, extremely shocking. I am not referring to the chappy from a Night Club who leans so dejectedly against a lamp-post; still less to the couples lying on Hampstead Heath in paradisal forgetfulness of the outside world. But look at the men in the Salvation Army

Rescue Home, at the slum children at a basement window, at the miner's family. These are photographs not of actors in realistic stage-sets, but of people as they are, in their real and unescapable surroundings. Is there any English man or woman who can look at these without a profound feeling of shame? "Things are much better than they used to be," we say, truly enough, to save our faces and to calm our consciences; and then we turn to the next page. But for the people in these photographs things are not better than they used to be, and in their lives there is no more cheerful next page to which they can turn. Again you may argue that the people in the Enclosure at Ascot are no happier than the people on the other side of the course; one can indeed see any day at the Ritz women whose elaborate make-up cannot conceal faces just as miserable as that of the miner's wife in Mr. Brandt's photograph. But the misery caused by extreme poverty is in no way made less horrible by the fact that other causes for misery exist. I am not talking politics – about the quickest and surest method of abolishing destitution there are different opinions – but does anyone seriously maintain that the squalor exposed in these photographs is necessary? Is food so scarce that thousands of children must continue to be under-nourished? Is there in this country such a shortage of bricks or of labour that hundreds and thousands of our fellows must continue to live in foul and fantastically overcrowded hovels? In Glasgow, for instance, it is not uncommon for eight, ten or even twelve persons, to be herded, irrespective of age and sex, in a single room. Is there any public man, whatever this politics, who will maintain that this is unavoidable? And if it is not unavoidable, why is it not avoided? The reason is not so much callousness as a lack of imagination. If every Member of Parliament had to spend one week in each year living in such slums, there would very quickly be no such slums left for them to go to. One's pleasure in being English is somewhat modified by knowledge of this unnecessary, this humiliating squalor. And if one insists on referring to it, one is likely to be called a Bolshy. But it is not *talking* about these facts which makes people Communists – it is the facts themselves. I believe myself that decent housing and proper food and reasonable leisure can be found for everyone in this country without destroying the pleasant traditions and individual liberties which so many of these photographs illustrate. But while children are less well nourished than our dogs and worse housed than our pigs, these traditions and liberties are in danger of being suddenly and violently overwhelmed.

Introduction to *A Night in London*

James Bone

London at night suggests many things. It is a big part of the lure of London that the poets have long been chanting or whispering to the young men from all over the country who came to London in their teens and are now elderly and see no poetry in London, although the lights are ten times stronger and the buildings ten times more extensive.

> "Oh London, London, our delight
> Great flower that opens but at night!
> Great city of the midnight sun
> whose day begins when day is done!"

The writer of that is still alive and active across the Atlantic but he never comes back to taste its delights or to behold the new "iron lilies of the Strand." Dickens, of course, has given us more of the London night than any other writer. He knew it well. He knew it as a street boy who had watched the men and boys sleeping in the Dark Arches under the Adelphi, and as a reporter working late in Parliament and walking home, alive to all the queer phenomena of early Victorian London, and as a novelist,

James Bone, introduction to Bill Brandt, *A Night in London: Story of a London Night in Sixty-Four Photographs* (London: Country Life; Paris: Arts et Métiers Graphiques; New York: Charles Scribner's Sons, 1938) [unnumbered pages]. Copyright © James Bone, and published with the kind assistance of the Macmillan Publishing Company and Reed International Books (Hamlyn Publishers).

The London editor of the *Manchester Guardian* placed Brandt's photographs of the capital by night in a literary and artistic tradition.

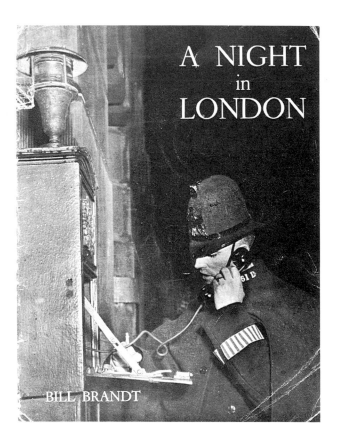

Fig. 21. Cover of *A Night in London*, 1938.

his brain teeming with visions so that he could write no more and must walk through the night, on and on, to Gadshill. The camera with its sleepless eye under modern lights and with modern equipment is now fitted to record nocturnal London. How Dickens with his instantaneous observation and remembering mind would have welcomed it!

Bill Brandt, choosing his subjects for their picturesqueness and character, reminds us how different London is from other great capitals. It has no great processional places or avenues as Paris or Vienna have, no towering water-front like New York or Chicago, and generally no great architectural grouping on an ordered plan. London's noblest buildings are just "round the corner": the Abbey that does not appear from Victoria Street, its street of approach, until you are almost on it, or Westminster Cathedral that is just out of the same street: St. Paul's that has a railway bridge crossing its main aspect as you approach it from the west and so on. Brandt has given us one view of the accidentalness of London where it has a certain odd beauty: the view of Lever House as it were in the skies over the railway bridge with the bright road way running under the bridge.

It is a glittering night of London that the camera of Bill Brandt sees. Floodlit attics and towers, oiled roadways shining like enamel under the street lights and headlights, the bright lacquer and shining metals of motorcars, illuminated signs, the reflections of strong lamps on the river, searchlights, the bright bare dog-racing arena. A middle aged man can remember a London night that had hardly any of these things. Some of the old sights that used to figure in such books as George Augustus Sala's "Round the Clock" are still here. The Billingsgate scene is little changed with the fish porters wearing the same protective headgear as in Hogarth's picture, Covent Garden before dawn, the Soho restaurants, the man going round the garbage cans, the hansom cab and the sheen of silks and tall hats at the theatre door, are much as they were. St. Paul's, the Houses of Parliament, the Tower Bridge are still the high backgrounds of the scene. But none of Brandt's forerunners have so whetted the pictorialism of London night as he has. He can give even the jaded Londoner a thrill with his presentation through the tall railings of the guardsman in his shining helmet as though we were beholding the living London through the bars of its cage. His device, too, of revealing a room through the window, the occupants at cards or reading papers or glancing up at the intruder makes one feel a new Asmodeus. The Bloomsbury group caught in the fact, the slum room with its children tucked in and the vigorous mother, the polite quartette at bridge, the little Islington room with its "handsome black marble presentation clock", all are there in the pulsating London night. There are prints too, of the London that never sleeps, the alleys and courts where the lights discover little groups of men talking together or disappearing round corners and the watching women at upper windows. One thinks of the trek, reported in the London statistics, of the homeless men that cross London every night north to south or south to north on their mysterious occasion.

One of the early photographers was so bothered by Turner's incessant interest in his processes that he chased the great painter out of his studio. Times have changed since then. Photographers now inveigle artists into their studios and learn what they can from them: we have had "artistic" photographers that made photographs look like etchings, pastels and drawings. Now our best photographers are again throwing the artists out of the studio and giving the photograph in its best photographic qualities, the camera installed in its own right. "How photographic!" they used to say of the Pre-raphaelite pictures. "How

Pre-raphaelite" we might say of Bill Brandt's "A Night in London," but that only means that he has a great talent for design and his subjects always come well in the space of the print. That is a part of fine art.

Pictures by Night

Bill Brandt

Night photography is often a very leisurely way of taking pictures. The main thing you need is patience. But you also have plenty of time. After midnight, in particular, there is hardly anybody about, you can do almost anything without being disturbed. There are rarely any watchers, and you are seldom troubled even by passing cars.

Night photography can indeed be a quiet and pleasurable sort of game. But if you go after night life, it can also be an exciting one. There are the people, waiting for other people or pursuing their various (and sometimes shady) occupations, the sleepers on park benches who have nowhere else to go, the busy pleasure seekers of the fashionable centre of town, the Neon signs, and the traffic. And the night photographer weaves his way in and out among the quiet and the busy life, watching without being noticed, catching glimpses of everything.

The Lights

A night picture usually consists of a lot of night and a little light. The light is undoubtedly the more important of the two. It may be advertising signs, or flood lights illuminating the whole street, or just a few odd street lamps lighting up a solitary corner.

Bill Brandt, 'Pictures by Night', [p. 185–91, 3 illus.] in L.A. Mannheim, ed. *The Rollei Way: the Rolleiflex and Rolleicord Photographer's Companion* (London and New York: Focal Press, 1952). Courtesy of Noya Brandt and Focal Press.

Although published in 1952, this article gives an insight into Brandt's earlier night-time photography in London.

When taking night shots, try to use whatever lamps there are to make the picture. That is not always easy, for lamps have their snags too. The main one of these is that nearly all night views include one or more lamps in the picture. These lamps usually come out as shapeless white blobs, often with a halo-like image round them.

To some extent the lamps may even help the picture, but they are mostly a nuisance. Often they also give rise to flare spots: ghost images of large circles with a small star-shaped patch in the middle. These are caused by the reflection of very bright light within the lens.

Part of night photography is therefore a game of dodging lamps. Often a change in the camera position of a few feet, checking the image on the screen all the time, will eliminate the worst offenders. Alternatively, try to hide a lamp behind a tree or other suitable object. If necessary, you may even provide some obstruction yourself in the shape of an assistant posed in the right spot, or a raincoat draped over a convenient support.

If there is no way of getting rid of the lamp, it is useful to remember that any flare spots will appear on the side of the picture opposite to that of the lamp. The nearer the lamp to the edge of the picture, the nearer the flare spot will be to the opposite edge. Therefore, try to arrange the picture on the focusing screen in such a way that the flare would come into either an un-important part of the negative which could be left out during enlarging, or into a brightly illuminated area, where it would be so faint by comparison as to be invisible. Even lamps that are just outside the picture can cause flare spots if the light from them shines on to the camera lens.

In that case the lamps behave as if they were inside the area of a much larger negative. The flare they form then may or may not come just within the actual negative area. Unfortunately, these flare effects are rarely visible on the focusing screen. Therefore always use a lens hood for night exposures and take special care to avoid bright lights shining directly into the lens.

Dusk Helps

A lot of night photography can be done at dusk. The reason is that when we observe a night scene visually, we often see some definite tone in the sky. Yet this is so faint, that it just disappears in a photograph. At dusk, however, there is still quite a bit of light in the sky, while at the same time the lamps are already switched on. The photographic effect of that is very much more

like the visual effect of a real night scene, than a straight exposure actually at night would be.

So try to choose the subject and set up the camera before it is really dark. Then stand by and wait as the light fades, until the time is just right to take the picture.

The Picture On The Screen

Night pictures, almost more than any others, depend on arrangement of light and shade. They consist largely of extremes of contrast, with a few in-between tones. The focusing screen is thus indispensable for checking the composition: for seeing how the pattern of lights and masses of dark areas fit the picture. These masses are largely silhouettes. They may be the shapes of statues, benches, or other foreground objects against a brightly lit background, with their outlines illuminated by a kind of halo from a lamp hidden just behind. Or, they may be the forms of buildings just standing out against a faint night sky. Such background silhouettes again show up best at dusk before the sky has gone too dark.

Focusing at night is often a problem, as the screen image is rarely bright enough to allow judging its sharpness accurately. Bright lights or sharp silhouettes are the easiest to focus. Where these are not convenient, you can switch on a torch and put it near the part of the subject which you want sharpest. Then focus on the spot of light from the torch. Alternatively, get an assistant to hold the torch where required.

Admittedly, this is only practical for focusing on foreground objects. But then it is rarely necessary for more distant ones, as usually anything more than 20 yards away will be sharp when the camera is focused on infinity. And in doubtful cases stopping down the lens will provide the extra depth of field necessary.

These ways of focusing cover practically all occasions. As a final resort, we can always guess the distance, and set the camera accordingly by the focusing scale.

Exposures

Exposures for pictures at night are usually long. They therefore make a tripod absolutely essential.

Static views are the easiest of all. They may, however, require anything up to half-an-hour's exposure if the light is dim, or a few minutes, or as little as half a minute for flood-lit buildings. The best way is to set up the tripod, determine the view in the

finder, focus, open the shutter on T (if the camera has that setting) or B, and wait. People moving about won't matter much, because they don't stay still long enough to register on the negative during such a long exposure. On the other hand, cars in town may be a nuisance. If they are moving, their headlamps and sidelamps (and even their rear lights) will trace long lines of light on the picture. For that reason have a piece of black card or something of the sort handy (even a hat will do) to hold in front of the lens whenever a car comes into view, until it has passed. The time during which the lens is covered up in this way does not, of course, count towards the exposure. Do not touch or shake the camera while covering the lens.

When catching movement in busy brightly lit streets, exposures must obviously be much shorter. The best compromise is usually something in the region of one second. This won't stop any real movement, so to get over that, set up the camera near a spot (e.g. traffic lights) where traffic jams are likely to develop frequently, and last for several seconds at a time. Then, when cars, buses, lorries, cyclists, and all the rest of the traffic come to a dead stop, open the shutter and hang on until they start moving again. This game is largely a matter of luck, and requires a great deal of time and patience. A stoppage may last for a second or two, up to half a minute; on the other hand the traffic may begin to move while the shutter is still open.

The same technique works equally well for getting pictures of buses and trams at their stops. Here again, they only stand still for a second or so, and you have to work fast.

Unsharpness due to movement is not as disturbing at night as it is in daylight shots, mainly because there is so little fine detail which could show it up. In some cases, deliberate unsharpness of shots like crowds in the street may make a picture even more telling. In this case the blurred lights and shapes can effectively convey the impression of seething and glittering life at night in the Metropolis. Like all such tricks, this must be used in moderation, and only when it really improves the picture; it is no excuse for careless technique.

The exposure itself is largely a matter of guesswork and experience. Use an exposure meter to give some idea of what is needed. One good way is to point it at the light parts of the subject, and double the reading obtained. In night photography the shadows don't count, as they have to be black, anyway, so the exposures must be based on the highlights.

Where the shot includes lamps, point the meter at the lamp, and take a second reading from part of the scene illuminated by

it, working out some sort of mean value between the two. At the same time, the meter is never more than just a rough guide; you will nearly always have to adapt the readings to the conditions on the spot. If there are a lot of lamps or bright areas in the picture, the meter will indicate a much shorter exposure than when there are fewer lamps, even though these may be equally bright. Therefore, increase the meter reading more for bright subjects than for sparsely lit ones. Often the appearance of the image on the ground glass screen also gives some guidance. If it is very faint, expose longer, if it is very bright, a shorter time will do. On the whole, night exposures can be very generous, and it is much better to over expose rather than to cut it too fine.

Night pictures often need individual control during enlarging. Frequently dark areas have to be shaded, as the contrast is so great that they would otherwise print dead black without showing any detail.

Bad Weather

Rain, fog, and generally foul weather spoils photography in the daytime. At night, bad weather makes things really interesting. Rain-wet and, still more, snow-covered streets help enormously. They reflect a great deal of lamplight, and reduce the exposure needed. In addition, the reflections of the lamps from wet pavements bring life into the picture, and relieve otherwise monotonous areas of black shadow.

Mist and fog have quite a different effect. They reduce the night scene into bodiless soft shapes trailing away in the distance, and fill the inky blackness with a soft glow from the light diffused by the mist in the air. To make fog pictures, work near the pool of light formed round every street lamp. Choose a subject with a strong silhouette in the foreground to contrast with the dim outlines of objects further away.

Shots against the light will be even more effective. Again try to hide the light itself behind a tree or foreground object, and catch the aerial shadow it throws into the fog, with the rays of light, made bodily visible, outlining it.

The great amount of diffused light in misty weather will allow still shorter exposures. In this kind of weather about one-quarter the usual exposure will be sufficient.

Flash At Night

Flash light is one of the most useful allies of the night photographer.

In its simplest forms, it can help to light up dark portions of more or less stationary subjects. The best way is to set up the camera on the tripod, focus, and open the shutter. Then walk up to the subject, keeping outside the view of the camera, and fire the flash from the best position where it will do most good. Using the flash as open flash without synchronization has the advantage that it is not tied to the camera position in any way. You can thus use it wherever you want it. If necessary, this arrangement even allows firing two flashes in succession from different directions.

Moving subjects, particularly where there is a lot of other light about, need synchronized flash. Otherwise movement in the background will produce double images. As night pictures even with flash hardly ever call for shutter speeds faster than 1/25 second, the ordinary X-synchronization of the Compur-Rapid shutter is quite adequate.

To find the correct flash distance and aperture, use half the normal guide numbers, since there is nothing outdoors to reflect any light from the flash on to the subject.

Moonlight

This is a fascinating part of night photography. Usually moonlight pictures are only possible in the country, where there are few street lamps. In town, the main thoroughfares are generally lit up all night, but small side streets are often completely dark in the early hours of the morning.

Moonlit scenes always have a very peaceful if not desolate atmosphere. The housefronts and rows of buildings in the streets may sometimes appear almost eerily ghostlike. This deadness is what an effective moonlight picture tries to catch.

Moonlight is very weak, so the exposures usually run into 30 minutes or more, even when the moon is full.

Do not include the moon itself in the picture during such a long exposure, as it would move and appear as an elongated, sausage-like shape. Pictures which actually show the moon should not be exposed for longer than about 1 to 2 minutes.

One snag about shots which show the moon is that the moon itself appears much smaller than we think it is when we see it in the sky. The only really successful way of getting over this, and of preserving the natural illusion, is to photograph it with a long focus lens. This is not possible with the Rollei, therefore the second best method is to enlarge only a small area of the negative, with the moon and part of the silhouette of the skyline in it. That will make the moon look much more natural in proportion to the picture area.

War Work

Rupert Martin

Air Raid Shelters **and** ***London by Moonlight***

These two sets of photographs graphically depict the drama of a besieged city, with the sinister calm above ground complementing the chaos and claustrophobia underground. Both series include disquieting images of a city spellbound by the war: the people stoically enduring the discomforts and dangers of the Blitz whilst above, the city remains abandoned and derelict. The poet Kathleen Raine wrote of 'the sense of phantasmagoria which was cast over our blacked-out cities, making familiar places seem strange, and strange sights and scenes familiar'. Bill Brandt, with his experience of surrealism in Paris during the 1920s, was well equipped to exploit the surrealist possibilities inherent in the situation and to make photographs full of dramatic incongruity and a characteristic, dark lyricism.

The first major air raid was on 7 September 1940 in which 500 civilians were killed and over 1000 injured. Safety provisions were often inadequate and people on their own initiative began to occupy the Underground. By November 1940 some 200,000 people were crowding into the Underground nightly. Presented with this 'fait accompli' the Government took steps to provide amenities, beds, food and light, and to convert the Underground into air-raid shelters. Before this regularisation took place both Bill Brandt and Henry Moore were employed by

Rupert Martin, *Bill Brandt: War Work* [Exhibition Catalogue] (London: The Photographer's Gallery, 1983. 1 folded sheet. 6 illus.). Courtesy of Rupert Martin, Yateley.

An overview of Brandt's photography during the Second World War.

the Ministry of Information to record the scenes. Brandt depicted the social side of shelter life with people playing cards or reading, but he also portrayed the vulnerability of people sleeping, and conveys something of the suffocating atmosphere of the Underground. He was particularly alert to the curiosities of shelter life, the man sleeping in a sarcophagus or the question mark of a woman's umbrella handle propped behind her head.

These photographs were used for propaganda purposes, and a set was given by the Ministry of Information to Wendell Wilkie who used them as an annexe to his report to President Roosevelt, a report which undoubtedly influenced U.S. policy on aid for embattled Britain. Some of them were also included alongside Henry Moore's *Shelter Drawings* in an exhibition at the Museum of Modern Art in New York entitled *Britain at War, 1941*. Their work was later published together in the December 1942 issue of *Lilliput*.[†]

During this time the blackout transformed London into a apectral city lit only by moonlight. Bill Brandt wrote later in *Camera in London*:

> The London of the last war was a different place from the London of 1938. The glamorous make-up of the world's largest city faded with the lights. Under the soft light of the moon the blacked-out town had a new beauty. The houses looked flat like painted scenery and the bombed ruins made strangely shaped silhouettes.[††]

The insubstantial pageant of the town faded, and the buildings became like the theatrical back-drops in the light of the moon. London appeared to be a vast, deserted necropolis. The unreality of the scene, the deserted streets and the quality of light recall the enigmatic townscapes of de Chirico. Brandt's surrealism was of the same poetic, melancholy kind as de Chirico's, and their work possesses a sense of potential drama, as if something momentous is about to happen. Visually there are some striking resemblances, in their use of shadow as a formal element and in their liking for deep perspectives created by receding colonnades or windows. The light which irradiates their towns is an unearthly one and gives us a sense of timelessness.

This effect of light Henry Moore also perceived when he wrote in his sketchbook an idea for a drawing. 'View from inside shelter at night time with moonlight and flare light on bombed buildings.' Whereas Brandt's war work shows a transition from documentary realism to a romantic vision, Henry Moore's war

[†] 'Shelter Pictures by Brandt and Henry Moore'. *Lilliput*, vol. 11, no. 6 (Dec. 1942), p. 473–82. 10 illus. [5 by Brandt; 5 by Moore]. See fig. 22, p. 53.

[††] For full text, see document 'A Photographer's London', p. 84–93 in this volume.

work marks a significant development in his style from a pre-occupation with abstract forms to a concentration on 'the psychological human element.' What fascinated Moore was the sea of sleeping or reclining human figures stretched out before him down the Underground tunnels. He jotted down in his sketchbook these notes: 'Dramatic, dismal lit masses of reclining figures fading to perspective point.' This was characteristic of one particular shelter which attracted the attention of both Brandt and Moore, the unfinished extension of the line at Liverpool Street Station. Here there were 'no lines just a hole, no platform, and the tremendous perspective.' In one of his drawings, *Tube Shelter Perspective*, ghostly figures inhabit a cave-like setting hardly recognisable as a part of the London Underground system. By juxtaposing the different versions of the same scene we can see the contrast between the visual description of people in this photograph and the imaginative transformation of the drawing in which Moore has created a vision of an anonymous mass of people asleep, as if buried underground.

Architecture and Landscape

Bill Brandt trained as an architect and his interest in architecture was put to good use in commissions he received during the war from the National Monuments Record and from *Picture Post*. In these there appears an element of nostalgia, a fascination with ruins and a depiction of the decaying glories of the past, which can be related to the work of John Piper at the same time and to the neo-romanticism of that period. Encouraged by Sir John Summerson, his first projects included photographing the monuments in Canterbury Cathedral, and photographing bombed buildings in Bath after a 'Baedeker' raid.[†] The scope of his activity increased to include country houses, and his photographs portray the decay of the old order as much as his documentary images of the 1930s. The photographs of West Wycombe Park or Killerton Hall, made in 1944, are steeped in nostalgia, their neglect giving to these houses a poetic charm. Brandt was to continue the romantic photography of houses for his book *Literary Britain* (1951) in which he conveys the presence of the writer, and the spirit of his work, in photographs of the houses and the landscape in which they lived.

Houses in landscape, and landscape itself began to be a major photographic theme and already in May 1941 in his feature for *Picture Post* 'Spring in the Park'[††] we see the first signs of a landscape idiom which was to occupy the post-war years. The

[†] 'Bath: What the Germans Mean by a "Baedeker Raid" ', *Picture Post*, vol. 16, no. 1 (4 July 1942), p. 20–1. 8 illus.
[††] 'Spring in the Park'. *Picture Post*, vol. 11, no. 6 (10 May 1941), p. 18–21. 12 illus.

sheep seem incongruous in Hyde Park, whilst the man on horseback appears to be struggling to escape the net which has trapped him. On 10 May, when this issue of *Picture Post* was published, the last and one of the heaviest air raids of the Blitz took place, and although the Blitz was then over, the photograph possesses a symbolic value. His photographs of country houses and of landscape in the surrealist idiom gave way to a romantic conception of landscape in which Brandt sought to transcend representation and to arouse through association and memory a more profound echo. Above all he became preoccupied with what Paul Nash termed 'the Sprit of Place.'

After recording the specific historical moment of the Blitz. Brandt became more concerned with the process of time as revealed in historical houses and in landscape. From being a documentary record of a moment in time, the photograph becomes the crystallisation of a moment outside time. The surrealist, dream-like quality of his photographs of London during the Blitz leads naturally to his romantic concept of a landscape inhabited by the ghosts of the past.

The Shelter Photographs

Joanne Buggins

The shelter photographs were taken at a pivotal point in Brandt's career, between his initial social reportage in the nineteen thirties and his surreal, poetic post-war work. In September 1940 Brandt was commissioned by Hugh Francis, the Director of the Photograph Division at the Ministry of Information, to photograph life in London's underground shelters. The London Blitz had begun on 7 September and continued for seventy-six consecutive nights save for 2 November when bad weather kept the raiders at bay. It wrought devastation on the East End, West End and suburbs showing the capital to be totally unprepared for the onslaught. Official thinking was opposed to the use of deep underground shelters such as the tube. It was feared that a 'shelter mentality' would develop and that:

> If big, safe shelters were established, the people would simply live in them and do no work. Worse, such concentrations of proletarians could be the breeding grounds for mass hysteria, even subversion.[1]

1. Tom Harrisson. *Living Through the Blitz* (Collins, 1976), p. 35.

Abridged from Joanne Buggins, 'An Appreciation of the Shelter Photographs Taken by Bill Brandt in November, 1940'. *Imperial War Museum Review* 4 (1989), p. 32–42, 12 illus. bibliog. Reproduced here with the permission of Joanne Buggins and the Trustees of the Imperial War Museum, London.

Brandt's photographs of Londoners sheltering from the Blitz are some of his greatest wartime photographs. This article puts them into their historical context.

However, many Londoners, unable or unwilling to leave the capital and without adequate shelter provision, chose to ignore the official request. An Australian, Bert Snow, who joined the London Auxiliary Ambulance Service in the East End during the Second World War, commented that:

At first [sheltering in the underground stations] was a disorganised arrangement because the refugees were there in spite of official disapproval. They placed their bedding anywhere on the platform and it was not unusual to step over slumbering forms when using the underground at night. In a short time officials accepted the inevitable and special areas were marked on the platform for the nightly visitors.[2]

It is thought that at most only five per cent of Londoners sheltered in the underground with the highest estimate of the tube population for any one night being 177,000 on the night of 27 September 1940.[3] Contrary to official fears morale did not collapse during the Blitz and the shelterers behaved in an orderly fashion.

Brandt's photographs were taken after the Government had accepted that Londoners were using the deep underground shelters, but before plans to improve sanitation and render the areas more habitable had made much impact. Henry Moore who made drawings of the shelters in the early months observed that:

Bunks were not provided ... until several months after the bombing began, nor canteens and decent sanitary arrangements. But from my point of view, everything was then becoming too organised and commonplace. Up to perhaps the first two months of 1941 there was the drama and the strangeness, and then for the people themselves and for me it was all becoming routine.[4]

Brandt spent the nights of the entire week of 4–12 November visiting London shelters, and in this period of 'drama and strangeness', produced thirty-nine photographs. Perhaps his schedule was too rigorous, for in mid-November 1940 Brandt caught influenza and the project had to be abandoned. The shelter photographs were published in the leading arts magazine, *Horizon*, exhibited alongside Henry Moore's Shelter Drawings at the Museum of Modern Art in New York in 1941, and published (again with Moore's drawings) in the photographic magazine

2. From the memoirs of H.W. Snow, p. 38. Imperial War Museum, Department of Documents, p. 394.
 3. Harrisson, op. cit., p. 112.
 4. Henry Moore in the introduction to *Henry Moore. A Shelter Sketchbook* (London: British Museum Publications Ltd, 1988), p. 12.

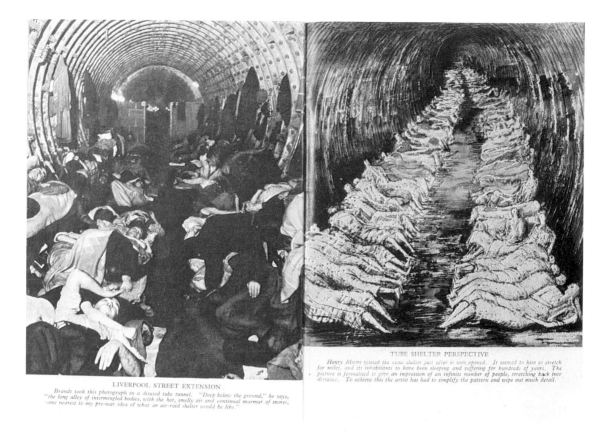

LIVERPOOL STREET EXTENSION
Brandt took this photograph in a disused tube tunnel. "Deep below the ground," he says, "the long alley of intermingled bodies, with the hot, smelly air and continual murmur of snores, came nearest to my pre-war idea of what an air-raid shelter would be like."

TUBE SHELTER PERSPECTIVE
Henry Moore visited the same shelter just after it was opened. It seemed to him to stretch for miles, and its inhabitants to have been sleeping and suffering for hundreds of years. The picture is formalised to give an impression of an infinite number of people, stretching back into distance. To achieve this the artist has had to simplify the pattern and wipe out much detail.

Fig. 22. 'Shelter Pictures by Brandt and Henry Moore'. Bill Brandt *Liverpool Street Extension*, Nov. 1940, and Henry Moore *The Shelter Perspective*, 1940. (Page spread from *Lilliput*, Dec. 1942). Copyright © Noya Brandt.

Lilliput.[†] A set were also sent to President Roosevelt to illustrate the plight of Londoners during the Blitz.

The pictures show many aspects of life in the underground shelters such as the squalid, claustrophobic, uncomfortable conditions and the lack of privacy. One observer has recalled that the shelter floors were 'a sea of blankets, with all sorts of faces appearing above the surface in the most unlikely propinquity'.[5] Bill Brandt's photographs of the platform at Elephant and Castle Underground Station crowded with sleeping people, and masses of Londoners lying on either side of an unfinished tunnel at Liverpool Street Station illustrate this well. One notes the ingenuity involved in the shelterers' attempts to make their lot bearable: such as the man who, avoiding all squeamish impulse, slept in an empty stone sarcophagus in Christ Church, Spitalfields; individuals resting between wooden shelving in the basement of a West End book business; and an

[†] 'Shelter Pictures by Brandt and Henry Moore'. *Lilliput*, vol. 11, no. 6 (Dec. 1942), p. 473–82, 10 illus. [5 by Brandt; 5 by Moore]. See fig. 22, above.

5. Reverend J. Mackay's observations on life in the Archway Central Hall Shelter, Archway Road, London, N19 during the Blitz. Imperial War Museum, Department of Documents, 74/135/1.

old woman asleep on top of a row of barrels in an East End wine merchant's cellar. Brandt also had an eye for the oddities of life in the underground shelters such as an elderly lady asleep in a makeshift bed with her prize possession – a silver-handled umbrella looking curiously like a question-mark – safely stowed away behind her, and another showing a young couple, covered by a garish floral quilt in a shop basement shelter.[†]

In many ways therefore the shelter assignment was eminently suited to Brandt's preoccupations. All of the photographs have a rather surreal and jarring effect derived from capturing the incongruity of people living their private lives in the public shelters. Nor can one ignore the symbolism inherent in some of the pictures – for instance that of the Sikh family sheltering in an alcove in Christ Church, Spitalfields of whom it has been said that they combine the exotic flavour of the Magi and the humbleness of the Holy family'.[6]

For the shelter photographs, as for the majority of his assignments, Brandt used an Automatic Rolleiflex camera and his lighting equipment consisted of 'Kodak lamp-holders, some photoflood bulbs and enough flex to stretch the full length of Winchester Cathedral'.[7] His carefully composed photographs were the result of slow and deliberate work, although with characteristic modesty he claimed that his composition was often the result of good fortune rather than good judgement.[8]

Brandt created his atmospheric shelter photographs by careful lighting – a combination of flash bulbs and the artificial light in the shelters – and the use of very long exposures. In this manner he caught the play of light and shadow on the long rows of sleeping bodies in the underground tube tunnels. The photographs display very distinct and intense contrasts, and this, although leading to a loss of detail, has the concomitant effect of increasing a picture's impact. Our attention is drawn to certain areas of the photograph: the rapt attention of a group of Orthodox Jews reading their Bibles in an East End shelter and the faces of sleeping Londoners oblivious to the camera.

The shelter assignment came at a significant juncture in this internationally acclaimed photographer's career. It followed his photo-journalism of the nineteen thirties and was also a prelude to the more poetic portraits, landscapes and nudes taken in later years. Evocative and surreal, Bill Brandt's shelter pictures offer a rare glimpse of one aspect of life on the home front during the Second World War.

† Fig. 24, p. 58.
6. Mark Haworth-Booth. *Shadow of Light* (London: Gordon Fraser, 1977), p. 19.
7. Brandt. *Camera in London* (London: Focal Press, 1948), p. 89.
8. Interview for the BBC programme *Master Photographers: Bill Brandt*, 1983.

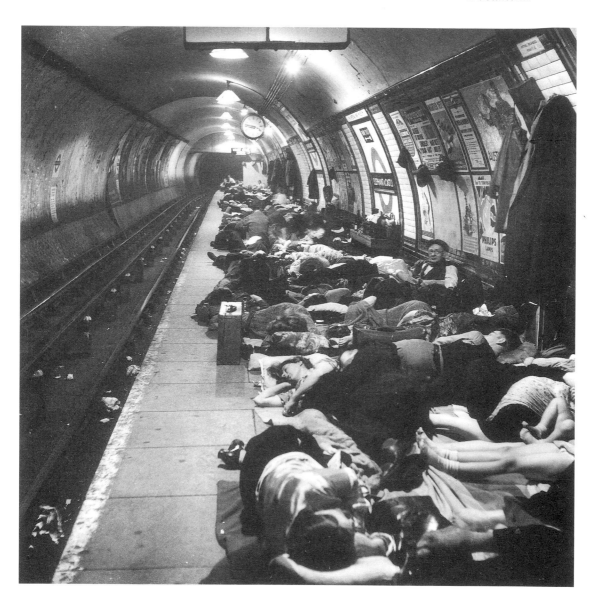

Fig. 23. [*Elephant and Castle Underground Station Shelter*], 11 Nov. 1940. Courtesy of the Trustees of the Imperial War Museum, London.

Bill Brandt at Work

Robert Butts

Brandt's work is perhaps really himself. The medium-sized, blond, thirtyish man I worked with in the shelters of bombed London during the last war could exist only in or through his photographs.

In the first place, he speaks in a quiet voice, almost a whisper, and he mostly answers questions – seldom makes the pace in a conversation. If he is sitting at your desk he doesn't seem to be there. Of course, his body is, but his mild eyes are away in space and he seems to have to bring his mind back to your desk to answer a question.

Quietly, almost imperceptibly, he will walk in and without a word place his photographs before you. Not a quiet word will come from him while you sit and go through them. Good or bad comment will not bring a remark from him. The mild eyes may turn to look at you, but the quiet, almost worried, repose will remain on his face.

It is just the same when you are giving him an assignment. He will listen – you will do the talking.

By all this I don't want to imply that Brandt believes he knows more than you and can therefore afford to be above your

Robert Butts. 'Bill Brandt at Work: An Eyewitness Report'. [last paragraph omitted] *Modern Photography* (combined with *Minicam Photography*) (New York), vol. 17, no. 2 (Feb. 1953), p. 43, 1 illus. Copyright © Robert Butts, with the kind assistance of *American Popular Photography*.

Butts describes working with Brandt photographing life in underground shelters during the London Blitz in 1940.

comment or direction. He seems just incapable of being anything else but Brandt, as a cornstalk is incapable of being anything else but a cornstalk. Unwittingly he can bend before any directional wind and, when the wind has ceased, unknowingly and gently he can sway back.

I have had the pleasure – and otherwise – of trying to direct many photographers in my time and I have always believed that good direction is the least possible – if you employ an artist you should use his head, not his hands. Another thing I feel is that desk-born direction is the worst kind – a good photographer is worthy of the director occasionally lifting himself out of his chair. I therefore found myself tramping through the streets of blacked-out London with Brandt.

Bombs or no bombs, I learned a lot. In those days Brandt used – and maybe he still does for all I know – just a Rolleiflex on a stand and a flash bulb fired from a unit not attached to his camera. On our joint assignments he took off the lens cap and I, on his instructions, fired the flash – always from the front. In the darker air raid shelters where it was not possible to focus with existing light I held a flashlight, which had no magnifying glass, just a small bulb, over the heads of the subjects while he focused on it.

The moment he started to work with his camera that sense of his being there in substance, but not in spirit, was even more apparent. His eyes and hands could have been mere mechanical instruments that were reproducing something inside that he could express in the only way he knew – with a camera. It was then that I began to wonder if he really saw what he took or just felt it.

Perhaps I'm a bit old-fashioned, but as I believe that friendship is not brought to rapid fruition by going around asking people if they know what they are doing, I waited.

One night we were in a shelter and all set to take a couple asleep under a quilt. Something woke them – probably my clumsiness with the flash and flashlight. They sat bolt upright and started to grin into the camera. I looked at Brandt and started to pull down the flashlight I was holding aloft. He motioned me to go ahead and I fired. Why I did not know. Certainly the picture he had set to take was no longer there.

As usual it was a day or so before I saw Brandt again. After shooting he always hibernated in his home – and locked himself in his darkroom and printed. Phone calls had little effect, and in any case his wife would probably answer for him in a very quiet

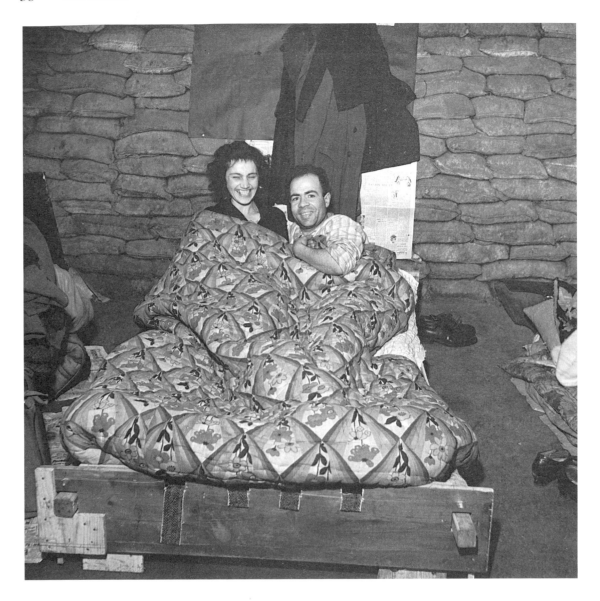

Fig. 24. [*A man and a woman wrapped in a large floral quilt in a West End shop basement shelter*], 7 Nov. 1940. Courtesy of the Trustees of the Imperial War Museum, London.

† Fig. 24, above.

voice similar to his own. You just waited, but you did not have to worry. Brandt and his Brandts would appear. And he did.

I thumbed hurriedly through for the couple in the shelter.† There they were, two grinning heads. The flat light of the front flash had been removed, shadows and tones had replaced it. The quilt looked like a king's robe covering an everyday couple taking, with Cockney perkiness in a dusty, sandbagged hole in

the ground, the worst aerial onslaught that had ever been unleashed on a city.

I turned to Brandt, pointed to the richness of the quilt and asked, 'Did you notice this when you took it?', and to the grinning faces, 'And that?' The mild eyes again went off into space, then turned and looked straight at me, and then the soft voice said slowly and deliberately, 'No, I don't think I have ever seen them before.'

Mighty *Lilliput*

Jozef Gross

Sir Alexander Korda (1893–1956), a Hungarian and the father of the British film industry, never tired of reminding his emigré compatriots that it is not enough to be a Hungarian; one must have talent as well.

In the 1920s a veritable avalanche of Hungarians descended upon Western Europe. Getting away from the post WW1 troubles, the abortive revolution which gave Hungary its first communist government and the subsequent counter-revolution, thousands of them fled to the West in search of a more peaceful existence.

Not all of them made it as far as the windswept shores of Albion. In fact, most of them went no further than Berlin and other cities of the new born Weimar Republic. There they witnessed the dramatic polarisation of riches and poverty and there, like their hosts, often short of bread, they joined the explosion of creative ideas, both artistic and political. It soon became manifestly clear that, not withstanding Sir Alexander's scepticism, the Hungarians did not lack talent. Neither did they lack imagination or the irrepressible taste for life.

Among the motley of Magyars on the move, was a certain Stefan Lorant. Initially settling in Berlin as the local Editor of the *Münchener Illustrierte Presse*, Lorant, in a comparatively short

Jozef Gross. 'Mighty Lilliput'. *Photography* (May 1988), p. 61–5. 4 illus. Copyright © Jozef Gross estate.

This article describes the rise and fall of *Lilliput*, the magazine in which many of Brandt's most famous images first appeared.

time, became this famous magazine's Editor-in-Chief. He improved the magazine by his outstandingly inventive page layouts and his innovative use of photographs. It could be said that the technique of the photo story was his invention.

Gathering around him the cream of German and Hungarian photographers he made the magazine one of Europe's most successful illustrated weekly publications. Hitler's seizure of power in 1933 sealed Lorant's fate in Germany. Jailed by the Nazis he was saved only by an international outcry demanding his release. Reaching Britain in 1934 with no fluent English, he nevertheless secured the editorship of Odham's new illustrated magazine which he himself helped to design. It was named *Weekly Illustrated*.

One must assume that Odham's were not receptive to Lorant's progressive ideas for they soon parted company. Once more on the street, the incredibly resourceful Lorant borrowed from his girlfriend a sum of £1,500 and in July of 1937 came out with a monthly pocket magazine named *Lilliput*. The little newcomer soon broke all publishing records in the UK when it sold over 100,000 copies of the first issue.

Lorant was able to get the best writers of the day, the best illustrators and indeed the best photographers. Many of them have become household names in Britain, many have passed on into history of their respective professions.

Reminiscing about *Lilliput* in 1945, Sydney Jacobson, one time editor, attributed the magazine's origin to a conversation supposedly held between Stefan Lorant and *Lilliput*'s future associate editor Alison Blair. I suspect that this myth was generated by Lorant himself.

Equally, in his book entitled *Chamberlain and the beautiful Llama* (1940), Lorant actually suggests that he was the inventor of the juxtaposed photographs, a device which, without any doubt, proved immensely popular with the public. The truth is that both the magazine and the idea of pairing images originated in 1929 in Berlin. It was there that the well known art dealer and sometime publisher, Alfred Flechtheim, produced a pocket monthly magazine entitled: *Der Querschnitt*. This was *Lilliput*'s prototype in all respects.

But even before *Lilliput*'s publication there appeared in February of 1937, in Chicago, USA, a very similar pocket magazine called *Coronet*. Astonishingly among the earliest contributing photographers were the Hungarians: Erno Vadas, "Biro", Rudolf Balogh, Brassaï and André Kertész. Their work was soon to be seen by the British public in Lorant's *Lilliput*.

Although the idea of the magazine was undoubtedly inspired by its German prototype, Lorant made his *Lilliput* a very British publication. Equally uncontested remains the claim that *Lilliput*'s most popular feature was Lorant's use of photography, "…We were not quite clear what kind of photos we were after. I looked through a pile of beautiful photographs…but I felt that there was no point in printing them as they were…" recalled Lorant in 1940.

He then described a conversation with his editorial staff in the course of which the idea of juxtaposing photographs and furnishing them with captions was born. Out of this witty idea, said Lorant, "…came the idea behind the idea. We wanted to debunk, we wanted to use this simple technique to show how stupid pomposity, how silly self-importance is".

In the highly charged atmosphere of the late 1930s, through the years of war and a decade of post-war recovery, the wry humour of the juxtapositions caught the public's fancy. In the more profound sense the juxtapositions were teaching the public to look at photographs. Never before had the British public seen photographs presented in this way and what photographs! The work of the finest photographers in Europe and the USA.

The initial 12 monthly issues contained six hundred full page photographs. These are the names of some of the photographers who made those photographs: Erno Vadas, Bill Brandt, Blumenfeld, André de Diens, Angus McBean, Zoltan Glass, Laszlo Moholy-Nagy, Tim Gidal, Brassaï, Wolf Suschicky, Ylla, André Kertész, Sougez, John Heartfield and Edward Weston. Many of them have become famous others, alas, are unjustly forgotten.

To give the readers a better conception of what a single copy of *Lilliput* offered the customers in sheer money value here is a detailed examination of a single issue of May 1939 (Vol. 4 No. 5).

To begin with there is a remarkable, historic feature entitled: "Unchanging London" photographed by Bill Brandt. Brandt was given the task of following the footsteps of the marvellous French illustrator Gustave Doré. Doré (1832–1883), visited London in the 1870's and produced an invaluable collection of detailed drawings depicting life in mid-Victorian London. Bill Brandt's photographs which match Doré's original drawings, rank among his finest documentary work.[†]

Then there was a section of eight images of Hungary by Erno Vadas, yet another of the great Hungarian wizards of the camera. His photographs appeared regularly in *Lilliput* until the Nazi

† Fig. 25, p. 63.

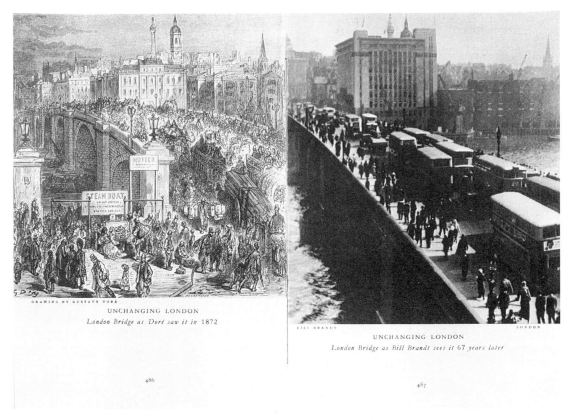

Fig. 25. 'Unchanging London'. Gustave Doré *London Bridge as Doré saw it in 1872,* and Bill Brandt *London Bridge as Bill Brandt sees it 67 years later* (Page spread from *Lilliput,* May 1939). Copyright © Noya Brandt.

invasion of France. Vadas stayed in his native land and inevitably paid the price of total eclipse by his famous compatriots who chose to seek their fortunes in the West of Europe.

With the threat of war on everybody's lips, Lorant did not need to conceal his hatred of the Nazis any longer. He took the earliest opportunity to introduce to the British public the work of the celebrated German photo-montage artist and a stalwart Nazi bater John Heartfield (1881–1968). A section of eight photo-montages entitled "Masterpieces of political art" featured this artist's most pointed attack upon the Nazi's pernicious doctrine while at the same time introducing to the British public a graphic technique which was soon to be used by British artists such as F. H. K. Henrion and A. Games, to aid the war effort.

There are two more eight page photographic sections in this truly historic issue. Of the sixteen photographs five ridicule: Count Ciano, Mussolini's Foreign Minister; Hermann Goering,

Hitler's Luftwaffe Chief, who is shown playing tennis fully attired and wearing a hair-net; a photograph of a wall plastered all over with the portrait of helmeted Mussolini is juxtaposed with a photograph of sculpted classical nudes turning their backsides towards "Il Duce"; nor does Neville Chamberlain escape *Lilliput*'s punishing wit. He is shown bending down to pick his fallen umbrella. The caption under his photograph reads: "The man who lost his appeasement". And it all cost only a sixpence!

The most prolific of all the contributors and the most consistent was Bill Brandt. Apart from many single images he produced dozens of photo-stories, the subject of most of them were the British towns and countryside. London and Londoners are depicted from the pubs of Pimlico to the parlours of Bloomsbury; from East End cops to Chelsea snobs. They're all there, usually in sets of eight to twelve pictures. It is not easy to believe but the initial 72 issues of *Lilliput* carried 36 photo-stories by him.[†]

All that is known of these outstanding essays today are the single images which Brandt in his later life abstracted from the sets and offered at exhibitions or through galleries for sale to the public. It is fascinating to observe how Brandt altered the interpretation of his documentary images.

But to conclude the story of *Lilliput*, it was founded by Stefan Lorant in 1937. A year later a small newspaper proprietor, Edward Hulton, subsequently Lord Hulton, wished to expand into the business of illustrated weekly magazines. Lacking any idea as to the shape or nature of the proposed magazine was not his only problem. He also lacked an editor to guide such an undertaking.

Maxwell Raison, then a General Manager of Hulton Press Ltd, admitted in an interview with Colin Osman in 1974, that neither he nor his chairman Edward Hulton knew Stefan Lorant, nor were they aware of Lorant's *Lilliput*. It was David Greenfield of Sun Engraving Company who knew Lorant and thought him a likely editor for the new venture.

Eventually, in order to secure Lorant's services, Hulton purchased Lorant's baby for £20,000. Thus *Lilliput* passed into Hulton's hands, which he edited until his departure for the USA following the collapse of France, in 1940.

Towards the end of the 1940s an attempt was made to change the "looks" of *Lilliput*. The revamped magazine lost intimacy, it became impersonal. The short and witty stories gave way to one long story. The photographic sections were all but gone. It then

† For details of Brandt's major photo-stories for *Lilliput*, see 'Selected Photo-Stories by Bill Brandt in *Lilliput* and *Picture Post*', Bibl. **37–112**.

became a bi-monthly, not really all that bad either but certainly a far cry from its former excellence.

Why did it die? Well, seen as a package *Lilliput* was fashioned in the image of a cultivated European bourgeoise male. It represented his world view, his imaginary liberalism, his cultural aspirations, his sexual fantasies and his dream of the stability of the Victorian era. This social figure became extinct after WWII and *Lilliput*'s days were over.

'Below Tower Bridge' – A *Lilliput* Photo-Story

Photographs by Bill Brandt

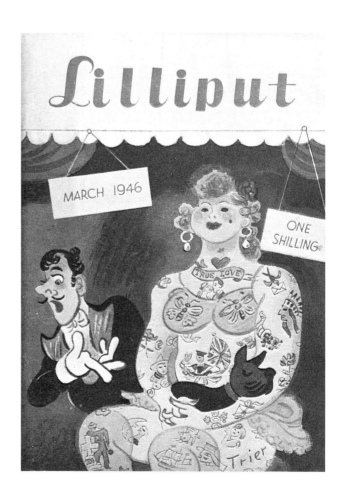

Fig. 26. Cover of *Lilliput,* March 1946.

A photo-story about London's docklands. Illustrations, Copyright © Noya Brandt.

Bill Brandt. 'Below Tower Bridge. *Lilliput*, vol. 18, no. 3 (March 1946), p. 155–62. 8 illus.

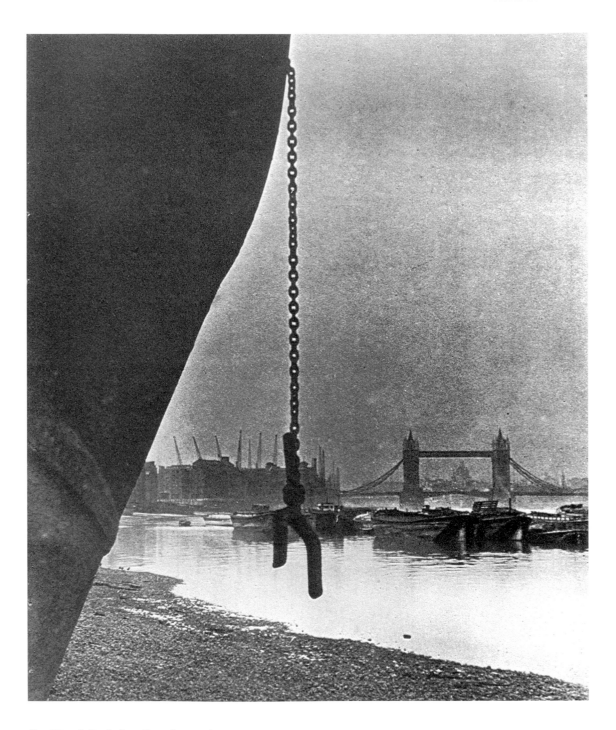

Fig. 27. *St Paul's Seen From Bermondsey*

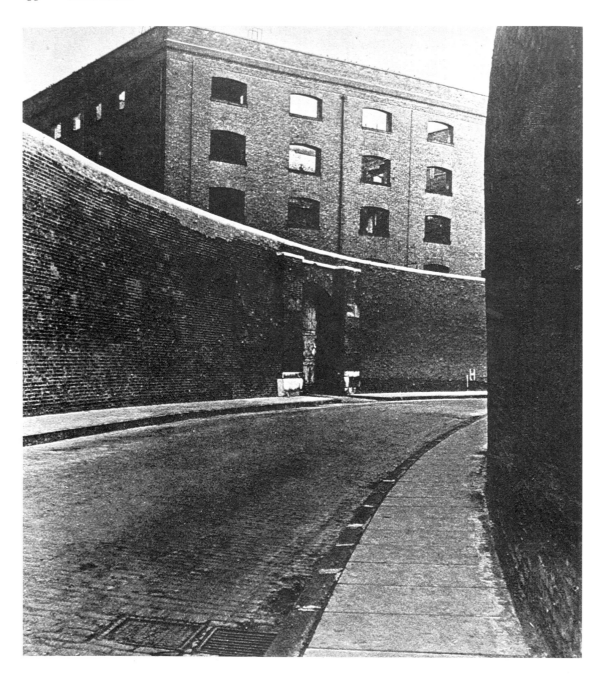

Fig. 28. *'As I was walking down Nightingale Lane...'*

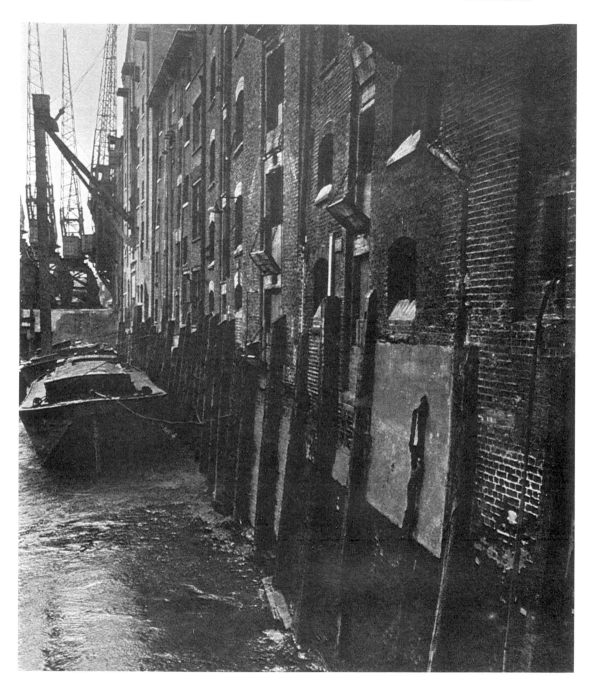

Fig. 29. *Warehouses Along the South Bank*

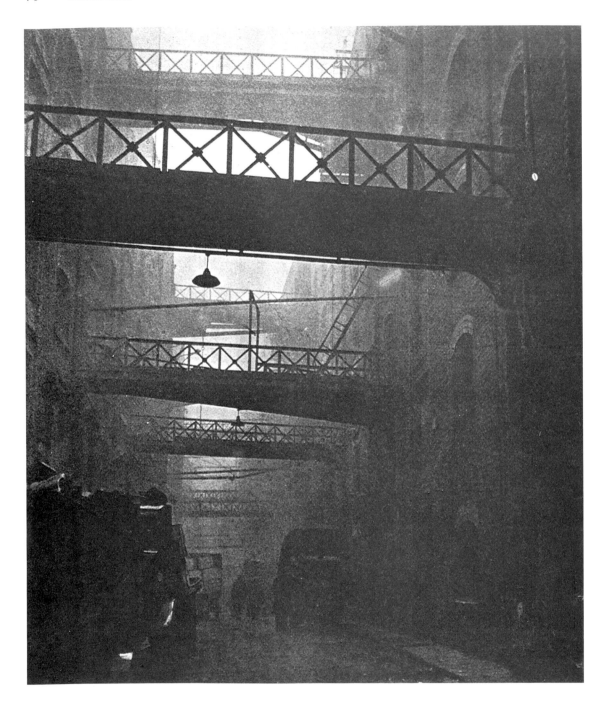

Fig. 30. *Shad Thames*

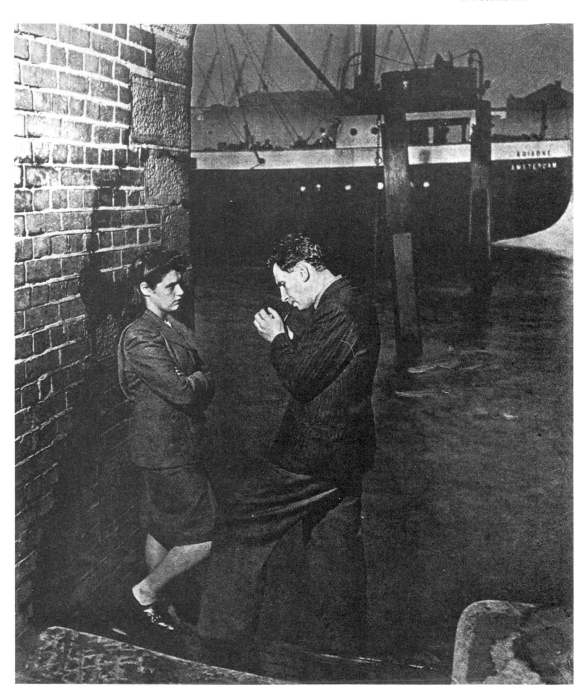

Fig. 31. *Hermitage Stairs, Wapping*

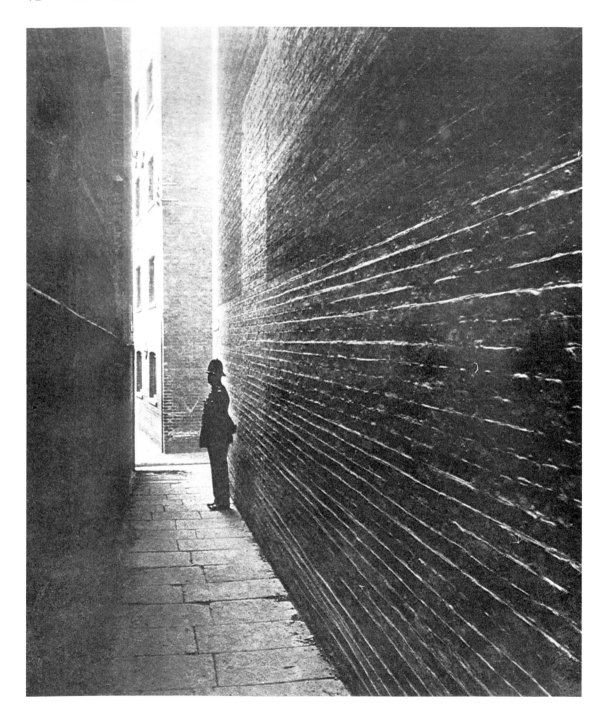

Fig. 32. *Horselydown New Stairs, Bermondsey*

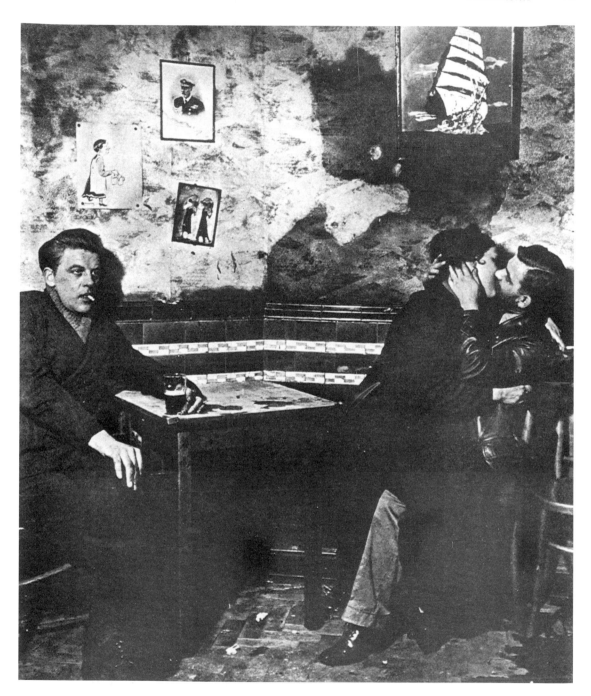

Fig. 33. *Charley Brown's, Limehouse*

Fig. 34. *Wapping – The Wharves*

Bill Brandt / True Londoner

Norman Hall

When considering the art of Bill Brandt it is well to remember that he is, first and always the true Londoner. London is his home, his working base and the continual source of his inspiration. Since Victorian times others have sought like Alexander the Great to conquer the world, bringing back records of their travels so that their standing is often related to the number and variety of entries in their passports. This cannot be said about Brandt. Whenever he takes a camera away from London it is because he has been commissioned to do so. Some portrait is required for a magazine or book or perhaps a record of literary or historical association. Perhaps he is pursuing a specific landscape for which he has long awaited suitable conditions of light or weather. He always travels purposefully; never in blind hope or speculation.

During a long career London and its environs have supplied the ideas and material for the bulk of his photography. It is true that there is a great deal of variety about this but nothing that disputes the overall importance of London's abiding spell. He remains, as always, the essential Londoner.

His devotion to the urban scene, his surrealist tendencies and because he worked for a short period in Paris during the

Norman Hall. 'Bill Brandt/True Londoner'. Introduction to exhibition catalogue *Bill Brandt* (New York and London: Marlborough Gallery, 1976). Reproduced with the kind permission of Barbara Mary Hampton.

Brandt's friend and former editor of *The Times*, to whom the second edition of *Shadow of Light* is dedicated, emphasizes London's abiding spell on the photographer.

late-1920's prompted some writers to claim that his style is derived from Atget – a much-too-facile theory and completely unjustified. Brandt's admiration for the photography of Atget is certainly not reflected in the subtleties of his own. It is far more feasible that some influence could be attributed to his close contemporary, Brassaï. Using identical methods, materials and equipment, they were each engaged in the portrayal of their respective cities and, naturally enough, there are some details in both the London and Paris books which bear comparison. Again, one can detect similarities between Brandt and other Parisians, Izis, Ronis and Doisneau. It seems likely, though, that here Brandt was the animating influence.

Nor can it be assumed that his vision has been prompted by the superb street studies of John Thomson or the London types of Paul Martin. In fact, it seems difficult to think of any photographer other than Brandt himself who is responsible for the pervading magic of his work.

But stay! It is perhaps possible that he owes something to Gustave Doré the great French illustrator? Certainly, there is an uncanny affinity between Brandt's work and the drawings of this 19th century artist. In his book *London, a Pilgrimage* (1872) Doré recorded the gaslight, fog and grime of the London known by Dickens. Brandt's London, and many of his images of the Depression years in the Midlands and the North should be studied side by side with the illustrations of this artist.[†]

In the strength and sheer audacity of his tones, in his impeccable composition and vitality Brandt will be found to match the Doré engravings – an achievement not equalled by any other photographers. Doré made of London an historical document which could not then have been duplicated by any camera. Not only does it tell us what London looked like but it treats with its life and mores, its pleasures, its industry and its vice. The images are comparable with those of Hogarth. An equal awareness of the transient nature of life in a great city is implicit in the pictures of Brandt. He seems to see everything in relation with its proper time. This adds a rare dimension which is a compelling characteristic of his work.

How marked is this awareness of passing time in the haunting scenes he produced during his landscape period! More than mere topography they seem to suggest times past, present and future. More than mere settings they are also symbols.

But evocation is a strong feature in most of Brandt's photography. This, more than anything else distinguishes him from others. What is seen in his pictures is rarely the simple

† See fig. 25. Doré's and Brandt's pictures were printed side by side in 'Unchanging London', *Lilliput*, vol. 4, no. 5 (May 1939), p. 485–500, 16 illus.

statement it first seems to be. This is particularly so with his wonderful and mysterious nudes.

It will help to approach his art with these few observations firmly in mind. They should be helpful in defusing many another wild theory by those who have not understood. The chief premise, always is to accept his validity as a genuine Londoner. Nothing is more important than that.

'The Day That Never Broke' – A *Picture Post* Photo-Story

Photographs by Bill Brandt

'The day when visibility was a yard and fog was a great healer, and – if you went the right way about it – you had the whole purged city to yourself.'

Bill Brandt. 'The Day That Never Broke'. *Picture Post*, vol. 34, no. 3 (18 Jan. 1947), p. 30–3. 4 illus. Text by courtesy of Noya Brandt. Illustrations, Copyright © Noya Brandt.

One of Brandt's most successful photo-stories in which a man cycles through a deserted fog-bound London. 'He had achieved his life-long ambition of being, for a few hours, the only man in London.'

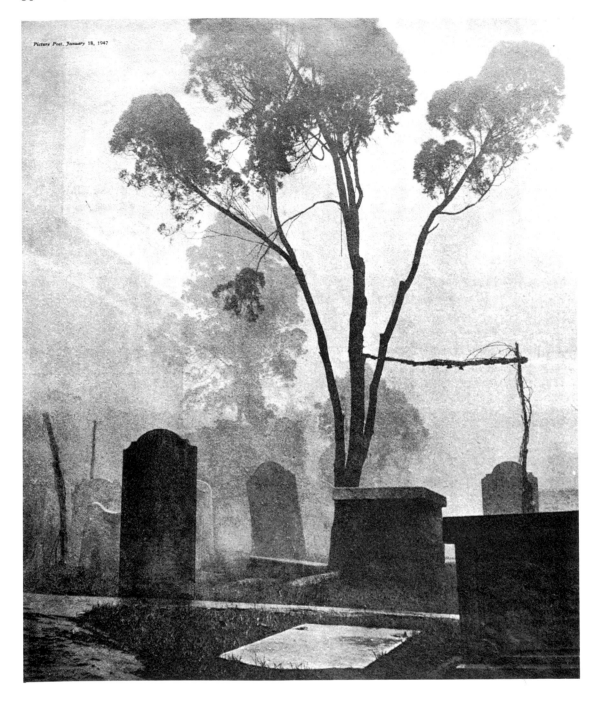

Fig. 35. *The Londoners Who Are Quit of the London Fog for Ever*

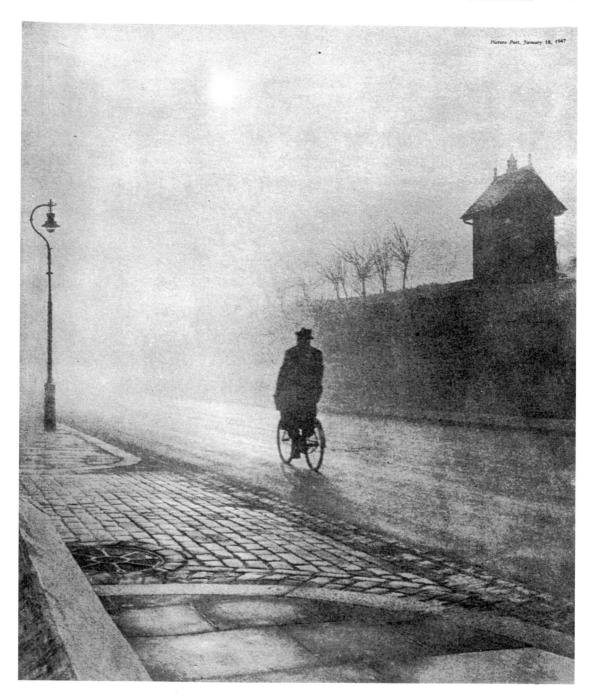

Picture Post, January 18, 1947

Fig. 36. *The Man Who Found Himself Alone in London*

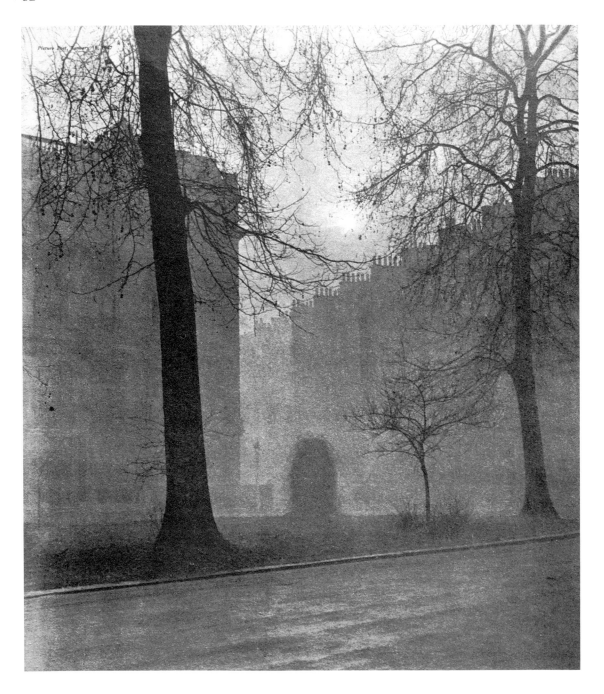

Fig. 37. *The Square Where the Nightingale Died With the Fog in its Throat*

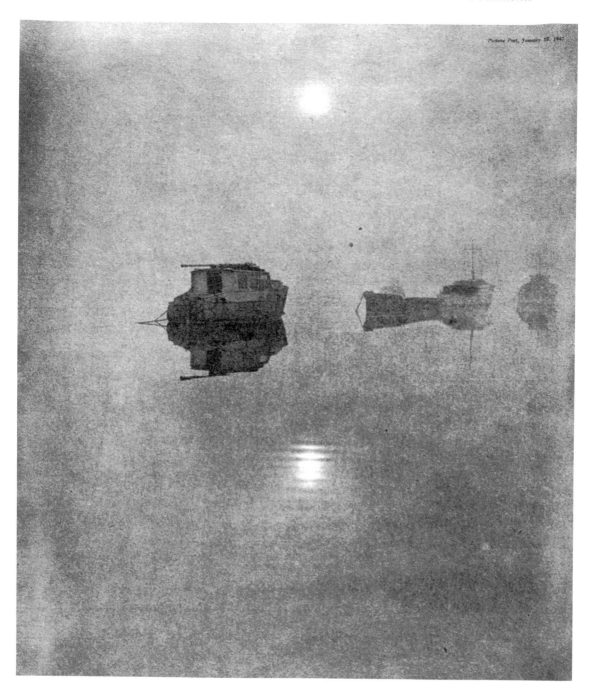

Picture Post, January 18, 1947

Fig. 38. *The Phantom Sun that Got Lost in the Yellow River*

A Photographer's London

Bill Brandt

I wonder if anyone could ever succeed in photographing London? There are the well known views bought by the hundreds – Trafalgar Square and Piccadilly Circus, the British Museum and Buckingham Palace, Whitehall and Regent Street. But these are not London, any more than a casserole is the same thing as the smells and savours of the dish within. London is something too complex to be caught within a set of views or by any one photographer. It would take a library of picture books to show London's many moods – and then the photographer would probably have missed that side street in Islington where each house has a pair of graven sphinxes besides its entrance door.

There is very little generally acknowledged beauty in London. It has no great avenue like the Champs Elysées in Paris and no overpowering sky-line like New York or grand waterfront like Chicago. Trafalgar Square with Nelson's Column, the Thames with the Houses of Parliament or the Tower Bridge, are sufficiently unique to stand as symbolic landmarks, but they do not sum up London like the bridges across the Danube summed up what used to be the splendour of Budapest. Apart from the little that is left of John Nash's Regents Park Terraces, London

Bill Brandt. 'A Photographer's London'. [p. 9–19] introduction to Bill Brandt, *Camera in London* (London: Focal Press, 1948). Courtesy of Noya Brandt and Focal Press.

Brandt's major statement about his photography. He describes the need to recover the simple pleasures of seeing, the ability to experience the world anew. He also explains some of his working methods.

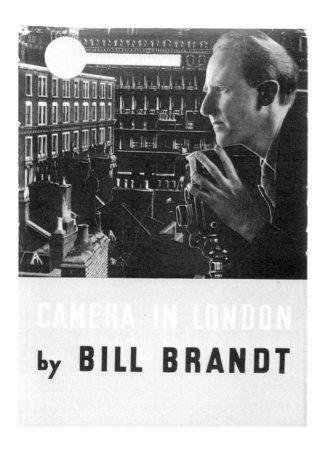

Fig. 39. Cover of *Camera in London*, 1948.

has no great grouping on an ordered plan. The casual visitor may never discover the real beauty of London unless he finds the surprising backwaters and small towns hidden behind the noisy main streets. I am thinking of the Clerkenwell squares, the Montpellier district of Knightsbridge, Holly Place in Hampstead and Cheyne Row in Chelsea, or the quiet streets of Campden Hill where over the tops of the chestnut trees of a Victorian garden one can see all London and beyond as far as the Surrey downs. It is in these byways that I find the attraction of London. There I have tried to capture something of its magic, something of the spell it can work as one strolls through deserted streets on a quiet summer evening, something of the brooding fantasy hidden in its stones.

At least that is my purpose to-day. But I did not always know just what it was I wanted to photograph. I believe it is important for a photographer to discover this, for unless he finds what it is that excites him, what it is that calls forth at once an emotional response, he is unlikely to achieve his best work. For me it was not easy. Simply because my response was so much a matter of

instinct that consciously I could not formulate it. In fact I did not try to do so. I now have through experience a more conscious knowledge of what it is that excites me – or would it be more exact to say of what does not excite me? Yet instinct itself should be a strong enough force to carve its own channel. Too much self-examination or self-consciousness about it or about one's aims and purposes may in the early stages be a hindrance rather than a help.

If his instinct did not guide him, either consciously or subconsciously, a photographer might work for years without experiencing the excitement of creative work with his camera. To discover what it is that quickens his interest and emotional response is particularly difficult for the photographer to-day because advances in technical equipment have made it possible to take such a wide variety of subjects under such varying conditions that the choice before him has become immense in its scope. The good photographer will produce a competent picture every time whatever his subject. But only when his subject makes an immediate and direct appeal to his own interests will he produce work of distinction. It may be that he already has some existing interest – in lighting, people's expressions, science – which will determine his choice, because where his interests are there will his seeing eye be also. If he is not lucky enough to find his own field in this way, then either deliberately or compelled by indecision he has to experiment.

My own experimenting was somewhat haphazard. I always had an interest in architecture, so that early in my career I photographed buildings. But my pictures did not satisfy me. I looked upon the work then as the recording of buildings and as records my pictures were adequate. Yet they lacked something, some quality which I could not name and only vaguely felt would have given me pleasure. So I turned to landscapes. I am not sure why I did this, because although I appreciate the beauties of the countryside I have never thought of myself as a lover of nature. And yet here was a seeming paradox. Something in these pictures of landscapes pleased me, although I had no great interest in the subject matter. Slowly a new development took place. Almost without my realising it stone-work began to encroach upon my landscapes. Little by little – a milestone, the tombs in a churchyard, a distant house in a park – until there was a fusion, not consciously sought by myself, of the subject that interested me and that indefinable something which gave me pleasure – aesthetic or emotional, or call it what you will. I began to feel that I might produce good pictures.

The trouble had been, as I have since realised, that I came to architecture in the first place with preconceived ideas; while with landscapes I had an unprejudiced eye.

Thus it was I found *atmosphere* to be the spell that charged the commonplace with beauty. And still I am not sure what atmosphere is. I should be hard put to define it. I only know it is a combination of elements, perhaps most simply and yet most inadequately described in technical terms of lighting and viewpoint, which reveals the subject as familiar and yet strange. I doubt whether atmosphere, in the meaning it has for me, can be conveyed by a picture of something which is quite unfamiliar to the beholder. The photograph of the unknown – such photographs as those taken with a microscopic attachment of lowly forms of life or such as a close-up of the heart of a cabbage – seldom arouses in the spectator any emotion beyond bewilderment or curiosity or perhaps a logical attraction or repulsion. While if it does not show the subject in a new light, the photograph is dead, a record on the flat print and nothing more.

Everyone has at some time or other felt the atmosphere of a room. If one comes with a heightened awareness, prepared to lay oneself open to their influence, other places too can exert the same power of association. It may be of association with a person, with simple human emotions, with the past or some building looked at long ago, or even with a scene only imagined or dreamed of. This sense of association can be so sharp that it arouses an emotion almost like nostalgia. And it is this that gives drama or atmosphere to a picture. If the atmosphere of a landscape, a person or an interior is uncongenial to me, I am at once repelled. It is like going into a room where one expected a welcome and finding it empty. The sense of nothingness confronting me can be almost depressing. That is why subjects which cannot have an atmosphere – such as that same heart of a cabbage – do not interest me.

When I have seen or sensed – I do not know which it is – the atmosphere of my subject, I try to convey that atmosphere by intensifying the elements that compose it. I lay emphasis on one aspect of my subject and I find that I can thus most effectively arrest the spectator's attention and induce in him an emotional response to the atmosphere I have tried to convey.

At first this was very much a hit-or-miss process. I would produce an effective picture, photographed and printed, I believed, in my usual way. Taking thought, I would then try to reproduce the same effects with another subject and fail

completely. Learning by trial and error, I now know how to produce and sharpen my effects.

Composition is very important, but I believe it is largely a matter of instinct. There are text-book rules on the subject, but they are likely only to result in stereotyped pictures. They hamper anyone's native imagination. I hope that composition never becomes an obsession with me, as was the unhappy plight of an enthusiastic amateur of my acquaintance who could not look at anything without composing it. As a matter of fact I am able to forget photography almost completely when I am not working and never carry a camera except on an assignment.

On seeing my subject I must of course have an exact idea of the effect I want to produce. This determines the point of view from which I take the picture. I may, for instance, want to give an impression of the immensity of a building. Then I approach close to some small architectural detail, photographing it from such an angle that the lines of the building run into the far distance, giving a feeling of infinity. I may want to convey an impression of the loneliness of a human figure in an outdoor scene. Taking that figure close to the camera and on a path stretching away behind him to a distant horizon intensifies the effect of solitude.

I am not very interested in extraordinary angles. They can be effective on certain occasions, but I do not feel the necessity for them in my own work. Indeed, I feel the simplest approach can often be most effective. A subject placed squarely in the centre of the frame, if attention is not distracted from it by fussy surroundings, has a simple dignity which makes it all the more impressive.

Intensification of my effects is often done in the process of printing. Each subject must determine its own treatment. Taking some pictures of a country house, I came upon a reclining stone figure in the garden. It was a grey winter day and there was an air of unreality about the sleeping figure, with distant trees half-showing through mist in the background. Making a soft print heightened the dream-like atmosphere of the scene, emphasising the whiteness of the stone and the softness of the mist.

A light print heightened the weird beauty of Stonehenge in the snow, seen from a distance against a dull grey sky. The light print, eliminating details such as the shadows in the snow, had an unearthly transparent effect.[†]

When photographing a writer,[††] I was forcibly impressed by the Victorian character of the room in which he sat. A hard print brought out this impression. Details were lost as they were in

† Fig. 40, p. 101.
†† E.M. Forster.

early Victorian photographs. My print did not imitate those old photographs; the method of printing simply formed a link of association between the two, adding its reminiscent effect to the Victorian setting.

The atmosphere of a scene does not need to be attractive or pleasant. On a path over a bare bit of moorland near a mining village I came across a miner leaning over his bicycle; the man's clothes were black and the grass by the side of the path was black, as it is near pit heads. The scene was dreary in the extreme, yet moving by its very atmosphere of drabness. A dark print of the photograph added to the effect of darkness associated with the miner's life.

I consider it essential that the photographer should do his own printing and enlarging. The final effect of the finished print depends so much on these operations. and only the photographer himself knows the effect he wants. He should know by instinct, grounded in experience, what subjects are enhanced by hard or soft, light or dark treatment.

But he will not do this with the perfect discrimination he wants if he has not in the first place himself received a sufficiently strong stimulus from the subject. No amount of toying with shades of print or with printing papers will transform a commonplace photograph into anything other than a commonplace photograph. The photographer must first have seen his subject, or some aspect of his subject as something transcending the ordinary.

It is part of the photographer's job to see more intensely than most people do. He must have and keep in him something of the receptiveness of the child who looks at the world for the first time or of the traveller who enters a strange country. Most photographers would feel a certain embarrassment in admitting publicly that they carried within them a sense of wonder, yet without it they would not produce the work they do, whatever their particular field. It is the gift of seeing the life around them clearly and vividly, as something that is exciting in its own right. It is an innate gift, varying in intensity with the individual's temperament and environment.

I believe this power of seeing the world as fresh and strange lies hidden in every human being. In most of us it is dormant. Yet it is there, even if it is no more than a vague desire, an unsatisfied appetite that cannot discover its own nourishment. I believe it is this that makes the public so eager for pictures. Its conscious wish may be simply to get information. But I think the matter goes deeper than that. Vicariously, through another

person's eyes, men and women can see the world anew. It is shown to them as something interesting and exciting. There is given to them again a sense of wonder.

This should be the photographer's aim, for this is the purpose that pictures fulfil in the world as it is to-day. To meet a need that people cannot or will not meet for themselves. We are most of us too busy, too worried, too intent on proving ourselves right, too obsessed with ideas, to stand and stare. We look at a thing and believe we have seen it. And yet what we see is often only what our prejudices tell us to expect to see, or what our past experiences tell us should be seen, or what our desires want to see. Very rarely are we able to free our minds of thoughts and emotions and just see for the simple pleasure of seeing. And so long as we fail to do this, so long will the essence of things be hidden from us.

I know this from my own experience. I have said that my first attempts at photographing architecture were failures. I know now that I was looking at buildings with the preconceived ideas of what I had learnt about architecture; this or that was the important feature to be caught. I was not content to let the buildings make their own impressions on me. When it came to landscapes, I had no preconceived ideas. I was content to look at them in vacant mood.

Yet when all is said and done, I do not really know how I take my pictures. I photograph the subject as I see it. Perhaps something lies in being ready to see the picture. Just as there is a right moment in action photography, so other subjects too have moments when they are seen in their most interesting or exciting aspects. A photographer must be prepared to catch and hold on to those elements which give distinction to the subject or lend it atmosphere. They are often momentary, chance-sent things: a gleam of light on water, a trail of smoke from a passing train, a cat crossing a threshold, the shadows cast by a setting sun. Sometimes they are a matter of luck; the photographer could not expect or hope for them. Sometimes they are a matter of patience, waiting for an effect to be repeated that he has seen and lost or for one that he anticipates. Leaving out of question the deliberately posed or arranged photograph, it is usually some incidental detail that heightens the effect of a picture – stressing a pattern, deepening the sense of atmosphere. But the photographer must be able to recognize instantly such effects.

On an assignment, I was looking for pictures to show autumn in Bayswater. I went and looked at a street I already knew well. It had always attracted me, although it was simply one of those

streets of upper middle class houses to be seen by the score of London. But when I looked at it through the view-finder I could not see a picture there. I went on to other places. After tramping around for a long time I found myself in the late afternoon back at the same spot. I was reluctant to give up the idea of photographing that street, yet I felt a sense of futility as I looked at it again. I had better give it up. I felt tired and it was getting late. Perhaps I really needed some dinner. I stared absent-mindedly at some leaves in the gutter and forgot the picture I was looking for. Then I glanced up. There was the street suddenly lit up by a low sun. The houses, brilliantly white against a mauve coloured, thundery sky, were throwing gigantic shadows across the pavement. The sun was rapidly sinking behind some distant roof tops, but for a minute or two this street in Bayswater had something of the dream-like atmosphere of an Italian piazza in a Chirico painting. There was all the nostalgia of an autumn afternoon and there was my picture.

Why had I not seen all this before? It was the same street, the sun had been shining earlier in the afternoon and still it had all looked flat and uninspiring. What I needed for this autumn picture was the sun at almost street level, the long shadows and the thundery sky.

If there is any method in the way I take pictures, I believe it lies in this. See the subject first. Do not try to force it to be a picture of this, that or the other thing. Stand apart from it. Then something will happen. The subject will reveal itself.

As I said before, I hardly ever take photographs except on an assignment. It is not that I do not get pleasure from the actual taking of photographs, but rather that the necessity of fulfilling a contract – the sheer *having* to do a job – supplies an incentive, without which the taking of photographs just for fun seems to leave the fun rather flat.

I like whenever possible to prepare the ground beforehand. If it is a certain district I am going to photograph, I try to visit it first – wandering round, looking at the houses, watching the people, in short trying to get the atmosphere of the place. Even if I am taking only a single building, I like if possible to look over it in advance. When taking the series on Chelsea, I went there several times before I actually took any photographs. I usually take a camera with me, however, even when I do not yet intend to take any shots, because one never knows when one may come across a picture which is typical of the subject but is the accidental sort of thing which happens only once. Usually I work alone, but when taking people it is an advantage to have

someone with me. My companion can talk to my subject and engage his attention. I find it slightly distracting to have someone watching me as if I might spring upon him and extract a tooth at any moment. I am left free to gather my impressions of the people and their surroundings and to make up my mind where and how to arrange them together to get what I want.

I believe that some of the foremost American photographers go out on a job with an entourage of helpers to hand them ready-loaded cameras, operate flash bulbs and so on. It must be most imposing, but I think I personally would find the helpers somewhat in the way. And I am used to reloading my own camera on the job. The method of working with an army of helpers is probably useful if one takes a great number of photographs, say about five hundred, from which one will use half-a-dozen prints. But I find that on an average I get three usable prints out of every spool. Something of my methods may be due to the fact that I usually work with a twin-lens reflex, which has only twelve negatives to the film, whereas range-finder miniature cameras, with thirty-six negatives to the film, are a temptation to keep on shooting. But the final choice in the matter probably rests with temperament.

By temperament I am not unduly excitable and certainly not *trigger-happy*. I think twice before I shoot and very often do not shoot at all. By professional standards I do not waste a lot of film; but by the standards of many of my colleagues I probably miss quite a few of my opportunities. Still, the things I am after are not in a hurry as a rule. I am a photographer of London.

Often I am asked if I do not feel that I have come to an end of the possibilities of photographing London – I have been photographing it for several years now and surely the subject must be exhausted. Happily, I have never had to ask myself that question. Even if London did not change, my own outlook on life does. And that means that for me photography changes too. Apart from any discoveries in equipment and advances in technique, my aims in taking pictures must undergo a sensible development.

But London does change. Out of the ruins of the Great Fire rose the buildings of Wren. And London has changed more rapidly than ever in the last few years. The London of the last war was a different place from the London of 1938. The glamorous make-up of the world's largest city faded with the lights. Under the soft light of the moon the blacked-out town had a new beauty. The houses looked flat like painted scenery and the bombed ruins made strangely shaped silhouettes. Through the

gaps new vistas were opened and for the first time the Londoner caught the full view of St. Paul's Cathedral.

And perhaps out of the ruins of the war will rise new buildings which will rival those of Wren. I hope that will be in the not too distant future, because I want to be there to photograph them.

Technical Data

Bill Brandt

Bill Brandt thinks that a perfect all round camera has yet to be made. He uses an *Automatic Rolleiflex* (1.5 cm. Tessar f 3.5) for the great majority of his pictures. In cases where a telephoto lens is needed he uses a *Reflex-Korelle* with a 6 inch Dallon Tele-Anastigmat f 5.6 or a 25 cm. Tele Tessar f 6.3. For portraits, interiors and architectural pictures he prefers a Deardorff's view camera ($3^5/_8$ inch Dagor f 8). He has a Thalhammer tripod and a Weston exposure meter.

His lighting equipment consists of two Kodak lampholders, some photoflood bulbs and enough flex to stretch the full length of Winchester Cathedral. For his flashlight exposures he uses a Sashalite Pistol Grip Reflector.

Brandt considers his Kodak Finisher Enlarger the most perfect of its kind.

He always works with his exposure meter and stops down to the smallest aperture possible under existing lighting conditions. He does not usually snap pictures in a hurry, but works slowly and deliberately. He prefers photoflood lights to flashlight and dislikes synchronised flash. He uses Verichrome film for most of his work and super pan for portraits. He never uses filters.

Bill Brandt. 'Technical Data', from *Camera in London* (London: Focal Press, 1948) [folding out page] p. 89. Courtesy of Noya Brandt and Focal Press.

These notes provide an interesting insight into Brandt's photographic technique in the 1930s and 1940s.

95

Page	Subject	Camera	Sch.
21	Looking down the river	Rolleiflex	30
22	Westminster	Rolleiflex	30
23	Waterloo Bridge	Reflex Korelle	30
24	London waterfront	Reflex Korelle	30
27	Mayfair	Reflex Korelle	27
28	Cheyne Row	Rolleiflex	30
29	House in Cheyne Row	Rolleiflex	30
30	Street in Chelsea	Rolleiflex	30
31	Street in Hampstead	Rolleiflex	30
32	Some snow in Hampstead	Rolleiflex	30
33	More snow in Hampstead	Rolleiflex	30
34	Spring in Chelsea	Rolleiflex	30
35	Autumn in Chelsea	Rolleiflex	30
36	The sun on Hampstead	Rolleiflex	30
37	The sun on Albany	Rolleiflex	30
38	House beyond a Chelsea balcony	Rolleiflex	30
39	Houses beyond Chelsea bridge	Rolleiflex	30
40	Seasonal bleakness over Adelphi roof tops	Reflex Korelle	30
41	Lasting bleakness in Shoreditch backyards	Rolleiflex	30
42	Riverside pub	Rolleiflex	30
45	Inside any pub	Rolleiflex	27
46	Family supper	Rolleiflex	30
47	Friends after supper	Rolleiflex	30
48	East End morning	Rolleiflex	27
49	Mayfair morning	Rolleiflex	30
50	The antique shop	Rolleiflex	30
51	The antique photographer	Rolleiflex	30
52	Outside Buckingham Palace	Rolleiflex	27
53	Outside a Soho night club	Rolleiflex	30
54	On guard	Rolleiflex	30
55	Off guard	Rolleiflex	30
56	Making it up	Rolleiflex	30
57	Having it out	Rolleiflex	30
58	Forgetting it all	Rolleiflex	30
61	Lambeth Walk	Rolleiflex	30
62	East End fight	Rolleiflex	30
63	Watching it	Rolleiflex	30
64	East End fun	Rolleiflex	30
65	No fun at all	Rolleiflex	27
66	Responsibility	Rolleiflex	30
68	Exotic pattern in Chiswick House Gardens	Rolleiflex	30
69	English mist in Chiswick House Gardens	Rolleiflex	30
70	Day's beginning	Rolleiflex	30
71	Night's ending	Rolleiflex	27
72	Wine from across the road	Rolleiflex	30
73	Milk for round the square	Rolleiflex	30
75	Overlooking Trafalgar Square	Rolleiflex	27
76	Right in the middle of Piccadilly Circus	Rolleiflex	27
77	Just outside Piccadilly Circus	Rolleiflex	27
78	The last days of a hansom cab	Rolleiflex	27
79	By no means the last days of an old taxi	Rolleiflex	27
80	They have just come home in South End Road	Rolleiflex	27
82	Moon on the Adelphi	Rolleiflex	30
83	The moon on Park Crescent	Rolleiflex	30
84	Terrace near Regents Park	Rolleiflex	30
85	Square in Bloomsbury	Rolleiflex	30
86	The people –	Rolleiflex	30
87	who used to live in the houses	Rolleiflex	30
88	The church which has seen it all	Rolleiflex	30

Stop	Exposure	Date	Lighting Conditions
f 16	1/25	1945	Fine Autumn day
f 5.6	1/25	1946	Foggy afternoon
f 12	1/50	1945	Early morning in May
f 9	1/25	1945	Autumn sunshine
f 12	1/25	1932	Spring afternoon
f 11	1/50	1944	Spring sunshine
f 11	1/50	1944	Spring sunshine
f 11	1/50	1944	Spring sunshine
f 8	1/25	1945	Winter afternoon
f 11	1/25	1945	Winter afternoon
f 11	1/25	1945	Winter afternoon
f 11	1/25	1944	Spring afternoon
f 5.6	1/50	1944	Spring afternoon
f 11	1/25	1938	Spring sunshine
f 11	1/25	1945	Sunny morning in April
f 11	1/25	1944	Spring sunshine
f 11	1/25	1944	Spring sunshine
f 12	1/25	1939	Grey Autumn day
f 11	1/25	1939	Winter day
f 11	1/25	1945	Fine Autumn day
f 11	1/45	1936	Flashlight
f 8	1/45	1937	Flashlight
f 11	1/45	1945	Flashlight
f 8	1/50	1937	Morning in September
f 11	1/25	1945	Daylight only
f 11	1/10	1944	Daylight and one photoflood
f 11	1/2	1942	One photoflood
f 11	1/25	1935	Autumn daylight
f 11	1 sec.	1942	One photoflood
f 11	1/45	1936	Flashlight
f 11	1/45	1942	Flashlight
f 6.3	1/2	1945	Twilight
f 5.6	1/10	1936	Railway station lighting
f 11	1/50	1940	Spring afternoon
f 8	1/50	1939	Afternoon in March
f 8	1/50	1939	Spring day
f 5.6	1/50	1939	Grey Winter day
f 6.3	1/100	1939	Afternoon in March
f 6.3	1/50	1937	Grey Autumn day
f 5.6	1/50	1939	Winter daylight
f 22	1 sec.	1944	December afternoon
f 22	1 sec.	1944	Late afternoon in December
f 6.3	1/50	1946	Foggy day in December
f 4.5	1/25	1934	Light fog
f 5.6	1/50	1942	Noon in February
f 16	1/10	1946	Bright morning in November
f 8	5 sec.	1936	Winter afternoon, street lighting
f 5.6	1/45	1936	Flashlight
f 5.6	1/45	1936	Flashlight
f 8	1/45	1936	Flashlight
f 8	1/45	1934	Flashlight
f 8	1 min.	1937	Night, street lighting
f 8	15 min.	1939	Moonlight
f 8	10 "	1939	Moonlight
f 8	12 "	1942	Moonlight
f 8	15 "	1942	Moonlight
f 8	1/45	1940	Flashlight
f 11	1/45	1940	Flashlight
f 8	15 min.	1942	Moonlight

Bill Brandt's Landscapes

Tom Hopkinson

When I first met Brandt, in 1936, his obsession was with documentary work. He was taking gloomy, often impressive, pictures of slums and slum-children. Occasionally by contrast he would produce a brilliant glimpse from the world of top-hats and night life, or of trim-aproned maids tending wealthy suburban mansions.

This documentary period was followed by one of realistic portraits – people in their own settings, in their drawing-rooms, at their desks or easels, in their gardens. Frequently the subjects gave the impression of having posed themselves, most carefully, underneath the family portraits or against the sun-dial, but the effect produced was not quite the one they had intended. It was the one the photographer intended.

Brandt never hurried. Like the wild-game hunter, he was prepared to wait hours to get in his shot, to let his subjects relax, and assume the face which he felt expressed – or sometimes exposed – them best. He was minutely careful over every accessory.

I remember his going to photograph a well-known bird-trainer with his tame eagles. It was the middle of the war, when travel conditions were appalling, and people would sometimes stand for hours packed face-to-face in crowded corridors without even

Tom Hopkinson. 'Bill Brandt's Landscapes' in *Photography*, vol. 9, no. 4 (April 1954), p. 26-31. 6 illus. Reproduced with the kind permission of Amanda Hopkinson.

The former editor of *Lilliput* and *Picture Post* identifies three key elements which set Brandt's landscape photography apart from the work of lesser photographers.

being able to reach for a pocket-handkerchief. The picture was for *Lilliput*, and would bring, at the most, £3 or £4. But Brandt conveyed to beyond Liverpool and back, a particular large Victorian glass and china lamp, which he had visualised as a property in the completed picture. The result well justified his trouble – which no other photographer I know of would have taken.

After portraits – which he still continues to take, particularly for the American *Harper's Bazaar* – came a period of concentration upon landscape. This began about the end of the war. It arose not primarily from an interest in natural beauty, but from a preoccupation with space, and the possibilities of conveying impressions of space by photographic means – just as Claude and, at certain periods, Rubens and Turner were haunted by space, and applied the full force of their talent to conveying a sense of space through painting.

I saw many of Brandt's landscapes at this time. I did not realise that it was space which was his chief concern, but I did realise that he was producing landscapes which were not simply photographs of a place, but which summed up a whole type of country in a single picture.

As editor of a picture magazine, I was constantly faced with, what seemed to me, the quite extraordinary dearth of good landscape photographs. We were continually needing beautiful pictures of the English scene; partly because I was well aware of the strong feeling most of us cherish for our own countryside; partly because there were at that time many picture-series dependent for their effect on conveying a sense of natural beauty which was so frequently threatened by various post-war developments.

It was an easy matter to assemble two or three thousand so-called 'landscape-pictures'. But when one went through them for the pictures which summed up the emotion aroused in one by a particular type of country – the picture which says 'These are the Downs' or 'This is the slow-moving brook where the cows stand knee-deep in king-cups and the boys catch sticklebacks' – nothing was ever good enough. Thousands of postcards; but no pictures.

Thinking it over, as to why so very few good landscape photographs are taken, I came to the conclusion that it was lack of selectivity. Some of the most delightful impressions of our country are those of the early English water-colour painters. A study of their work shows how persistently they cheated. They did not simply sit down in front of a 'view', and try to get it all,

just as it was, on to their paper. They recomposed everything in the most subtle way, omitting this and emphasising that. Their aim was to be true to the spirit of what they saw, not to be accurate in every detail.

And now here was Bill Brandt doing exactly the same thing in photography. How was he doing it? The essence of Brandt's landscapes is simplification and exclusion. The more is omitted, the stronger the interest that's focussed on what is left. How does Brandt achieve this exclusion of everything extraneous to the thing, or things, he wants to emphasise?

First, by a meticulous choice of viewpoint. An hour or two can easily be spent in search for exactly the right spot – and then another hour looking for a ladder, a tree, a suitable roof, a barrel to stand on, because he needs to be just a few feet higher. Secondly, by choosing his moment with the greatest certainty – which often means, of course, the moment of utmost inconvenience to himself. Take the picture of Stonehenge.

Stonehenge, as most of us see it, is obscured by barbed wire, iron gates, notices. There are visitors wandering to and fro, a string of cars, a mess of litter. How has Brandt got rid of all the rubbish?

'I'd always planned to photograph Stonehenge under snow' he says. 'The cold would mean there were no visitors, and the snow would obliterate so much that's distracting and unnecessary'. In the bitter January of 1947, he saw his chance. The picture he then took was used by *Picture Post* as a symbol for Britain on the cover of a special issue.[†]

The third method Brandt invariably uses to select what he wants out of a landscape is control of lighting. Brandt is in alliance with the Goddess of Night. What he wishes to conceal appears shrouded in darkness, while a gleam of sunshine, or in some cases moonlight, picks out the few features he decides to emphasise. To me the most striking feature of Brandt's landscapes is precisely this, his power to draw a magic veil of shadow, mist or midnight over the incidental, the trifling or the vulgar.

Brandt's own description of the way he takes a landscape is not technical at all, and it carries us back to our beginnings 'I have to become obsessed with a particular scene. I have to feel as if I've been to this place long ago, and am trying to recapture how it used to look. I don't know whether this feeling is literary – that having read the Brontës gives me a special feeling about Haworth. I only know I can't take a good picture unless I get this feeling.'

† Fig. 40, p. 101.

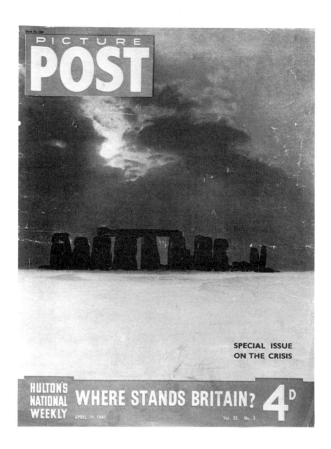

Fig. 40. *Stonehenge, Picture Post,* 19 April 1947.

Now Brandt has moved on again. For the past two or three years he has been gripped by a new obsession. He is taking photographs of nudes, which bear the same kind of relation to the human body as do the sculptures of Henry Moore – and, like Moore, his aim is to use the human body to express certain feelings and impressions about space. Space in landscape: space in and around and through the human body. The nude enclosed between the four walls of a room becomes a symbol for humanity imprisoned in the world, or the spirit confined within its mortal body.

And beyond that, faintly looming over the horizon, or – more accurately perhaps – casting its shadow round the studio door, is the idea of colour. But it won't be the mad riots of so-called 'natural colour' that we're accustomed to. Colour, to be allowed to pass through Bill Brandt's lens, will have to submit to the same stringent control, selection and rejection which black-and-white has been putting up with for the last twenty years.

'Over the Sea to Skye' – A *Lilliput* Photo-Story

Photographs and commentary by Bill Brandt

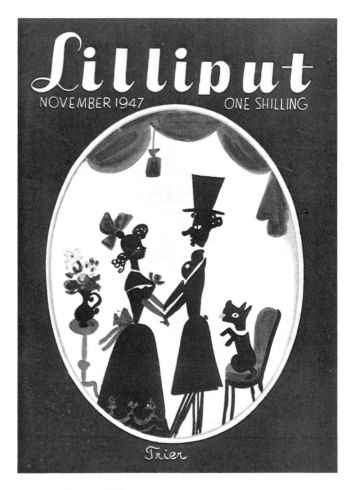

Fig. 41. Cover of *Lilliput*, Nov. 1947.

Bill Brandt. 'Over the Sea to Sky'. *Lilliput*, vol. 21, no. 5 (Nov. 1947), p. 389–96, 8 illus. Text by courtesy of Noya Brandt. Illustrations, Copyright © Noya Brandt.

Brandt's photographs of the beautiful Scottish island.

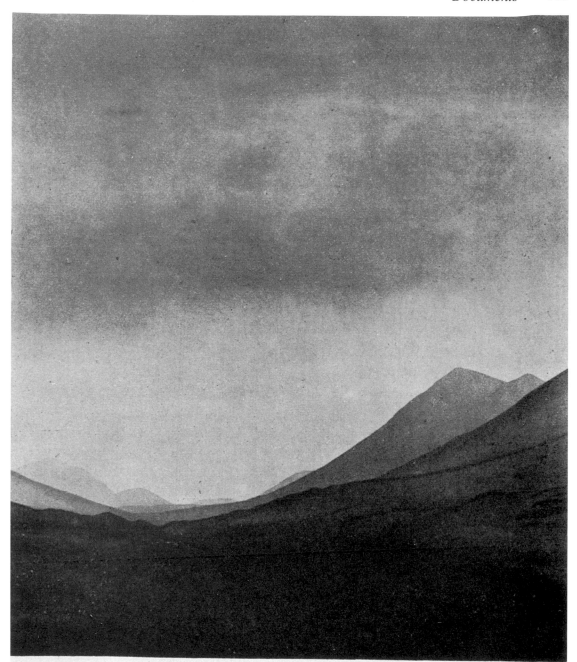

Over the sea to Skye

PHOTOGRAPHS AND COMMENTARY BY BILL BRANDT

IN the gentle autumn rain the peaks of Lord Macdonald's Forest look like the ethereal background of a romantic painting. Clach Glas in the distance is a favourite haunt of eagles. Ravens, wild cats, and highland stags can also be found in Skye. At one time the island must have teemed with deer, for in the sixteenth century organised hunts took place among these hills in which a thousand deer were killed and gralloched and carried home slung from poles.

Fig. 42. [*Lord Macdonald's Forest*]

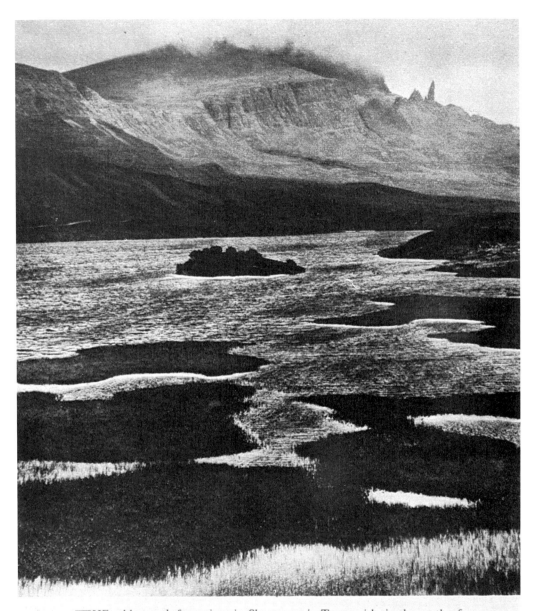

THE oddest rock formations in Skye occur in Trotternish, in the north of the island. "Old Man of Storr" is a curious pillar, 160 feet high, which has never been climbed. Loch Fada at the foot of Storr is unusually well stocked with brown trout. In most lochs on Skye fish are lacking. This is invariably attributed to suicide; the islanders believe that the fish disappear from a loch when anyone has drowned themselves; where they go is a mystery.

390.

Fig. 43. [*Trotternish*]

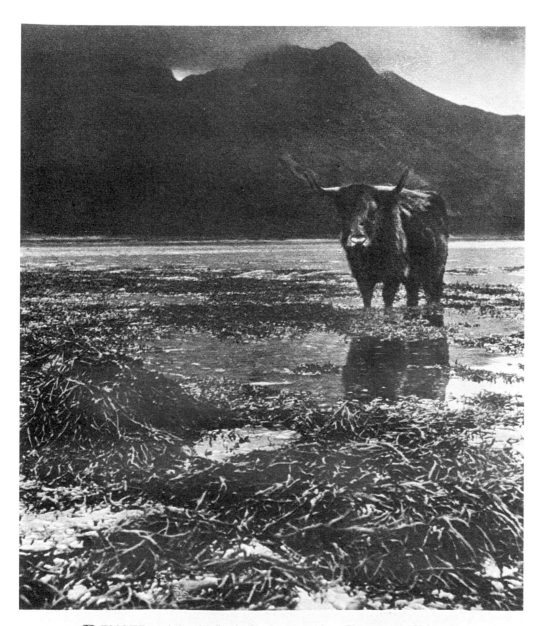

REMOTE and lonely Loch Slapin lies below Blaven and Clach Glas. Blaven, its jagged top in clouds, is geologically the most eastern outpost of the Coolins. It shares with them the angular and precipitous peaks of black and purple gabbro rock. On still evenings highland cows often come to the dark waters of Loch Slapin. Hardiest of all breeds, these shaggy-coated cattle can stand any weather and are sure-footed over the roughest country.

391

Fig. 44. [*Loch Slapin*]

SKYE has probably not changed much since Dr. Johnson's visit in 1773. It has no aerodrome, no railway, and roads are few and bad. Atmospheric effects of strange, unearthly beauty make up for the island's misty climate. After the rainy season of August and September the hills and moors are a dripping sponge. But October always brings a brilliant Indian summer before Skye disappears behind the clouds and darkness of the long island winter.

392

Fig. 45. [*Skye*]

PORT NA LONG is the village of the weavers and spinners in Skye. The most suitable wool for spinning comes from the poorest type of sheep that live on the barren moors of the Outer Hebrides. While spinning yarn during long winter nights the women of Port na Long sing traditional weaving songs. Some curious taboos are still found in Skye. You should not give a woman a needle without a thread in it for fear it would render her barren.

393

Fig. 46. [*Port Na Long*]

ON the sloping hillside of Elgol a crofter cultivates his holding. He pays about £10 a year for the rent of 7 acres of arable land. Potatoes are the staple food in Skye and oats are grown for fodder. The island with its 650 sq. miles has only 11,000 inhabitants. Many emigrated during the last century. An emigrant ship would come into one of the lochs by night and next morning a whole village would be empty, its inhabitants embarked for Australia.

394

Fig. 47. [*Elgol*]

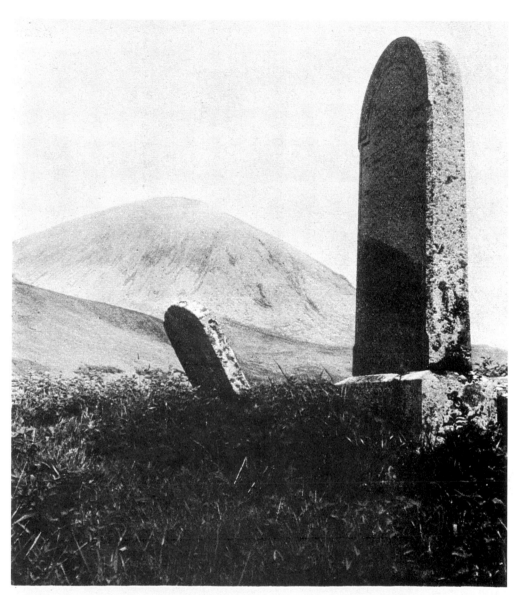

THE ancient graveyard of Strath lies miles away from any village, at the foot of the Red Hills. It was here that St. Maelrubha came to preach and hung his bell on a tree. The bell was quiet all the week but every Sunday morning it started pealing of its own accord and went on pealing until sunset. But when it was taken down from the tree and hung in the church near by, it remained quiet for ever, and the tree soon afterwards withered away.

395

Fig. 48. [*Strath*]

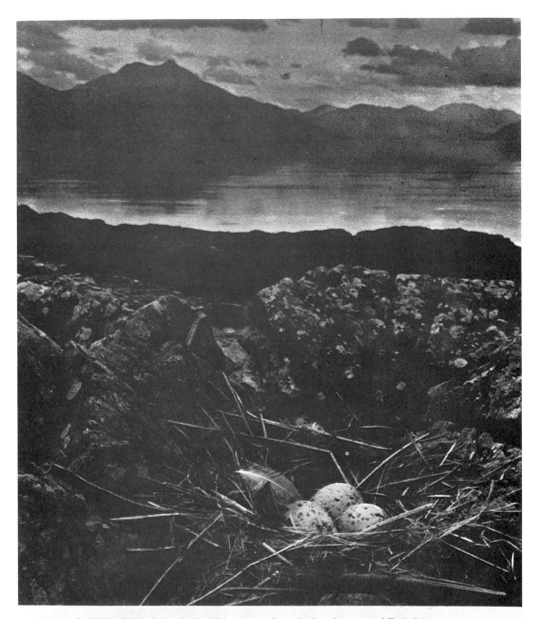

A GREAT black-backed gull has nested on the lonely coast of Duisdalemore. It is midsummer night and the eggs are almost hatched. Across the windstill Sound of Sleat appears the Scottish mainland, and Loch Hourn, famous for its wild gloom, is serene in the pale green summer twilight. The northern nights are short at this time of the year and in another hour or two a new day will break over Skye, while men and animals further south still sleep.

396

Fig. 49. [*Duisdalemore*]

The Portraits

Mark Haworth-Booth

Although Bill Brandt's career began, decisively, with his close-up portrait of Ezra Pound in 1928, his subject in the 30's was the social portrait and the urban setting. An exception is a dramatic head of his brother Rolf, lit in the style of expressionist cinema, from the mid-30's. Brandt's portraiture flowered in the 40's. Its hallmarks are seriousness, reticence and, despite some spectacular exceptions, a circumambience perhaps best described in the words of Elizabeth Bowen: "a tense bright dusk." Brandt portrayed artists and thinkers thoughtfully and in isolation. He rarely photographed politicians or businessmen. It is possible that as a young man in Vienna he may have known something of the activities of the art historian Heinrich Schwarz (of the Küpferstich Kabinett), who was then in the midst of his exciting rediscovery of the calotypes of Hill and Adamson from the 1840's. The appearance of Brandt's photograph of *Caledonian Market* (1929) in the pages of *Das Deutsches Lichtbild* in 1932 coincided with the publication in the same volume of an article by the Austrian art photographer Heinrich Kühn titled "The Photographic Mastery of Extreme Light and Shade." Kühn argued for manipulation of chiaroscuro in the interests of expression. The human eye, he wrote, is constructed

Mark Haworth-Booth. 'Portraits'. [p. 40–2] in *Bill Brandt: Behind the Camera. Photographs 1928–1983* (New York: Aperture, 1985; Oxford: Phaidon). Copyright © Mark Haworth-Booth, and with the kind assistance of Aperture.

A discussion of Brandt's portraits from 1928 to 1981.

in such a way that "high lights always become blended with shadows and … the action of the iris and other physiological processes co-operate to bring extreme contrasts closer together." Such physiological processes must be understood by "real photographers, who know how to portray atmosphere and mood convincingly and who have a message to deliver to the soul of man." Kühn opposed a photography which offered merely mechanical renderings of tone gradation. He celebrated instead the achievements of David Octavius Hill, whose "powerful expressionism of the Talbotype/Calotype … led him to the decisively characteristic outline of draughtmanship." Brandt contrived, in his portrait of E.M. Forster (1947), something of the shadowed luxuriance of calotype and later wrote of his intentions in *Camera in London* (1948):

> When photographing a writer, I was forcibly impressed by the Victorian character of the room in which he sat. A hard print brought out this impression. Details were lost as they were in early Victorian photographs. My print did not imitate those old photographs: the methods of printing simply formed a link of association between the two, adding its reminiscent effect to the Victorian setting.†

In this period Brandt consistently used the Rolleiflex camera which emerged on the photographic scene along with Brandt in 1928. The camera's ground-glass provided a clear view of the subject and the $2^1/_4 \times 2^1/_4$-inch negative gave Brandt the latitude he required for darkroom work. Brandt intensified or lightened his prints, cropped and retouched – sometimes drastically – and experimented tirelessly to achieve the veiled chiaroscruo tones typical of his photographs at this time. His serious portraiture began with a feature for *Lilliput* in December 1941. "Young Poets of Democracy," with text by Stephen Spender, presented Brandt's new portraits of Spender, C. Day Lewis, Dylan Thomas, Louis MacNeice, Alun Lewis, Anne Ridler, Laurie Lee and William Empson – representatives of both the Auden Generation and the poets in reaction to them, whom Cyril Connolly named the 'new romantics'. Brandt and his wife Eva, who published a remarkable novel called *The Mermaids* in 1956, regularly read John Lehmann's *New Writing*. Tom Hopkinson kept them in touch with interesting developments elsewhere, notably in *Horizon* where his own stories were achieving acclaim. Composers were photographed in 1946 and visual artists in 1948. In November 1949, *Lilliput* published "A Gallery of

† For full text see document 'A Photographer's London', p. 84–93.

Literary Artists": E.M. Forster, Norman Douglas, Ivy Compton-Burnett, Robert Graves, Edith and Osbert Sitwell, Elizabeth Bowen, Evelyn Waugh and Graham Greene. Brandt's portrait series for *Lilliput* closed in November 1949 with "The Box Office Boys" – the theatre producers of London's West End. This was an unlikely subject for him but times were changing. This phase of his portraiture came suddenly to an end when, in October 1949, Tom Hopkinson was forced out of the editorship of *Picture Post*. Many years later Sir Tom Hopkinson, as he became, speaking of the photojournalist Donald McCullin, said that a photographer of this caliber was akin to a thoroughbred racehorse and should be handled with great sensitivity by the responsible editor. As Bill Brandt's editor, Hopkinson always used another "thoroughbred" with discernment. At American *Harper's Bazaar*, the editor Carmel Snow gave Brandt similar encouragement and support in the later 40's and into the 50's. Brandt's early portraiture omits one individual, not exactly a writer and not usually described as a visual artist, whose oeuvre seems to have some say in the amply shadowed apartments in which we find so many of Brandt's sitters. In 1982 the present writer noted the omission in conversation with Bill Brandt: "Ah, Hitchcock, I would love to have photographed him. It could never be arranged. I had even chosen the exact spot. It was to have been at Charing Cross Underground Station. There is an amazingly long empty corridor that looks as if it goes right under the river. That is where I wanted to photograph him."

A second and distinct period of portrait photography began in the late 50's. Brandt's later portrait interpretations are expressed through the use of the Superwide Hasselblad. The 90° angle of the lens was exactly right for Brandt's portrait interiors. For outdoor pictures it allowed Brandt to calculate the composition of his three-quarter length study of Francis Bacon and to include the sweeping lamp-lit perspective of Primrose Hill in Camden Town, London. The high-energy vanishing lines and the high-contrast printing style Brandt then adopted gave the later portraits an abrasive edge dissimilar to the earlier portraits and highly typical of the 60's. Brandt continued to take portrait assignments until 1981 and in that year added a final series to the pantheon of the creative individuals he particularly admired.

Photographing Picasso

Bill Brandt

In 1955 *Harper's Bazaar* asked me to take a portrait of Picasso, but the editor did not help me with an introduction to him. Luckily I knew in Antibes a friend of Picasso's, Monsieur de la Souchère, the director of the Musée Grimaldi, a very kind and helpful man. He thought it would not be difficult to arrange a sitting for me. Picasso agreed at once and asked me to come to 'La Californie' at 12.30 the next day.

When I arrived the gate-keeper telephoned the house to ask for permission to let me in, but Picasso had changed his mind and did not want to be photographed that day.

I went back to Antibes and de la Souchère again telephoned Picasso, who promised to sit for me the next day. But when I arrived, full of hope, Picasso asked the gate-keeper to tell me that I should come back in three days time. When I rang the bell, again at 12.30, on the appointed day, Picasso postponed the sitting for another week.

It was October, the weather was beautiful, I bathed and sunbathed and the time passed quickly, but the problem of how to penetrate the defences of Picasso's front gate weighed heavily on me.

I drove up to 'La Californie' twice a week and got to know all the barking dogs in the neighbourhood, but Picasso, hidden in his white villa, eluded me.

Presumed to be unpublished. No date. Courtesy of Noya Brandt.

Picasso proved an elusive subject for Brandt.

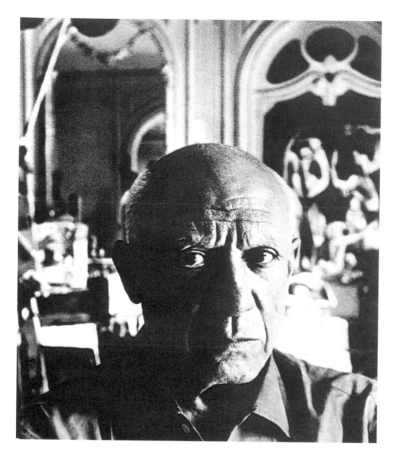

Fig. 50. *Pablo Picasso*, 1956.
Copyright © Noya Brandt.

After three weeks the gate-keeper gave me a final message which I received almost with relief. Picasso suggested I should come back in a year's time and I went home to England without any pictures, without even having seen Picasso.

In October next year I was back in Antibes and after the usual telephone appointment, I renewed my friendship with the gate-keeper. But Picasso, though very willing on the telephone, did not feel like being photographed when I came to the house.

De la Souchère now suggested a new approach. The Antibes hospital was short of funds, and Picasso had given them one of his drawings, which made it possible for them to buy a badly needed iron lung. To thank him for this splendid gift, a delegation of five doctors was going to visit the artist. Since de la Souchère himself was going to take them to the Villa Californie, he told me to join the party at the gate and walk in with them as though I were one of the doctors.

The gate-keeper smiled as she let us in, and though some of the doctors looked suspiciously at my camera, no remarks were made as we all walked solemnly into the house.

Picasso was not yet to be seen. While waiting for him, we were introduced to Jacqueline Rocque – now Madame Picasso, and when I asked her if she would let me photograph her, she readily consented. While I was still taking her picture, Picasso appeared on the terrace. 'Who are you?' he asked me. 'Why aren't you photographing me?' He came down into the garden, was very friendly and charming and I let myself be persuaded to take his picture.† He posed very well, chatted a great deal and said I could stay as long as I liked and photograph anything that took my fancy. I stayed for another hour to photograph the house and the sculptures in the garden.

When I left, Jean Hugo had arrived for lunch and they were eating grilled sole. Picasso accompanied me to the gate and said I should come and seem him again, whenever I was on the Côte d'Azur.

I thanked him and left in a happy mood, but have never tried to photograph Picasso again.

† Fig. 50, p. 115.

Perspective of Nudes

Mark Haworth-Booth

The ninety photographs that makes up *Perspective of Nudes* were the result of a pictorial exploration that Bill Brandt pursued for fifteen years, from 1945 to 1960. Rolf Brandt's fascinating collection of his brother's early, experimental photographs include a solarized nude study inscribed "Wien–London" and dated 1934. In February 1942, *Lilliput* printed Brandt's first published nude, a study photographed through muslin in the style of Erwin Blumenfeld. Three years later, after peace was declared in 1945, Brandt began this project and pursued it in earnest. On the advice of the painter and fellow-photographer Peter Rose-Pulham, Brandt acquired a brass and mahogany stand camera. His thoughts about this are reflected in Chapman Mortimer's introduction to *Perspective of Nudes*. Mortimer, who appears in some scenes in *A Night in London*, was a well-known novelist and long-time friend of Brandt's. In his 1961 introduction, he wrote:

> According to Brandt, modern cameras are designed to imitate human vision and perspective, and he says that having used them to photograph London in the thirties and during the war he began to find them too perfect. They reproduced life like a

Mark Haworth-Booth. 'Perspective of Nudes'. [p. 62–4] in *Bill Brandt: Behind the Camera. Photographs 1928–1983* (New York: Aperture, 1985; Oxford: Phaidon). Copyright © Mark Haworth-Booth, and with the kind assistance of Aperture.

Mark Haworth-Booth considers Brandt's first book of nude photography and R.B. Kitaj's use of Brandt's photography in his painting *Screenplay*.

mirror, and their efficiency prevented him from entering the mirror ... He wanted a camera (as he thinks now because that was what he found) that would give him "an altered perspective and a less conventional image." He hoped for a lens that might see more: that might see, "perhaps, like a mouse, a fish or a fly."

The camera did not allow Brandt to see like a fly, Mortimer added, but "he could look into his camera as the storyteller once looked into his memory." The threshold of his new vision was nearer to the threshold of his imagination. Brandt intended to achieve all this with a camera which had been designed for use by untrained policemen. Although it has often been referred to as a nineteenth-century camera, this was the Kodak Wide Angle camera introduced by Kodak in 1931. It was in use by the New York Police Department and others during the 30's, and it required no skill to operate. The camera had a fixed lens which covered a 110° angle. Anything four feet or more from the camera was in focus. A frame at the front guided the operator. Any point in the room which could be seen inside this frame would be included in the picture. Brandt enthusiastically acknowledged a debt to Orson Welles's *Citizen Kane* (1941) and its wide-angle, deep-focus camera work.

Perspective of Nudes is divided into six sections. It begins with nudes placed in shadowed interiors, usually of the stately proportions of apartments in Campden Hill, Belgravia and St. John's Wood. As with the landscapes of the same period, the associations in these photographs are at once Victorian and modern. Furnishings and pictures establish a nineteenth-century atmosphere but the perspective from which the nudes are observed is post-Picasso. In the second section of the book, smaller rooms are shown – sometimes with glimpses of abstract paintings, Picasso prints and emblems of the seashore. The series evolves from twilit, romantic images in which the large Victorian rooms seem to impose on the figure to images of a more intimate scale and modern idiom. The distance between camera and model contracts further in the third section or "chapter." The body fills the frame. Then, in the fourth group, the nude is found under full natural light on the seashore. The fifth section returns to an interior. This room is a studio which contains mechanical instruments of unknown use and jaggedly patterned paintings. Having noted these contrasts in relation to the figure, the camera again moves close to the intimate parts of the body. The final section continues this erotic nearness on the seashore and, from

plate to plate, detail by detail, it unifies the contours and weight of limbs with the smooth antiquity of marine objets trouvés and stone.

The series was photographed in years in which Brandt made his second marriage to the beautiful Marjorie Beckett with whom he had worked on *Picture Post*. They lived happily in London, and in a newly acquired apartment at Vence above the Baie des Anges in the South of France. (She died in 1971 and Bill Brandt continued to divide his time between London and Vence with his third wife – his widow – Noya Brandt, whom he married in 1972.) Marjorie Beckett was the author of the strange and perfectly apt title of the book that brought Brandt's whole achievement vividly to the attention of a new generation. *Shadow of Light* was published in 1966 with an introduction by Cyril Connolly, who likened it to the "collected works" of a poet. From then on Bill Brandt's photographs inhabited a large public domain, reaching into the imaginations of a public beyond any sectional interest of subject matter, medium or style. His work has passed into other minds and formed new kinds of imagery. One example that could be chosen from many is an extraordinary and enigmatic painting called *Screenplay* (1966). It is by the American painter R.B. Kitaj, who has chosen to work in London. *Screenplay* is based on two Brandt photographs which are superimposed and altered in Kitaj's painting. The first is the famous view of Top Withens, or "Wuthering Heights," with the derelict cottage perched on the moors. The second is a photograph Brandt took from inside Withens; a window frames a view in which the moors look strangely like a beach; and *become* a beach in Kitaj's painting. Several lightly painted concentric rings focus, like a range-finder, on the empty skyline, as if looking for a figure. The central image, seen as if through a window, is framed by a decorative device which is loosely reminiscent of Viennese styles of about 1900. However, as yet there is no sign of any dramatic event or concealed figure that would justify the title *Screenplay*. Looking closer at an ambiguous area of paint – which is applied in a manner analogical to the grain of newspaper photographs – certain forms between the beach and the moors seem to resolve themselves into the configuration of a nude. But if it is a figure, it is also simultaneously figure and ground. These forms belong in the language of heroic modernism and in particular to their adaptation by Bill Brandt in his book *Perspective of Nudes*. The forms in the painting are ambiguous and conjectural as they are in Brandt's work. The title *Screenplay* invites us to "read" the painting.

In *Perspective of Nudes*, Brandt tells a story. It is the tale of a journey from a shadowed nineteenth-century romantic past, through many changes of location and position, to a final destination – a sun-filled place of creative freedom and amplitude where everything seen has two simultaneous meanings. Perhaps, on the basis of what we now know of him, Bill Brandt was telling a story analogical to his own. During his life, he journeyed from a city in northern Europe where he grew up under constriction, passed through places during strange and surprising moments in their history, and finally reached the imaginative openness and sun and warmth of a Mediterranean shore. His creative imagination may have found a mainspring or dynamic in the contrasting northern and southern qualities in himself, just as, in Pierre MacOrlan's words apropos Atget, "le révélateur de la lumière est l'ombre." Light is revealed by shadow. The two opposites are combined, as in the words "Shadow of Light" and the photographs they evoke.

Notes on *Perspective of Nudes*

Bill Brandt

Photography can be singularly frustrating. It was after the war, when I was busy photographing London celebrities for English and American magazines, that I began to feel irritated by the limitations imposed by such jobs. I was taking portraits of politicians, artists, writers, actors in their own surrounding, but there was never enough time for me to do what I wanted. My sitters were always in a hurry. Their rooms were rarely inspiring backgrounds, and I felt I needed exciting backgrounds to make pictures of the portraits. I wanted more say in the pictures; I wanted rooms of my own choice. And so I came to nudes. Nudes, at that time, were photographed in studios. I thought of photographing them in real rooms, and suggested the idea to Leonard Russell, the founder and, at that time, editor of a very successful annual, the 'Saturday Book'. The idea pleased him, and he asked me to do a feature of sixteen pictures. This feature, however, never appeared. Before he had even seen the pictures, Leonard Russell rang and told me, with some embarrassment, that as his publisher was starting a purity campaign, he doubted whether nudes would be allowed in the 'Saturday Book'.

However, having started, I continued to take such pictures, and eventually decided not to publish any of them until I had

Bill Brandt. 'Notes on *Perspective of Nudes*'. *Camera* (Lucerne), vol. 40, no. 4 (April 1961), p. 7. Reprinted *Camera* (Lucerne), no. 5 (May 1971), p. 23. Courtesy of Noya Brandt.

Brandt describes the origins of his interest in nude photography and his use of an old Kodak police camera.

BILL PERSPECTIVE
BRANDT OF NUDES

Preface by Lawrence Durrell Introduction by Chapman Mortimer

Fig. 51. Cover of *Perspective of Nudes*, 1961.

enough for a book. I was working with a marvellous old camera, which I found while searching for a lens with a sufficiently wide angle, to enable me to take nudes in enclosed space. Such lenses hardly existed in England in those days, and it was thanks to Peter Rose-Pulham, the painter and former 'Harper's Bazaar' photographer, that I discovered one in a second-hand shop near Covent Garden. It was a beautiful old wooden Kodak, old enough for a museum. It had a fixed focus, no shutter, and could take a complete panorama of a room with a single exposure. I learned that the camera had been used at the beginning of the century by auctioneers, for photographic inventories, and by Scotland Yard for police records.

My first try-outs were hardly nudes; I called them experimental interiors. It was fascinating to watch the effect of the lens which created a great illusion of space, and an unrealistically steep perspective, and soon I discovered that it could produce fantastic anatomical images which I had never seen before.

Delighted to have found a camera which was not designed to imitate human vision and conventional sight, I let myself be

guided by the lens. The camera took the pictures for me; I interfered very little. There were many failures, but even these were often stimulating, and always surprising.

Over the years, I learned much from the old Kodak. I learned even how to use modern cameras in an unorthodox way and, for the last section of 'Perspective of Nudes', photographed on the beaches of East Sussex, Normandy and southern France, I discarded the Kodak altogether.

But I continued to let the lenses discover images for me. It is difficult to explain how I took the last photographs. They were perhaps chance pictures; unexpected combinations of shapes and landscapes. I watched them appear on the ground glass and exposed. It was as simple as that.

The Uses of Photography

John Berger

Bill Brandt is a photographer with an international reputation who deserves it. An anthology of his photographs has now been published by Bodley Head (at 3 guineas) and called *Shadow of Light*. This book gives some idea of the difficulties that a photographer faces. Either he tends to be treated as a tradesman, in which case his work is bought and used but considered entirely as a commodity, or else he is treated as an artist and is made an honorary member of the cultural establishment. The book illustrates what this establishment means.

The layout is so clumsy that many of the best photographs are virtually destroyed. The introduction of Cyril Connolly is pretentious, ignorant and insulating. Not exactly the kiss of death for a photographer – rather a chair drawn up and prepared in the club of sleep, with a glass of brandy, a few inappropriate lines quoted from Baudelaire, and the elite talking in their dreams.

The introduction begins: 'A great photographer is a combination of a lyric poet and historian'. He may incidentally be a poet, but it is far more important that he has *visual* imagination and sensibility. Photographs are to do with selecting and organising appearances. The first necessity for a photographer is an eye. As for being a historian, this is simply sleepy thinking. A photographer's material is always the present

John Berger. 'Arts in Society: The Uses of Photography'. *New Society*, vol. 8, no. 211 (13 Oct. 1966), p. 582–3. 3 illus.

Berger attacks Cyril Connolly's introduction to *Shadow of Light* and examines the significance of Brandt's change of direction in the late 1940s.

moment. His evidence can become historic. He may sometimes choose to photograph what he thinks will become historically significant. But this has nothing to do with the professional function of the historian.

Connolly anyway has a very hazy idea of history. Brandt first became known as a photographer for the pictures he took during the 1930s of industrial towns during the Depression. This is what Connolly has to say about the pictures and the period; it requires no further comment:

'Brandt records all groups and grasped the fact that in a class-ridden society all groups could still be happy – the middle classes through their possessions, the workers through their capacity for enjoyment. Contrast and inequality were everywhere, but not discontent – or the system would have been unworkable. He distinguishes between poverty and misery.'

There are over 150 photographs in the book, divided into five sections. First: pre-war London – a housemaid drawing the curtains in Kensington, a postman in a street of mean neat houses like government forms in brick, a young wife in Bethnal Green scrubbing a floor, the famous one of the slum girl (aged 12?) stepping out to do the Lambeth Walk,[†] a child with her nanny in a Mayfair nursery, kitchenmaids and a cook in the big kitchen late at night, wooden beds in a doss-house like coffins.

The second section is about the Depression in the North; the third about London during the war – the silhouettes of blacked-out buildings whose silence is so heavy that you have the sensation of being deaf, the sleepers in the underground stations with letters in their handbags from places they cannot visualise and their shoes off.[††]

The fourth section is a series of literary portraits ranging from Osbert Sitwell through Dylan Thomas and Iris Murdoch to Harold Pinter, and the last section consists of English landscapes – mostly romantic — and nudes, highly distorted, sculptural, Henry Moore-ish, from Brandt's *Perspective of Nudes* (Bodley Head, 1961).

Yet the real division is not between these sections, but is a chronological one. In about 1947 Brandt's work changed fundamentally.

Probably in fact the change was gradual, but in this book one picture stands out like a sudden turning point. It is a photograph of a gull's nest on the Isle of Skye,[†††] taken late on a summer night. Just three eggs, a tiny feather, rocks, water, silhouetted mountains, sky.

† Fig. 52, p. 126.
†† See, for example, fig. 23, p. 55.
††† Fig. 53, p. 127.

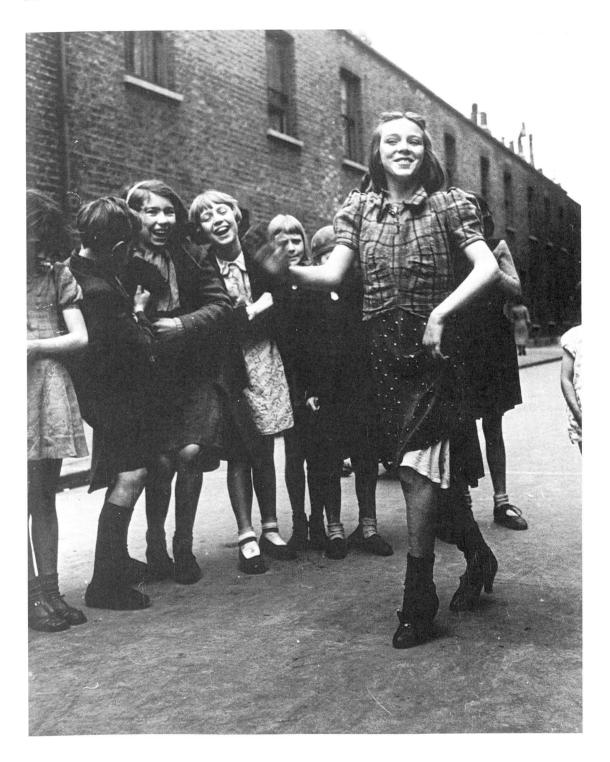

Fig. 52. *Lambeth Walk*, 1939. Courtesy of Hulton Deutsch Collection Limited.

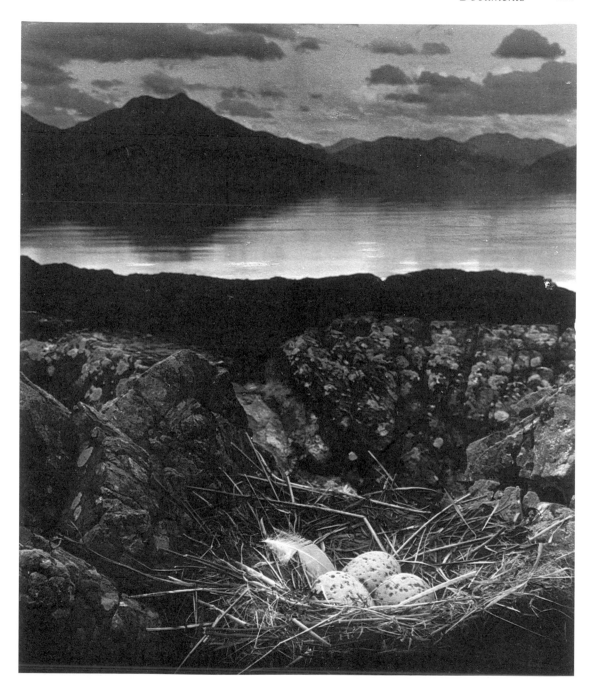

Fig. 53. *Gull's Nest, Isle of Skye, c.*1947. Courtesy of the J. Paul Getty Museum, Malibu, California. Copyright © Noya Brandt.

Brandt's photographs were always romantic. He originally studied under Man Ray in Paris and in all his work one can feel something of the surrealist's predilection for the highly-charged, mysterious image. He has always worked a lot in the dark-room on either negative or print. The kind of image at which he aims is full of *created* drama, in which feeling predominates over fact.

So what makes the Isle of Skye picture different is not its romanticism. Nor is it its failure. It looks like an arrangement in a highly sophisticated shop window – Prunier's seafoods? It is different because here for the first time everything has been sacrificed to Brandt's private purpose. The photograph commemorates the idea of taking this photograph. It was to be a surprise – and for this all *natural* surprise has been jettisoned. From this moment onwards Brandt manipulates the world to fit his preconceived vision.

This is most obvious in the literary portraits, which are highly mannered and which romanticise all the sitters in the name of art, establishing the superiority of the private reality. Later, in the nudes and some landscapes, the results are infinitely more successful, but the approach remains.

What does this change mean? One can only begin to try to answer in terms of Brandt and photography. But clearly the question has wider associations, for the change was typical of his generation. Social commitment during the 1930s and the war: and then withdrawal into, or concentration upon, the problem of a few private verities.

Connolly talks about Brandt deciding to become a poet instead of a reporter. But this is only because in the club the window blinds are made of slats of quoted poetry to keep the light and view out. Brandt's earlier photographs are in no way less poetic than his later ones.

The girl doing the Lambeth Walk[†] is perhaps the most poetic photograph he has ever taken. In her high-held face, in the discreet gesture of her hand raising her skirt above her knee, in the disclosed white of her petticoat and her black socks which are like boots, there is implied an appetite which is truly lyric. You might argue that this is the quality of *her* youth rather than that of the photograph. But this would be false, and to make the point clearer we can take another example.

In a picture like *A Snicket in Halifax* its power as a metaphor for an enforced way of life (uphill, bleak, dimmed, counted in pennies or cobbles) is due to Brandt's imaginative identification with the place. And 30 years ago a picture like this was far more original than it seems now. Many of Brandt's pictures of this

† Fig. 52, p. 126.

period look like prophetic stills for what were then far distant films like *A Taste of Honey* or *A Kind of Loving*.

So the change did not mean greater poetry. Did it mean greater profundity – more concentrated, significant content? The cry of the 1950s was that the political attitudes of the 1930s were superficial. Are Brandt's recent nudes, like white boulders amongst pebbles or like light in a cloudy sky (the distortions are such that all immediate, if not all eventual, sexual significance has been lost), are these nudes more profound than the pictures of back streets, public bars or taxis?

Yes and no. They are a more profound expression of Brandt's private view of life, which may apply to certain experiences shared by many, many other people. But, at the same time, these later pictures are much simpler – in the sense that almost nothing has been allowed to intrude into the artist's preconceived vision. There are no accidents – but, equally, there is no life except Brandt's.

These later pictures represent a formidable reduction of the possibilities of photography, yet they may in one single direction have extended these possibilities.

One must accept that in the late 1940s and 1950s Brandt could never have continued doing what he did in the 1930s. One must also accept the price he has accepted to pay for his later achievement. What he has failed to consider in his last pictures should not prevent us appreciating what he has set out to do.

'He reveals', wrote Tom Hopkinson about *Perspective of Nudes*, 'through the slope of an arm or the bend of a knee, a kind of noble sensuousness which seems part of the very substance of creation'. Yet, in nine cases out of ten, an artist's decision to become 'private' is the direct result of his finding the world at large too complex and too full of contradictions. Therein lies the danger.

The Shadowy World of Bill Brandt

Aaron Scharf

'Sometimes', says Bill Brandt, 'I feel that I have been to a place long ago, and must try to recapture what I remember.' And so, guided by his paramnesia, he waits for the seasons, the weather, the time of day or night, to draw that memory out of obscurity, to find the picture he knows to be there.

Is it this reverie we sense so strongly in his works? Can one photograph memories? But what else does the artist do but choose to recreate from the multitude of his experience those persistent reflections of his own being. Can one doubt that these things in Brandt come through to us? Look at his still and deserted streets, those nocturnal landscapes like sweet and lonely echoes of a dream. He is in love with shadows, November mist and rain, the Isle of Skye, dark and mute, Yorkshire just after a storm when a high wind is blowing over the moors. He tells of his discovery of a gull's nest in Skye one sunny afternoon, 'but as the light was then too flat and the nest looked to pretty for this very wild part of the island, I decided to come back in the evening. It was almost midsummer-night and the pale green twilight started rather late. When I approached the nest on an isolated outpost of rocks, an enormously large gull which had been sitting on the eggs, flew off and circled low

Aaron Scharf. 'The Shadowy World of Bill Brandt'. [p. 18] in *Bill Brandt: Photographs* [Exhibition Catalogue] (London: Arts Council of Great Britain, 1970). With the kind permission of Mrs Aaron Scharf.

The author of *Art and Photography* stresses the need to look long and hard at Brandt's photographs.

around my head barking like a dog. It was windstill, the mountains of the Scottish mainland were reflected in the sea – the light was now just right for the picture.'†

At the beginning of the war Brandt returned to London from the north where, during the depression of the 'thirties, he recorded the begrimed existence of those beneficiaries of the Industrial Revolution. He came south to photograph the blackout and the air-raid shelters for the Ministry of Information. But he did not document the devastation of the Blitz, for even in war there was poetry. The necropolitan unreality of the empty streets impressed him as beautiful. Illuminated only by the moon, he says, and devoid of people, London took on the two-dimensional aspects of a stage set. Brandt lost his taste for reportage once the end of hostilities drew near. The more poetic possibilities of photography exciting him as it had before in Paris in 1929, just after Atget and the heroic years of Brassaï, Kertész and Cartier-Bresson – and Man Ray in whose studio he worked.

For over fifteen years Brandt was preoccupied with photographing nudes. But this was not nude photography as one ordinarily thinks of it. Nor was it merely an interest in the distortion of perspective scale. Brandt was driven by an urge to find something beyond the real. Something was awakened in him by artists and film-makers who were concerned with the world beyond human vision, yet not beyond human comprehension. He committed a rare act among photographers. He submitted completely to a camera which would not let him see. That cherished old wooden Kodak he speaks about, purchased second-hand in 1945 from a shop near Covent Garden, had a wide-angle lens with an aperture so small that he had virtually no image on the ground glass. He had to photograph blind. He wanted to photograph blind. The instrument had to guide him, and interpret the world to him. And with characteristic humility, he interfered very little, allowing himself to be taken on a voyage of discovery. 'The lens', he says, 'produced anatomical images and shapes which my eyes had never observed … It taught me how to use acute distortion to convey the weight of a body or the lightness of a movement.' That camera taught him to see more intensely, to perceive in every object the image of another. And the displaced fragments of the female form became the metamorphosed elements of new, imaginary landscapes. In the world of minutiae which exists on the threshold of perception is a strange and often frightening poetry. Brandt has ventured there too. As the fragments of the female form are to the conventional nude, so are Brandt's

† Fig. 53, p. 127.

basilisk eyes of artists, ancient and unfathomable, to the portrait.

Can a portrait taken with a camera be anything other than a momentary glimpse, true as an image, but false as a reflection of the real person? A profound likeness to Brandt is that which reveals the past and suggests something of the future. 'I always take portraits in my sitters' own surroundings. I concentrate very much on the picture as a whole and leave the sitter rather to himself. I hardly talk, and barely look at him. This often seems to make people forget what is going on and any affected or self-conscious expression usually disappears. I try to avoid the fleeting expression and vivacity of a snapshot.' Patience, it was said of the earliest photographers who had to wait for the interminably long exposures – 'Patience is the virtue of asses.' But a photographer without patience is about as successful as a seducer in a hurry to catch a train. How long it takes Brandt to wait out a subject! Look at his portraits. Who can call them snapshots? They are not instantaneous but as still as a moving film suddenly stopped. That precise and rare moment is seized when the inner being flashes on the surface before fading quickly into the mask that convention and civilised behaviour bid us to wear. But whose inner being? The subject's or the photographer's? To achieve his best work a photographer, Brandt knows, 'must discover his own world'. And in that precious moment, Brandt's people peer out, slightly puzzled, at the intruder. And they are so much the same. Are they just likenesses or are they not also mirrors of Brandt's own phantoms?

The fashionable, never innovators, are always ready slaves to the rules of the moment. Brandt's originality, I think, is in his essential conservatism. He is not bound by the rules of the day nor dictated to by fashion but is motivated by a deeper insight into art. The artist, he knows, does everything necessary to obtain the desired result. 'It is the result that counts, no matter how it was achieved … I do not understand why this is supposed to interfere with the truth.'

We have become used to treating photographs as pictorial ephemera, and at the connivance of photo-mechanical reproduction are in danger of treating all art that way. I once saw a lady, an intelligent-looking and presentable lady, rushing up the great inner staircase of the Louvre, shouting with a frantic note in her voice, 'Guard! Quick! The Mona Lisa! Where is she? I'm double-parked!' Don't go to Brandt in that way. The longer you look, the more you'll find and so much richer will be your experience.

The Collages

Mark Haworth-Booth

In this exhibition Brandt moved strikingly into a new medium: the collages on which he has apparently been working since 1968. These are composed for the most part of marine flora and fauna applied to square boards painted in such hues as sepia and grey, toned to suggest depth, and framed in perspex with raised sides. Twenty-one collages were exhibited, with a group of twenty-seven of Brandt's photographic portraits of artists and fellow-photographers in the downstairs gallery. The collages are also made with small driftwood pieces, coloured pebbles and worn bottle glass, chips of mirror glass, littoral detritus like plastic babies and tatters of the US flag. There are also complete grouse and partridge wings and the long tail feather of an exotic pheasant. There is a wide bone-white fish mouth which opens like a man-trap. The material is very Brandtian – one might have guessed that he is an expert beach-comber. There are some rare finds: corkscrew-shelled molluscs, wonderful members of the sponge family, outstandingly the gauzey cornucopia-shaped creature from the Pacific called Venus's Flower Basket. The elements are composed with a sure and inventive hand, exploring the square or bursting from its centre, and in some cases becoming figurative as in the gathered bones which are the mask of an owl rushing eerily in dusk. Some effects are

Mark Haworth-Booth. 'Bill Brandt Collages'. *The Connoisseur*, vol. 187, no. 751 (Sept. 1974), p. 74. 1 illus. Copyright © Mark Haworth-Booth.

A review of the first exhibition of Brandt's three-dimensional assemblages held at the Kinsman Morrison Gallery, London (17 June–12 July 1974).

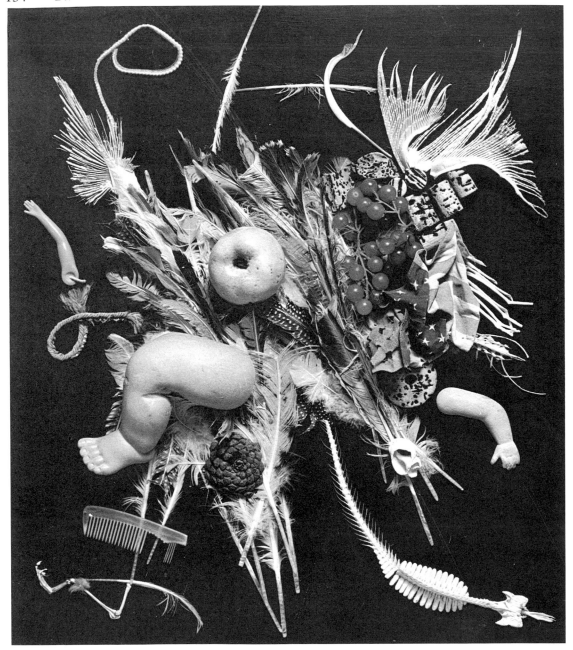

Fig. 54. *[Assemblage Number Twelve]* c. 1970. Photographed by Edward Woodman. Courtesy of Stephen Lacey and Adam Lowe. Copyright © Edward Woodman.

barbaric: little blue stones upon a greenish mottled sponge, eyes peering from a cerebellum. Gull's feathers are used interestingly – here the sheer single plume, there the miserable clutter left by the workmanship of the peregrine and the crow. The found natural and man-made weathered things have been manipulated into connected worlds where each thing belongs, a little system which can produce quivering voltage. The work implies Surrealism, of course, but also the search for kinship with the natural world which is the contemporary issue.

The group of portraits contains many masterpieces, above all the series of close-ups of the eyes of certain artists. Dubuffet blazes with the intensity of a raptorial. Among the recent works there is one of Brandt's master, Man Ray, a new one of Henry Moore and a fine and charming study of Jacques-Henri Lartigue.

Brandt's Reticence

Ian Jeffrey

Brandt's career, from beginning to end, was the most elaborate and mysterious in the whole history of twentieth-century photography. Ostensibly, he was a documentarist who explored traditional British themes during the 1930s, before becoming a national landscapist and portraitist during and after the Second World War. Finally he gained the standing of an artist, and recognition as Britain's greatest photographer of the modern era.

Brandt was never interested in disclosure and discouraged searching enquiries about himself throughout his life, preferring to be known as an enigma. Whenever some sort of response was called for, he rarely volunteered more than a decent minimum. He considered himself very much a British artist, albeit with Russian and Dutch antecedents; there had, indeed, been a family house in St. Petersburg, a painting of which hung in his London flat.

He generally concealed the fact that he had been born in Hamburg and brought up in Germany during the Great War; German origins were, after all, sometimes a cause for suspicion in a country often at odds with Germany. Brandt, as a documentarist with a taste for mist and darkness, must have easily been taken for a suspicious person, especially with his

Ian Jeffrey. Extract [p. 12–14] from the introduction to *Bill Brandt Photographs 1929–1983* (London: Barbican Art Gallery in association with Thames and Hudson, 1993). Copyright © Barbican Art Gallery, London.

Ian Jeffrey discusses Brandt's selective disclosure of information about his life in photography.

German accent. It is as likely, though, that he preferred non-disclosure and mystery as a matter of policy. Perhaps he even thought, towards the end, that there was much in his past which should be concealed, and not just his German origins.

We know that he was an active photographer on the staff of the *Weekly Illustrated* during its garish heyday in the mid 1930s. *Weekly Illustrated* was no very distinguished address, especially after the foundation, in 1938, of the more responsible and respectworthy *Picture Post*, to which Brandt contributed from the December of that year. *Weekly Illustrated* had itself started quite soberly in 1934, with behind-the-scenes reports, and short stories by Pirandello, but it soon developed a penchant for the vulgar and the exotic. In its great populist days, Brandt's photographs of health centres, for instance, were outmatched every time by features on popular domestic subjects and by sensational reports from the new front lines in Abyssinia and Spain.

Even the period in Paris, where he had undergone an apprenticeship of sorts in the studio of May Ray in 1929, had to be treated with caution. Casual researchers in the 1960s connected him with Surrealism and with Man Ray, who had been admitted to the twentieth-century photographic pantheon by then, although largely as a fashion photographer. He had one reason for admitting to Man Ray, however, and that was his own interest in nude photography, which culminated in 1961 in *Perspective of Nudes*. This bold collection was given an acceptable pedigree by reference to Man Ray's album of 1934, *The Age of Light*, in which female nudes figured prominently.

There was not much point, however, in making other Parisian references, which might have been confusing. It seems, for example, that he knew René Crevel in Paris, for in 1934 Crevel wrote a long and fierce article around one of Brandt's photographs in the fourth issue of *Minotaure*, the Surrealist magazine published in Paris by Skira. Crevel, a homosexual and combatant in the struggle around the politicization of Surrealism in the early 1930s, committed suicide in 1935. By the time photographic stock-taking of the period began, in the 1960s and after, Crevel had been filed with the forgotten literature.

Brandt's reticence also extended to a stay in Vienna in 1927. He went there after six years in a sanatorium at Davos, and the visit involved psychoanalytical treatment for tuberculosis. One destination in Vienna was the clinic of Dr. Eugenie Schwarzwald, who suggested to Brandt that he should take up photography. At the Schwarzwald salon he also met Ezra Pound,

whom he photographed in 1928 and who, as we have noted, gave him an introduction to May Ray in Paris. At the same time he met, and was impressed by, Adolf Loos, the great Viennese architect and moralist. As a child in Hamburg, Brandt had been trained in drawing by the Czech architect K.E. Ort at the Kunstgewerbeschule, and his interest in architecture was always notable. One of his early photographs is of the façade of Loos' Möller House in Vienna, which was under construction in 1927–28.

His main contact in Vienna was his younger brother Rolf, who had preceded him to the city. His final destination was the Active-Analytic Clinic of Wilhelm Stekel, a busy analyst throughout the 1920s, and a prolific author. Stekel was quoted, admired and denounced by his contemporary, Sigmund Freud. The two were known for their disagreements, which centred on the interpretation of dreams. In later editions of Freud's *The Interpretation of Dreams* Stekel is attacked for his arbitrary readings. Notwithstanding Freud's disapproval, Stekel's many books were translated and republished well into the 1950s. His own work on dreams first came out in 1911, and during the 1920s he published works primarily on sado-masochism and fetishism. His huge books on these topics are made up of a multiplicity of case-studies interspersed with theoretical observations. This involvement with Stekel was first disclosed by Rolf Brandt in conversation with Dr. David Mellor, the author of 'Brandt's Phantasms'.†

The Vienna period was formative, but is liable to misinterpretation. There was even a shadow over his time with *Picture Post*, which constituted his finest decade. *Picture Post*, for which he worked as a staff photographer, was admirable, but the standing of *Lilliput*, the associated Hulton magazine to which he contributed as a free-lance, was ambiguous. He may have produced much of his best work for *Lilliput*, which made use of the country's finest writers and illustrators as well as the world's leading photographers, but *Lilliput*, for all that, was *Picture Post*'s slightly dubious *alter ego* : clever and talented, maybe, but not above titillation and exploitation. In its pages photography by, among others, Brassaï, Blumenfeld and Kertész was often reduced to cartoon level by flippant caption writers. It was also known for its nudes: artists' models and chorus girls mainly. In October 1945, its editors, looking back over the first hundred issues, counted around one thousand pictures 'including or concentrating on girls', though not all, admittedly, submissive

† In *Bill Brandt: Behind The Camera* (Oxford: Phaidon, 1985), p. 71–97.

to the male gaze. But Brandt may very well have found that the association called for silence.

The artist whom he allowed to emerge in the 1960s and 1970s, when he was taking his place in photography's new-found history, was in essence designated by a limited corpus of pictures only slightly attached to specific times or places, and certainly not to places of publication. It was as if they had all been taken, these canonical pictures, in one fabulous excursion through an extended Symbolist twilight. Their relatively large scale and emphatic shadows and highlights declare them to be prints rather than photographic records. They sidestep insistent questions regarding site and time, as they imply a kind of finality. You need look no further, they declare, concluding with a flourishing signature, like certificates authenticated.

BIBLIOGRAPHY

Books by and about Bill Brandt

1 *The English at Home*. Introduction by Raymond Mortimer. (London: B.T.Batsford Ltd, Spring 1936. [72 pp]. 63 illus.). [Captions in English and French].

2 *A Night in London: Story of a London Night in Sixty-Four Photographs*. Introduction by James Bone. (London: Country Life; *Londres de Nuit*, Paris: Arts et Métiers Graphiques [Introduction by André Lejard]; New York: Charles Scribner's Sons; 1938. [68pp]. 64 illus., ppbk. only). [Captions in English and French].

3 *Camera in London*. Introduction 'A Photographer's London' by Bill Brandt. Commentary by Norah Wilson. Technical data by Bill Brandt. (London: The Focal Press, April 1948. 89pp., 59 illus.). [Masters of the Camera Series. Series editor Andor Kraszna-Krausz].

4 *Literary Britain*. Introduction by John Hayward. Excerpts from the work of 76 British writers. (London: Cassell and Company Ltd, 1951. [200pp]. 100 illus.) [For revised edition see below].

5 *Perspective of Nudes*. Preface by Lawrence Durrell. Introduction by Chapman Mortimer. (London: The Bodley Head; New York: Amphoto; *Perspectives Sur Le Nu*, Paris: Le Bélier-Prisma éd.; 1961. [108pp]. 90 illus.).

6 *Shadow of Light: A Collection of Photographs from 1931 to the Present*. Introduction by Cyril Connolly. Notes on the photographs by Marjorie Beckett. (London: The Bodley Head; New York: The Viking Press; *Ombres d'une Île*, Paris: Les Éditions Prisma [Introduction 'Ombres d'une Île' by Michel Butor]; 1966. [148pp]. 161 illus. [including 8 colour]. [For revised and extended edition see below].

7 Mark Haworth-Booth, Editor *The Land: Twentieth Century Landscape Photographs Selected by Bill Brandt*. Texts by Jonathan Williams, Aaron Scharf and Keith Critchlow. (London and Bedford: The Gordon Fraser Gallery Ltd, 1975; New York: Da Capo Press, 1976. 80pp., 48 illus.).

This book of landscape photographs by various photographers, selected by Bill Brandt, was originally published as an exhibition catalogue

to accompany an exhibition of the same name, London: Victoria and Albert Museum (13 Nov. 1975 – 15 Feb. 1976); Edinburgh: 6 March – 11 April 1976); Belfast: Ulster Museum (24 April – 6 June 1976); Cardiff: National Museum of Wales (19 June – 1 Aug. 1976).

8 *Shadow of Light*. Revised and extended edition [Dedicated to Norman Hall]. Introduction to the previous edition by Cyril Connolly. Introduction by Mark Haworth-Booth. (London: The Gordon Fraser Gallery Ltd. [Gordon Fraser Photographic Monographs 7]; New York: Da Capo Press Inc.; *Ombre de Lumière*, Paris: Chêne; 1977. [182pp]. 169 illus. bibliog.).

9 *Bill Brandt: Nudes 1945-1980*. Introduction by Michael Hiley [In English, French and German]. (London and Bedford: The Gordon Fraser Gallery Ltd. [Gordon Fraser Photographic Monographs 8]; Boston: The New York Graphic Society/Little Brown and Company, 1980. 120 pp., 100 illus.).

10 *Bill Brandt: Portraits*. Introduction by Alan Ross. (London and Bedford: The Gordon Fraser Gallery Ltd. [Gordon Fraser Photographic Monographs 11]; Austin: University of Texas Press, 1982. 116pp. 104 illus.).

11 *Bill Brandt*. Introduction 'Photographe Solitaire et Inquiet' and afterword 'Portraits, Paysages et Nus' by Mark Haworth-Booth. (Milan: Gruppo Editoriale Fabbri S.P.A., 1982 [I Gran Fotografi]; Paris: Union des Editions Modernes, 1984. 64pp., 50 illus. bibliog. chronol. [note on technique]) [Les Grandes Maîtres de la Photo 11].

12 *Literary Britain* 2nd (revised) edition. Foreword by Sir Roy Strong. Introduction by John Hayward. Excerpts from the work of 42 British writers. Edited with an afterword and notes by Mark Haworth-Booth, and 'Poetry: Bill Brandt Photographer' [reprinted from *Lilliput,* Aug. 1942, p. 130, 141] and 'A Retrospect' by Tom Hopkinson. (London and Bedford: The Gordon Fraser Gallery Ltd.; London: Victoria and Albert Museum in association with Hurtwood Press; London: Victoria and Albert Museum in association with Aperture; New York: Da Capo Press Inc.; New York: Aperture in association with Westerham Press, 1986. [173pp]. 79 illus. [75 landscapes]).

Mark Haworth-Booth's notes indicate the changes made in this revised edition of the book. This edition was originally published as a catalogue to accompany an exhibition of the same name, London: Victoria and Albert Museum (6 March – 20 May 1984).

13 *Bill Brandt: London in the Thirties* (London and Bedford: The Gordon Fraser Gallery Ltd., 1983; New York: Pantheon Books, 1984. [98pp]. 96 illus.).

14 Jacques Bosser, Editor. *Bill Brandt Photojournalist*. Text by James Darwen. A portfolio of 10 prints from negatives by Bill Brandt. Printed by Philippe Salaün on Ilfobrom 1K paper, 30 × 40cm. Signed by Bill Brandt. [Edition of 25, 3 artist proofs, and 1 copy reserved for Bibliothèque Nationale, Paris]. [*c*.1983].

(1) Tic-tac Men at Ascot Races
(2) Late Evening in the Kitchen
(3) Fog Over London's River, London Bridge
(4) Cocktails in a Surrey Garden
(5) November in the Suburb
(6) Children in Sheffield
(7) Eton Sprawls
(8) Train Leaving Newcastle
(9) St Paul's Cathedral in the Moonlight
(10) Sunday Evening

15 *Bill Brandt: Behind The Camera, Photographs 1928–1983*. Introductions 'European Background'; 'The English at Home'; 'A Night in London'; 'Wartime and Its Aftermath'; 'Portraits'; 'Literary Britain'; 'Perspective of Nudes' by Mark Haworth-Booth. Essay 'Brandt's Phantasms' by David Mellor. (Oxford: Phaidon; New York: Aperture, 1985. 99pp., 89 illus. bibliog.).

Originally published as a catalogue to accompany an exhibition at the Philadelphia Museum of Art (8 June – 21 Sept. 1985), and subsequently at the Burden Gallery; Port Washington: Public Library; Detroit: Institute of Art; San Francisco: Museum of Modern Art; Florida: John and Mabel Ringling Museum of Art; Columbus, Ohio: Museum of Art. It is the principal source of biographical and bibliographical material about Brandt.

16 Mike Seabourne, Editor. *Shelters: Living Underground in the London Blitz, Images by Bill Brandt and Other Unrecorded Photographers*. Introduction 'Shelters: Living Underground in the London Blitz' by Mike Seabourne. (London: Nishen, 1988. 32pp., 30 illus. [7 by Brandt], ppbk. only.). [Nishen Photography: The Photo-Library 7].

17 Patrick Roegiers. *Bill Brandt: Essai* [French] (Paris: Pierre Belfond, 1990. 212pp., 16 illus. bibliog.). [Les Grands Photographes. Series editor Jean-Luc Monterosso].

This is a critical biography of Brandt containing extensive bibliographical material in the notes.

18 Zelda Cheatle and Adam Lowe, Editors. *Bill Brandt: The Assemblages.* (Kyoto, Japan: Kyoto Shoin, June 1993. 102pp., 57 illus. [31 colour, 26 duotone]).

This book reproduces colour photographs of 31 of Brandt's collages together with Brandt's own black-and-white images of some of them.

19 Ian Jeffrey, Editor. *Bill Brandt Photographs 1929-1983*. Introduction by Ian Jeffrey. (London: Thames and Hudson, Sept. 1993. 192pp., 200 illus. bibliog. chronolog. appendices).

This book was originally published to accompany an exhibition at the Barbican Art Gallery London (30 Sept. – 12 Dec. 1993). It includes many previously unpublished photographs by Brandt together with a long critical essay and detailed bibliographical information about Brandt's magazine work, including the locations of photo-stories and individual pictures for *Weekly Illustrated*, *Lilliput*, *Picture Post* and *Harper's Bazaar*.

Articles by Bill Brandt

20 'The Beauty and Sadness of Connemara'. *Lilliput* vol. 20, no. 3 (March 1947), p. 265–76. 10 illus.

Brandt's photo-story and commentary about the landscape and inhabitants of this part of the West coast of Ireland.

21 'Over the Sea to Skye'. *Lilliput,* vol. 21, no. 5 (Nov. 1947), p. 389–96. 8 illus.*

Brandt wrote the commentary which accompanies his photographs of the Scottish landscape.

22 A Photographer's London'. [p. 9–19] introduction to *Camera in London* (1948). Bibl. **3**.*

This is Brandt's fullest statement about photography and in particular the importance of atmosphere in his work.

23 'Technical Data'. [p. 89 folded page] *Camera in London* (1948). Bibl. **3**.*

Details of Brandt's camera settings, dates of the photographs and so on are given here for all the images in *Camera in London*.

24 'Painter's Country'. *Lilliput,* vol. 23, no. 3 (Sept. 1948). p. 77–84. 8 illus.

Brandt's photographs and commentary about Van Gogh's Provence.

25 'Pictures by Night'. [p. 185–91. 3 illus.] in L.A. Mannheim, ed. *The Rollei Way: the Rolleiflex and Rolleicord Photographer's Companion*, London and New York: Focal Press (1952).*

This article, written for would-be night-time photographers, provides an interesting insight into Brandt's working methods.

26 [A short statement]. *Photography,* vol. 14, no. 6 (June 1959), p. 32.

27 'Notes on *Perspective of Nudes*'. *Camera* (Lucerne), vol. 40, no. 4 (April 1961), p. 7.*

In this short article Brandt describes his approach to nude photography.

28 'Bill Brandt' in Frantz André Burguet. 'Dialogue avec les Faiseurs d'Images' [in French]. *L'Arc Photographie* (France), no. 21 (Spring 1963), p. 6–33. 6 illus.

Burguet put the same 16 questions to ten photographers including Brandt. This is a transcript of their answers.

29 'Il Faut Éviter L'Expression Fugitive' [in French]. *Photo* (France), no. 23 (Aug. 1969), p. 37.

This is a statement by Brandt.

30 'Bill Brandt'. *Album,* no. 2 (1970), p. 46–7. 2 illus.*

Brandt gives an overview of his work up to 1970.

31 'Brandt in Colour'. *Album,* no. 3 (1970), p. 2.

A brief comment by Brandt about colour photography:

'Until 1962, all my work had been in black-and-white. Since then I have tried to exploit the idiosyncrasies of present-day colour-film to heighten the strangeness of a landscape. I experimented on the beaches of Normandy and Southern England, where I photographed rocks and that strange bottom-of-the-sea world which emerges at low-tide. I experimented, but I may not have succeeded. However, I think that, by exploiting unrealistic distortions, there are endless possibilities for the photographer working in colour.' [complete text]

32 'Notes on *Perspective of Nudes*'. *Camera* (Lucerne), no. 5 (May 1972), p. 23.

This reprints the article that appeared in *Camera* (April 1961).

33 'The Unprejudiced Eye'. *Camerawork,* no. 4 (Nov. 1976), p. 11.

An extract from 'A Photographer's London', the introduction to *Camera in London* (1948).

34 'Brassaï'. [p. 3] introduction to *Brassaï: A Major Exhibition* London: The Photographers' Gallery (November 1979) (London: The Photographers' Gallery, 1979, 16pp., 16 illus.).

Brandt wrote this short introduction to an exhibition on the occasion of Brassaï's 80th birthday.

35 'Chris Steele-Perkins' [a note on *Ted, Market Tavern, Bradford, 1977*] p. 32; and 'Josef Koudelka' [a note on *Prague, 1968*] p. 34, in *Personal Choice*. Introduction by Mark Haworth-Booth. [catalogue of an exhibition] London: Victoria and Albert Museum (23 March – 22 May 1983), 260pp., 130 illus.

These are two short pieces about the photographs that Brandt selected for the exhibition *Personal Choice*.

36 'Photographing Picasso'. Undated. Unpublished manuscript.*

This unpublished article describes Brandt's struggle to photograph Picasso which he eventually achieved in 1956.

Selected Photo-Stories by Bill Brandt in *Lilliput* and *Picture Post*

Lilliput

37 'London Night'. vol. 2, no. 6 (June 1938), p. 581–88. 8 illus.

38 'Unchanging London'. vol. 4, no. 5 (May 1939), p. 485–500, 16 illus.
In this photo-story 9 of Brandt's photographs of London and 7 of Doré's engravings are juxtaposed.

39 'Twenty-Four Hours in Picadilly Circus'. vol. 5, no. 3 (Sept. 1939), p. 233–40. 8 illus.

40 'Blackout in London'. vol. 5, no. 6 (Dec. 1939), p. 551–558. 8 illus.

41 'Autumn in a Forgotten Wood'. vol. 7, no. 4 (Oct. 1940), p. 343– 45. 3 illus.

42 'A Simple Story about a Girl'. vol. 9, no. 3 (Sept. 1941), p. 235–42. 8 illus.
A young woman meets and falls for a soldier home on leave.

43 'Young Poets of Democracy'. vol. 9, no. 6 (Dec. 1941), p. 477–84. 8 illus.

44 'The Northern Capital in Winter'. vol. 10, no. 2 (Feb. 1942), p. 145–52. 8 illus.
This is a photo-story about Edinburgh.

45 'Soho in Wartime. Eight Bits of a Quarter'. vol. 10, no. 4 (April 1942) p. 323–30. 8 illus.

46 'London by Moonlight'. vol. 11, no. 2 (Aug. 1942), p. 131–40. 10 illus.
This issue also contains a short profile of Brandt, 'Bill Brandt – Photographer', by Tom Hopkinson [p. 130, 141].

47 'Flower Portraits by Brandt'. vol. 11, no. 3 (Sept. 1942), p. 239–46. 8 illus.

48 'Backstage at the Windmill'. vol. 11, no. 4 (Oct. 1942), p. 323–30. 8 illus.

49 'Shelter Pictures by Brandt and by Henry Moore'. vol. 11, no. 6 (Dec. 1942), p. 473–82. 10 illus. [5 by Brandt; 5 by Henry Moore].
Brandt's shelter pictures are juxtaposed with Henry Moore's drawings of the same subject.

50 'What Our Artists Look Like'. vol. 12, no. 3 (March 1943), p. 239–46. 8 illus.

51 'The Cathedrals of England'. vol. 12, no. 5 (May 1943), p. 389–98. 10 illus.

52 'The Gardens of England'. vol. 13, no. 3 (Sept. 1943), p. 239–46. 8 illus.

53 'Odd Corners of Museums'. vol 14, no. 2 (Feb. 1944), p. 155–62. 8 illus.

54 'Animal Portraits'. vol. 14, no. 6 (June 1944), p. 491–8. 8 illus.

55 'Chelsea Photographed'. vol. 15, no. 2 (Aug. 1944), p. 137–46. 10 illus.

56 'A Small Town in Autumn Sunlight'. vol. 15, no. 6 (Dec. 1944), p. 491–98. 8 illus.
This photo-story is about Bradford-on-Avon.

57 'Bill Brandt Visits the Brontë Country'. vol 15, no. 6 (May 1945), p. 407–14. 8 illus.

58 'Brighton: the Home of the English Seaside'. vol. 17, no. 3 (Sept. 1945), p. 239–46.

59 'Hampstead Under Snow'. vol. 18, no. 2 (Feb. 1946), p. 155–62. 8 illus.

60 'Below Tower Bridge'. vol. 18, no. 3 (March 1946), p. 239–46. 8 illus.*

61 'Thomas Hardy's Wessex'. vol. 18, no. 5 (May 1946), p. 411–18. 8 illus.

62 'The Beauty and Sadness of Connemara'. [with a commentary by Bill Brandt] vol. 20, no. 3 (March 1947), p. 265–76. 12 illus.

63 'A Day in Dublin'. vol. 21, no. 2 (Aug. 1947), p. 155–60. 6 illus.

64 'Over the Sea to Skye'. [with a commentary by Bill Brandt] vol. 21, no. 5 (Nov. 1947), p. 389–96. 8 illus.*

65 'Hail, Hell and Halifax'. vol. 22, no. 2 (Feb. 1948), p. 151–56. 6 illus.

66 'The Poet's Crib'. vol. 22, no. 3 (March 1948), p. 77–84. 8 illus.
This is a series of photographs of poets' birthplaces.

67 'Six Artists'. vol. 22, no. 6 (June 1948), p. 37–42. 6 illus.

68 'The Borough'. vol. 22, no. 6 (June 1948), p. 77–84. 8 illus.
8 photographs taken in Aldeburgh with captions taken from George Crabbe's poem 'The Borough'.

69 'History in Rocks'. vol. 23, no. 2 (Aug. 1948), p. 63–68. 6 illus.

70 'Painter's Country'.[with a commentary by Bill Brandt] vol. 23, no. 3 (Sept. 1948), p. 77–84. 8 illus.
A series of photographs of Van Gogh's Provence.

71 'British Film Directors'. vol. 24, no. 2 (Feb. 1949), p. 59–66. 8 illus.
'An Odd Lot: A Gallery of Literary Portraits'. vol. 25, no. 5 (Nov. 1949), p. 49–56. 8 illus.

72 'Box Office Boys'. vol. 27, no. 6 (Dec. 1950), p. 51–57. 8 illus.
Consists of 7 portraits of impresarios by Brandt and one by John Gay.

Picture Post

73 'Buskers of London'. vol. 1, no. 10 (3 Dec. 1938), p. 53–55. 11 illus.

74 'Day In the Life of An Artist's Model'. vol. 2, no. 4 (28 Jan. 1939), p. 34–37. 13 illus.
The first of Brandt's four day in the life stories

of working women. Brandt's brother, the illustrator R.A. Brandt, features in one of these photographs sketching the model for a poster advertising the French Riviera [p. 37].

75 'Daybreak at the Crystal Palace'. vol. 2, no. 6 (11 Feb. 1939), p. 54–55. 8 illus.

76 'Nippy'. vol. 2, no. 9 (4 March 1939), p. 29–34, 18 illus.
A day in the life of a waitress at Lyon's Corner House, London.

77 'Enough Of All This!'. vol 2, no. 13 (1 April 1939), p. 54–57, 10 illus.

78 'A Barmaid's Day'. vol. 3, no. 1 (8 April 1939), p. 19–23, 12 illus.
The story of Alice, barmaid at 'The Crooked Billet' close to the Tower of London.

79 'The Perfect Parlourmaid'. vol. 4, no. 4 (29 July 1939), p. 43–47, 21 illus.
Brandt photographed his uncle's parlourmaid, Pratt, at work and at leisure.

80 'Spring in the Park'. vol. 11, no. 6 (10 May 1941), p. 18–21, 12 illus.

81 'This Was the War-Time Derby!'. vol. 12, no. 1 (5 July 1941), p. 13–17, 23 illus.

82 'A Day on the River'. vol. 12, no. 2 (12 July 1941), p. 12–15, 9 illus.

83 'What Are All These Children Laughing At?'. vol. 12, no. 8 (23 Aug. 1941), p. 16–17. 6 illus.
The children in these photographs are laughing at a Punch and Judy show.

84 'The Tay Bridge Disaster'. vol. 12, no. 2 (20 Sept. 1941), p. 11. 5 illus.
Brandt's photographs taken on the set of a film.

85 'Bath: What the Germans Mean by a "Baedeker Raid"'. vol. 16, no. 1 (4 July 1942), p. 20–21, 8 illus.
Brandt photographed the aftermath of a Luftwaffe raid on the historic town of Bath.

86 'Transport: Key to Our War Effort'. vol. 16, no. 13 (26 Sept. 1942) p. 11–15, 10 illus.

87 'Holiday Camp for War Workers'. vol. 16, no. 13 (26 Sept. 1942), p. 16, 4 illus.

88 'A Town That Takes Care of Its Troops'. vol. 17, no. 1 (3 Oct. 1942), p. 16–17. 7 illus.
The town in question is St Andrews.

89 'Fire Guard on the House of Commons'. vol 17, no. 7 (14 Nov. 1942), p. 11–13. 11 illus.

90 'A Cartoonist's Joke Becomes a Film Hero'. vol. 17, no. 12 (19 Dec. 1942), p. 14–15, 11 illus.
The film hero is Colonel Blimp in Michael Powell and Emeric Pressburger's *The Life and Death of Colonel Blimp*.

91 'The First Wartime Christmas to Bring a Vision of Peace'. vol. 17, no. 13 (26 Dec. 1942), p. 7–9, 6 illus.

92 'The Threat to the Great Roman Wall'. vol. 21, no. 4 (23 Oct. 1943), p. 12–15. 10 illus.
Brandt's photographs of Hadrian's Wall illustrate an article by C.E.M. Joad.

93 'The Portraits in the Servants' Hall'. vol. 21, no. 13 (24 Dec. 1943), p. 22–24. 10 illus.
The servants, the lady of the house and the portraits of past servants in Erthig Hall in Denbighshire, Wales are the subjects of this photo-story.

94 'A Year's Work by the National Trust'. vol. 22, no. 4 (22 Jan. 1944), p. 13–17. 17 illus.

95 'A Frosty Morning in the Park'. vol. 26, no. 3 (20 Jan. 1945), p. 13–15. 10 illus.

96 'The Magic Lantern of a Car's Headlights'. vol. 26, no. 13 (31 March 1945), p. 13–15. 10 illus.
Consists of photographs taken at night using a car's headlights instead of flash.

97 'Fountains Abbey: Should It Be Restored?'. vol. 32, no. 13 (28 Sept. 1946), p. 11–13. 5 illus.

98 'The Day That Never Broke'. vol. 34, no. 3 (18 Jan. 1947), p. 30–33. 4 illus.*
The story of one man on a foggy day in London.

99 'The Ghost Castle of Ravensworth'. vol. 37, no. 12 (20 Dec. 1947), p. 10–11. 6 illus.

100 'The Forgotten Gorbals'. vol. 38, no. 5 (31 Jan. 1948), p. 11–16. 13 illus. [3 by Brandt].
The photographer Bert Hardy also contributed to this photo-story about life in Glasgow slums.

101 'The Gibson Girl 1948'. vol. 38, no. 9 (28 Feb. 1948), p. 24–25. 4 illus.

102 'The Night Watch on Crime'. vol. 39, no. 5 (1 May 1948), p. 19–21. 8 illus.

103 'The Horizon of Richard Jeffries'. vol. 41, no. 6 (6 Nov. 1948), p. 11–13. 6 illus.

104 'Two For Travel'. vol. 44, no. 5 (30 July 1949), p. 29. 4 illus.

105 'Fashion in Bras'. vol. 44, no. 8 (20 Aug 1949) p. 32–33. 4 illus.

106 'Her Hair is a Fashion Asset'. vol. 44, no. 13 (24 Sept. 1949), p. 40–41. 5 illus.

107 'The Vanished Ports of England'. vol. 44, no. 13 (24 Sept. 1949), p. 16–19. 6 illus.

108 'Thoughts on Necks'. vol. 45, no. 6 (5 Nov. 1949), p. 33–34. 7 illus.

109 'Avenue Montaigne to Market Street: How Britain Adapts Paris Fashions'. vol. 45, no. 10 (3 Dec. 1949), p. 44–45. 10 illus.

110 'Paris Designs for the Small Purse'. vol. 45, no. 12 (17 Dec. 1949), p. 39–41. 8 illus.

111 'Raincoats are Promoted to Fashion'. vol. 46, no. 2 (14 Jan. 1950), p. 20–21. 7 illus.

112 'Spring Goes to the Head'. vol. 50, no. 12 (24 March 1951), p. 38–39. 6 illus.

Articles about Bill Brandt[†]

113 Alexander King. 'One Photographer's Formula: The Story of Bill Brandt, "The Super-Optical Night Bird"' *Minicam Photography* (Cincinnati), no. 3 (July 1940) p. 52–57. 5 illus.

An early appreciation of Brandt's work which includes the following description of his working methods: 'When all other good photographers have neatly tucked themselves into bed, Bill Brandt, like a super-optical nightbird, flutters his mist-moistened plumage and goes abroad to see what he can see. Many, in fact, most of his pictures are taken in what is considered very bad light. In Paris and London, where even in peacetime the subways stop at 1 a.m. and where the bus service at such an hour is extremely poor, he stalks the damp streets in search of sinister and revealing photo material. Much of his work has been very deliberately staged, but under all circumstances he prefers somber, dubious illumination to blatant lighting.'

114 Tom Hopkinson. 'Poetry: Bill Brandt – Photographer'. *Lilliput*, vol. 11, no. 2 (Aug. 1942), p. 130–41. 10 illus.

A short appreciation of Brandt and his photography.

115 Jonathan Tichenor. 'Bill Brandt'. *U.S. Camera Annual 1950* (New York: U.S. Camera Publishing Corp., 1950) p. 17–27. 10 illus. 1 port.

Introduces and comments on a portfolio of ten images by Brandt.

116 Robert Butts. 'Bill Brandt at Work: An Eyewitness Report'. *Modern Photography* (combined with *Minicam Photography*) New York: Feb. 1953, vol. 17, no. 2, p. 43. 1 illus.*

Butts describes working with Brandt photographing life in underground shelters during the London Blitz, 1940.

117 John Stewart. 'Bill Brandt: Photographer of Atmosphere'. *Modern Photography* (combined with *Minicam Photography*) (New York), vol. 17, no. 2 (Feb. 1953), p. 36–45, 120–21. 12 illus. 1 port.

†See also the introductions to books and catalogues listed in 'Books by and about Bill Brandt' and 'Selected Exhibition Catalogues of Bill Brandt's Work' sections of the Bibliography.

This article mentions that Brandt was originally interested in painting, which he practised at the sanatorium in Switzerland where he had been sent because of his tuberculosis. It includes the following comments, based on an interview: 'He says of himself that he was always very visual, and simultaneously with painting he experimented with a Box Brownie, his first camera; this was soon to become the more important, and as the time came to leave the sanatorium he felt that photography would keep him in contact with real life whereas painting would have been a continuation of the shut-away sanatorium existence.'

118 Tom Hopkinson. 'Bill Brandt's Landscapes'. *Photography* (April 1954), p. 26–31. 6 illus.*

Hopkinson suggests that the essence of Brandt's landscapes is simplification and exclusion. 'The more is omitted, the stronger the interest that's focused on what's left'. He identifies three factors which contribute to this effect: Brandt's meticulous choice of viewpoint; his choice of moment; and his control of lighting.

119 Tom Hopkinson. 'Bill Brandt'. *Camera* (Lucerne), vol. 33, no. 4 (April 1954), p. 152–57. 5 illus. portrait.

120 Anon. 'Bill Brandt'. *Popular Photography* (British Edition), vol. 4, no. 10 (July 1958), p. 32–33, 52. 3 illus.

The following comment by Brandt is quoted in this article [p. 32]:

'I think it was just the age-old pleasure of making pictures which brought me to photography. At first I was quite satisfied to photograph life around me as my eyes saw it; to make the camera see what I saw. But all the time I was fascinated by what the camera itself might be seeing, and now I am more and more inclined to let the lens see and produce pictures for me. It seems to me that the less I interfere, the better and more surprising are the negatives which appear in the developer. But this may be just one of my fads. I think there should be no rules in photography. Everything should be allowed, everything dared. For photography is still in its infancy, and its future developments are impossible to foresee.'

121 'Bill Brandt Today ... and Yesterday (with some appreciations by his friends)' *Photography,* vol. 14, no. 6 (June 1959), p. 4, 20–33, 52. 14 illus. 1 port.

Includes short statements by Cartier-Bresson, Tom Hopkinson, Robert Doisneau, Ansel Adams, Edouard Boubat, Beaumont Newhall, Albert Renger-Patzsch, H.J. Deverson (Picture editor of *The Sunday Times*) and Kaye Webb (art editor of *Lilliput*). It includes the following comments by Beaumont Newhall:

'Perhaps the most difficult quality for a photographer to achieve is an individual style. There is hardly any medium more difficult to impress with one's personality than the camera and sensitized film. Yet this is precisely what Bill Brandt has done. Over the years he has produced a body of work which is outstanding in its perception, in its sympathy for what is in front of the camera and his remarkable ability in making this personal view outstandingly visible in his photographs.'

122 Norman Hall. 'Infinities: Nudes by Bill Brandt'. *International Photography Yearbook* (New York: St Martin's Press Inc., 1960), p. 164–73. 10 illus.

123 André Thévenet. 'The Mastery of Bill Brandt'. *Camera* (Lucerne), no. 4 (April 1961), p. 6–19. 11 illus., 1 port.

This issue of *Camera* includes Brandt's 'Notes on *Perspective of Nudes*' [p. 7].

124 Norman Hall, Editor. 'Bill Brandt Nudes'. *Photography*, vol. 16, no. 3 (May 1961), p. 46–49. 7 illus.

125 Robert Doty. 'The Photography of Bill

Brandt by Robert M. Doty. The Life and Work of One of England's Major Photographers'. *Infinity* (New York) [American Society of Magazine Photographers] vol. 13, no. 1 (Jan. 1964), p. 5–9, 17. 3 illus.

126 David Bruxner. 'Bill Brandt: A Profile'. *British Journal of Photography* (25 Feb. 1966), p. 154–59, 170–1. 8 illus. 1 port.

127 Jan Olsheden. 'Bill Brandt – Legend i egen tid'. *Populär Fotografi,* no. 10 (Oct. 1966) p. 31–46. 17 illus. 1 port.

128 John Berger. 'Arts in Society: The Uses of Photography'. *New Society,* vol. 8, no. 211 (13 Oct. 1966), p. 582–83. 3 illus.*

Berger attacks Cyril Connolly's introduction to *Shadow of Light,* calling it 'pretentious, ignorant and insulating'. Berger identifies 1947 as a turning point for Brandt, identifying the photograph of the gull's nest on the isle of Skye as a pivotal picture 'here for the first time everything has been sacrificed to Brandt's private purpose.'

129 Arthur J. Dallaway, Editor. 'Bill Brandt'. *The British Journal of Photography Annual 1966* (London: Henry Greenwood and Co.) p. 74–81. 8 illus. 1 port.

130 Bill Jay. 'Bill Brandt – The Best from Britain'. *Creative Camera Owner.* no. 38 (Aug. 1967), p. 160–69, 184. 11 illus.

A survey of Brandt's work including some technical details. It also includes the following comments by Brandt:

[p. 161]: 'I last met Cartier-Bresson in Paris last autumn at the opening of his exhibition. He said to me "Of course we are on opposite sides." I laughed. I believe there are no rules in photography. A photographer is allowed to do anything, in order to improve his picture.'

[p. 161]: 'I'm an instinctive, not an intellectual, photographer. If it looks right, it is right.'

[p. 162]: On colour portraits: 'the results are always too soft, they lack impact. But I do think colour can improve a landscape, particularly when the colours are odd and "incorrect". Colour is so much better when the hues are non-realistic.'

[p. 162]: How do you cultivate design-sense? 'Keep looking at good pictures and paintings in museums and exhibitions. I found this of great value in my first years of photography.'

131 Anon. 'Bill Brandt'. *The Observer Magazine* (London) (14 July 1968), p. 26. 1 illus.

This consists of a half-page interview in 'The World's Greatest Photographers' series.

132 Walker Evans. 'Bill Brandt'. [p. 186–87, 1 illus.] in Louis Kronenberger, Editor, *Quality: Its Image in the Arts* (New York: Atheneum, 1969).

A short comment on Brandt's photograph of two maids standing by a table set for dinner:

'This print of social history cum satire is the work of Bill Brandt.

It is an example of Brandt's straight style.

The task of finding perfect subjects for social record and satirical photography is more difficult than it may seem. It requires amounts of time and energy that most artists won't spend on foraging. This picture is Brandt striking home (in all senses of the word). Instantaneous precision is only the beginning of its quality; it proceeds to a lot more: surgical detachment, wit, theatre.

Bill Brandt has a cutting eye for the English, perhaps because he comes orginally from Germany. Eugène Atget, French to the core, would have found a set dining table in a Paris apartment, but without those preposterous bonneted maidservants, or their equivalent. Brandt's recording of the two incredible figures is his own inspired accent. Here, to perfection, is Rule Britannia seen through reversed binocu-

lars. For an incandescent instant, this flash almost outdoes Evelyn Waugh.' [complete text]

133 Anon. 'Bill Brandt'. *Aperture,* vol. 14, no. 2 (Fall 1969) [p. 50–51]. 2 illus.

A brief biographical note about Brandt.

134 John Szarkowski. 'Bill Brandt'. *Album,* no. 1 (1970), p. 12–28. 16 illus.

The 16 illustrations in the portfolio which accompanies this article are Brandt's own selection and arrangement of his favourite photographs:

(1) Fountain in Barcelona
(2) Flea Market, Paris [a tailor's dummy]
(3) Race-goers
(4) Bay [an ear on a beach]
(5) On the Isles of Scilly [figureheads]
(6) West Wycombe Park [a reclining statue]
(7) Crystal Palace Gardens before the war [a statue reaching into the air]
(8) In a room in South London [a pair of feet in a room]
(9) In the Maritime Museum, Greenwich [figureheads]
(10) Tic-tac men
(11) In a Bond Street Hatter's
(12) Caligo in a bush near Taxo D'Aval [a moth]
(13) Evening in Kew Gardens [a crane]
(14) Garden at Pressoir-Prompt near Paris [statues of animals]
(15) Seventeenth-century sculpture in Bomarzo near Rome
(16) A resident of Putney

135 Tom Hopkinson. 'Bill Brandt'. *Daily Telegraph Magazine* (London) (24 April 1970), 10 illus.

An article is in the 'Great Photographers of the World' series.

136 Jean A. Keim. 'Un Ermitte de l'Effroi'. *Nouvelles Littéraires* (4 June 1970).

137 John Bardsley and R. Dunkley. 'Bill Brandt: How Significant is his Photography?'. *The Photographic Journal* (London), vol. 110, no. 7 (July 1970), p. 250–58. 6 illus.

138 John Szarkowski. 'Bill Brandt'. *Modern Photography* (USA), vol. 34, no. 10 (Oct. 1970), p. 84–89. 5 illus.

139 'Bill Brandt: Composition Analysis'. in Willard Morgan. Editor. *The Encyclopedia of Photography: The Complete Photographer* (New York: Greystone Press, 1970–71), [20 vols] vol. 14, p. 2633.

This short article is on the subject of Brandt's photograph 'London Child'.

140 'Living Masters of Photography Part 2: Bill Brandt'. *Camera* (Lucerne), no. 5 (May 1972), p. 4–23. 8 illus.

Includes 'Notes on *Perspective of Nudes*' by Brandt himself [p. 23] previously published in *Camera* April 1961. Man Ray is another of the 'Living Masters' included in this issue.

141 Anon. 'West Wycombe Park 1943'. *Creative Camera,* no. 95 (May 1972), p. 159. 1 illus.

A short note about Brandt. It includes the following comment by Brandt when asked about the sudden change in his work towards the end of the war:

'I have often been asked why this happened. I think I gradually lost my enthusiasm for reportage. Documentary photography had become fashionable. Everybody was doing it. Besides, my main theme of the past few years had disappeared; England was no longer a country of marked social contrast. Whatever the reason, the poetic trend of photography, which had already excited me in my early Paris days, began to fascinate me again. It seemed to me that there were wide fields still unexplored. I began to photograph nudes, portraits and landscapes.'

142 *Life* (U.S.A) (15 Dec.1972) p. 102–3. illus.

This article about photographs of dolls includes a photograph by Brandt of a black doll [p. 103] described as follows:

'The doll is as big as a baby and it has sat in a chair in Bill Brandt's London home ever since his wife bought it about 20 years ago. Though Brandt insists he is not interested in dolls, he is completely won over by this one because of its expression. "The eyes are really beautiful. It is like a human being." 'And it was equally difficult to photograph. "When you move the head, the eyes move, and they never look straight at you." The portrait session was a long one. After all, you can't tell a doll what to do.'

143 Ruth Spencer. 'Bill Brandt'. *British Journal of Photography* (9 Nov. 1973).

144 Cecil Beaton. 'Bill Brandt'. [p. 194–97, 4 illus.] in Gail Buckland and Cecil Beaton *The Magic Image* (Boston and Toronto: Little Brown & Co., 1975. 304pp. 466 illus.).

In a short article Brandt is described as 'the Samuel Beckett of photographers'.

145 Norman Hall. 'A Restless Vision'. *Designer* (Jan. 1975), p. 15, 1 illus.

A brief survey of Brandt's career on the occasion of his winning the Society of Industrial Artists and Designers 1974 design medal – Brandt was the first photographer to win this award.

146 George Hughes. 'His Way. . .'. *Amateur Photographer*, vol. 151, no. 17 (23 April 1975), p. 96–100. 8 illus.

An appreciation of Brandt on the occasion of the SIAD award.

147 Tom Picton. 'The Unimportance of Being Mr. Brandt'. *Camerawork*, no. 4 (Nov. 1976), p. 11. 1 illus.

148 Colin Ford. 'Auto Portrait'. *Camera* (Lucerne), no. 9 (Sept. 1978), p. 4–43. illus.

Includes Brandt's self-portrait using Polaroid Type 105/665 positive/negative film [p. 33] and a biographical note [p. 43].

149 John Taylor. 'Bill Brandt and the Conversation Piece'. *Afterimage*, vol. 6, no. 6 (Jan. 1979), p. 4–5. 1 illus.

Taylor describes his article as 'a kind of cultural archaeology upon the portrait *Edith and Osbert Sitwell, Renishaw Hall, 1945*. In a later essay, 'The Use and Abuse of Brandt' (*Creative Camera*, March/April 1981) Bibl. **153**, he mentions that the photographer approved of his interpretation of this picture as 'a modern version of the conventional genre of the conversation piece'.

150 George Hughes. 'Brandt – Now and Then'. *Amateur Photographer*, vol. 159, no. 9 (28 Feb. 1979), p. 70–75. 6 illus.

Some previously unpublished photographs of rock formations, mostly variants of images which had appeared in the second edition of *Shadow of Light*, accompany this article.

151 Dave Saunders. 'Bill Brandt: Not Resting on His Laurels'. *Hot Shoe* (London), no. 15 (1981).

152 Mark Haworth-Booth. 'Talking of Brandt...' *Creative Camera*, no. 195/196 (March/April 1981), p. 20–22. 3 illus.

An edited version of a radio broadcast by Mark Haworth-Booth (BBC3, 26 Oct. 1980). It consists of a discussion of Brandt's nudes on the occasion of the publication of *Bill Brandt: Nudes 1945–1980*.

153 John Taylor. 'The Use and Abuse of Brandt'. *Creative Camera*, no 195/196 (March/April 1981), p. 17–20. 3 illus.

This is an examination of questions of interpre-

tation of Brandt's work, concentrating on *A Night in London*, *Camera in London* and the use of Brandt's photographs in the 1955 *Family of Man* catalogue.

154 Trevor Gett. 'Bill Brandt in Perspective'. *Australian Photography,* vol. 32, no. 4 (April 1981), p. 56–59. 7 illus.
Gett's article is based on an interview with Brandt. It includes the following comment by Brandt: 'I never considered myself a photojournalist, or anything in particular. I just took pictures I wanted to, and offered them to people to publish'.

155 Barry Monk. 'Bill Brandt'. *Amateur Photography,* vol. 163, no. 15 (11 April 1981), p. 96–100. 5 illus. 1 port.
Based on an interview with Brandt on the occasion of the Royal Photographic Society exhibition, Bath.

156 Douglas Davis. 'The Man in the Mirror' *Newsweek,* vol. 98, no. 14 (5 Oct. 1981), p. 69–70.
Brandt seemed reluctant to discuss his work with this interviewer: '"I don't know, I don't know, I don't know by whom I was influenced." he says, then pauses "I think the camera influenced me."' [p. 69].

157 Avis Berman. 'Bill Brandt: Through a Camera Darkly'. *Art News*, vol. 81, no. 3 (1982), p. 92–98. 7 illus.
This article, based on an interview with the photographer, includes Brandt's descriptions of his encounters with Magritte, de Chirico, Picasso and Brancusi.

158 Andrew Stephen. 'Bill Brandt'. *The Sunday Times Magazine* (2 May 1982), 15 illus. 1 port.

159 R. Clark. 'Photographing Brandt'. *British Journal of Photography* vol. 129, pt. 22 (28 May 1982).

160 R.B. Kitaj. 'R.B. Kitaj and Two Faces of Ezra Pound'. *Creative Camera,* no. 210 (June 1982), p. 536–37. 2 illus.
The painter R.B. Kitaj compares a portrait by Bill Brandt with his own mental vision drawn from reading Pound's poetry in his youth.

161 Roy Strong. 'Bill Brandt: Portraits'. *Creative Camera,* no. 210 (June 1982), p. 538–45.
This article includes a description of the experience of being photographed by Brandt.

162 Mark Haworth-Booth. 'Kitaj/Brandt/Screenplay'. *Creative Camera,* no. 210 (June 1982), p. 546–49.
Discusses Kitaj's painting *Screenplay* which is based on Brandt's photograph of *Top Withens*.

163 Mark Haworth-Booth. 'Bill Brandt: Portrait of an Artist'. *Vogue* (British Edition), vol. 139, no. 9, whole no. 2224 (Sept. 1982), p. 256–57, 308. 1 illus. 1 port. [by David Bailey].

164 Mark Haworth-Booth. 'In Perspective'. *Radio Times* (8–14 Jan. 1983)
Summarizes Brandt's career on the occasion of Peter Adam's Master Photographers programme (Friday 7.30 p.m. BBC2), see Bibl. **303**.

165 Ainslie Ellis and Peter Adam. 'The Making of *Master Photographers*'. *British Journal of Photography,* vol. 130, pt. 12 (25 March 1983), p. 30–71.
An interview with Peter Adam on the subject of the making of the television series Master Photographers, including the film about Brandt, see Bibl. **303**.

166 John Taylor. 'Picturing the Past'. *10–8* no. 11 (1983), p. 15–32. illus.
Discusses Brandt's documentary realism including *The English at Home*.

167 'Bill Brandt – Contribution to British Photography'. *The Times* (London) (21 Dec. 1983).

An obituary.

168 Jon Pareles. 'Bill Brandt, 79, Photographer of Foreboding Images, Dead'. *New York Times* (21 Dec. 1983).

169 Raymond Grosset. 'Bill Brandt'. *Photo* (France), no. 197 (Feb. 1984).

170 Michael Sladden. 'Obituary (Bill Brandt)'. *Afterimage* (Feb. 1984), p. 21.

171 Ian Fraser. 'A Close-Up of the Holland Park Flat of Influential Photographer Bill Brandt'. *The World of Interiors* (Feb. 1984), p. 76–80. 4 illus. [colour].

Based on a visit to Brandt's Holland Park flat shortly before the photographer's death, this article includes four colour photographs of Brandt and Mrs Noya Brandt and their home.

172 Peter Marshall. 'Further Look at Brandt'. *Creative Camera*, no. 231 (March 1984), p. 1310–11.

173 S. Kingston. 'The Shadows of Bill Brandt: A Tribute'. *Amateur Photographer*, vol. 169, no. 4 (1984), p. 50–55.

174 Mark Haworth-Booth. 'Remembering Bill Brandt'. *The V & A Album*, 3 (London: The Associates of the V & A, 1984), p. 40–45. 6 illus.

An affectionate account of Brandt by his friend Mark Haworth-Booth who worked closely with him selecting photographs for the exhibition *The Land* at the Victoria and Albert Museum, London.

175 Charles Hagen. 'Bill Brandt's Documentary Fiction'. *Artforum*, vol. 24, no. 1 (Sept. 1985), p. 11–14. 8 illus.

This article on the occasion of the publication of *Bill Brandt: Behind the Camera*, focuses on the fact that Brandt staged many of his best-known photographs using friends and relatives. It includes the following reassessment:

'Posed or unposed, Brandt's work can now be seen as explicitly an invention, the fabricated proof of an emotionally urgent inner landscape rather than a simple record of an objective social reality. The essential mystery of his early photographs turns out to be not the Dickensian one of the city in industrial culture, but the surrealist mystery of the remembering, dreaming self, imposing its emotional needs on the world around it.' [p. 112].

For the first published mention of this aspect of Brandt's photographic technique, see Alexander King's 1940 article, Bibl. **113**.

176 Richard Lacayo. 'Through A Lens Darkly'. *Connoisseur*, vol. 216, no. 899 (Dec. 1986), p. 80–55. 8 illus.

177 Jozef Gross. 'Mighty Lilliput'. *Photography* (May 1988), p. 61–65. 4 illus.*

Examines the history of the magazine which commissioned and printed many of Brandt's most famous photographs.

178 Maria Morris Hambourg. 'Photography Between The Wars'. *The Metropolitan Museum of Art Bulletin*, vol. 45 (Spring 1988), p. 3–56.

The section on Brandt (1 illus.) is p. 45–8.

179 Nancy Hall-Duncan. 'Brandt, Bill' [p. 115–17, 1 illus., bibliog., list of exhibitions] in *Contemporary Photographers*, 2nd ed. Colin Naylor (Chicago and London: St James Press, 1988).

180 Mark Haworth-Booth. 'Where We've Come From: Aspects of Postwar British Photography'. *Aperture*, no. 113 (Winter 1988), p. 2–9.

181 Peter Turner. 'Bill Brandt The Early Years 1930–1942'. [p. 22–28] in Peter Turner and Gerry Badger *Photo Texts* (London: Travelling Light, 1988).

Reprints the text from Turner's introduction to the Arts Council exhibition catalogue, *Bill Brandt: Early Photographs 1930–1942* (1974), Bibl. **189**.

182 Carol Armstrong. 'The Reflexive and the Possessive View: Thoughts on Kertesz, Brandt and the Photographic Nude'. *Representations* (USA) no. 23 (Winter 1989), p. 57–69. 10 illus. bibliog.

Armstrong claims that although Brandt's nudes seem to be exaggerated examples of the 'phallocentrism of the photographic process', they actually 'subvert and negate any simplistic theorizing of the male gaze'.

183 Joanne Buggins. 'An Appreciation of the Shelter Photographs Taken by Bill Brandt in November, 1940'. *Imperial War Museum Review*, 4 (1989), p. 32–42. 12 illus. bibliog.*

Buggins provides the background to Brandt's shelter pictures which were commissioned by the Ministry of Defence.

184 Patrick Roegiers. 'Bill Brandt and the England of the Thirties'. *Cimaise* (France), vol. 37, no. 209 (Nov./Dec. 1990), p. 37–48. 13 illus.

185 Bill Jay. 'Bill Brandt – A True But Fictional First Encounter,' [p. 71–73] in Bill Jay *Occam's Razor: An Outside-In View of Contemporary Photography* (Munich: Nazraeli Press, 1992). [This piece was originally part of a lecture presented at the San Francisco Museum of Modern Art for the opening of its Bill Brandt retrospective exhibition, Nov. 1987, and subsequently in *Shots* 14, the Alaska Photographic Centre (Sept. 1989)].

An insight into Brandt's reluctance to speak about his life and the difficulties this presented for interviewers.

186 Richard Woodfield. 'Bill Brandt'. *Katalog,* vol. 4, no. 3 (March 1992), p. 4–12. 7 illus. bibliog. [In Danish and English].

Examines the European influences visible in Brandt's work.

187 Nigel Warburton. 'Bill Brandt's Cathedral Interiors: Rochester and Canterbury'. *History of Photography,* vol. 17, no. 3 (Autumn 1993), p. 263–68, 3 illus. [accompanied by a portfolio of 7 photographs from Brandt's negatives, p. 269–76, 7 illus.].

A discussion of some of Brandt's wartime work for the National Buildings Record together with a portfolio of 7 images from this commission.

Selected Exhibition Catalogues of Bill Brandt's Work

188 *Bill Brandt: Photographs*. Foreword by Robin Campbell. Introduction 'The Shadowy World of Bill Brandt' by Aaron Scharf. (London: Arts Council of Great Britain, 1970. 16pp. 12 illus.). London: Hayward Gallery (30 April–31 May 1970); Exeter: Royal Albert Memorial Museum (13 June–5 July 1970); Newport: Museum and Art Gallery (11 July–1 Aug. 1970); Oldham: Museum and Art Gallery (8–30 Aug. 1970); Wolverhampton: Art Gallery (5–27 Sept. 1970); Newcastle-Upon-Tyne: Hatton Gallery (5–24 Oct. 1970); Norwich: Castle Museum (7–22 Nov. 1970); Sunderland: Art Gallery (28 Nov.–27 Dec. 1970); Aberdeen: Art Gallery (4–24 Jan. 1971); Middlesbrough: Art Gallery (30 Jan.–21 Feb. 1971); Lancaster: The University (27 Feb.–21 March 1971); Totnes: Dartington Hall (27 March–18 April 1971); Oxford: Museum of Modern Art (28 April–16 May 1971).

> This exhibition was originally shown at the Museum of Modern Art, New York (16 Sept.–30 Nov. 1969) and consisted of 123 prints chosen by John Szarkowski.

189 *Bill Brandt: Early Photographs 1930–1942*. Foreword by Joanna Drew. Introduction 'Bill Brandt – The Early Years' by Peter Turner. (London: Arts Council of Great Britain, 1975. 16pp. 12 illus. bibliog.).

190 *Landscape Photography: 50 Pictures Chosen by Bill Brandt*. Introduction by Mark Haworth-Booth. (London: Victoria and Albert Museum, 1976. 1 folded sheet. 5pp. bibliog.).

191 *Bill Brandt*. Introduction by Jean Dieuzade [French]. (Toulouse: Galerie Municipale Château d'Eau, 1976. 8pp. 11 illus. 1 port. chronol.). Toulouse: Galerie Municipale Château d'Eau (2 Feb.–29 Feb. 1976).

192 *Bill Brandt*. Introduction 'Bill Brandt/True Londoner' by Norman Hall. (New York and London: Marlborough, 1976. 32pp. 46 illus. chronol. bibliog.). New York: Marlborough Gallery (27 March–17 April 1976); London: Marlborough Gallery (Nov.–Dec. 1976).

193 *Bill Brandt: Fotografien*. (Cologne: Rheinisches Landesmuseum, 1977. 8pp. illus.).

194 *Bill Brandt*. Introduction by Rune Jonsson. (Stockholm: Fotografiska Museet,

1978. 16pp. illus. chronol.). Stockholm: Fotografiska Museet (21 Jan.–26 Feb. 1978).

195 *Photographs by Bill Brandt.* Acknowledgements by Annemarie Pope. Introduction by Mark Haworth-Booth. (Washington, D.C.: International Exhibitions Foundation, 1980. 16pp. 10 illus. bibliog.)
 The catalogue from a touring exhibition drawn from the Victoria and Albert Museum, London's collection.

196 *Surrealist Photographic Portraits 1920–1980.* Introduction by Dennis Longwell. (New York: Marlborough, 1981. 4pp. 7 illus.). New York: Marlborough Gallery (9 April–9 May 1981).
 This exhibition included work by Man Ray, Berenice Abbott, Brassaï, George Platt Lynes, Richard Avedon and Robert Mapplethorpe as well as 11 portraits by Brandt. Longwell writes in the introduction:
 'In the great portraits Brandt later produced, from the 1940s through the 1960s, we have some of the finest examples of Surrealist portraiture in any medium by any Surrealist artist. Here the full panoply of Surrealist techniques comes masterfully into play: the vast stage-like space; the wild disparity of scale between the subject and the objects around him; and the dizzying shifts in perspective that confound foreground with background. Brandt's *Self-Portrait With Mirror, East Sussex Coast 1966* is a brilliant compendium of Surrealist devices. The low angled view pointing up to the reflected image of the fragmented figure, the jagged patch of moon-like landscape in the background, the irrational horizon line, and the harsh impartial light vividly illustrate what Breton's convulsive beauty might, in fact, look like.' [excerpt]

197 *Bill Brandt: A Retrospective Exhibition.* Foreword by Valerie Lloyd. Introduction by David Mellor. (Bath: Royal Photographic Society, 1981. 48pp. 52 illus. 1 port. bibliog.). Bath: Octagon Gallery (15 April–4 July 1981).

198 *Bill Brandt: Portraits.* Foreword by John Hayes. Introduction by Richard Ormond. (London: National Portrait Gallery, 1982. 24pp. 17 illus.). London: National Portrait Gallery (7 May–22 Aug. 1982).

199 *Atelier Man Ray 1920–1935: Abbott, Boiffard, Brandt, Miller.* [in French] Philippe Sers, Editor. 'Bill Brandt' by Roméo Martinez [p. 48–50]. (Paris: Centre Georges Pompidou, 1982. 62pp. 74 illus. [3 by Brandt]). Paris: Centre Georges Pompidou (2 Dec. 1982–23 Jan. 1983).
 This is the exhibition catalogue from a group show featuring the work of four photographers who worked in Man Ray's studio in the 1920s and 1930s.

200 *Bill Brandt Photographs.* (Linz, Austria: Neue Galerie der Stadt Linz/Wolgang-Gurlitt-Museum, 1983). Linz, Austria: Neue Galerie der Stadt Linz/Wolgang-Gurlitt-Museum (13 Jan.–26 Feb. 1983).

201 *Bill Brandt: War Work.* Introduction by Rupert Martin (London: The Photographers Gallery, 1983. 1 folded sheet. 6 illus.). London: The Photographers Gallery (24 June–3 Sept. 1983).

202 *Bill Brandt: Vintage Photographs.* Introduction 'Bill Brandt, Starting Between the Wars' by David Travis. (Chicago: Edwyn Houk Gallery, 1985. 48pp. 40 illus.) [Limited edition of 1000 copies]. Chicago: Edwyn Houk Gallery (Nov. 1985–Jan. 1986).

203 *Bill Brandt Assemblages* Introduction by Nigel Warburton (London: Reed's Wharf Gallery, 1993. 1 folded sheet. illus. chronol.). London: Reed's Wharf Gallery (Sept.–Oct. 1993).

Book and Exhibition Reviews of Bill Brandt's Work

204 Anon. [Review of *The English at Home*.] *The Times Literary Supplement*, no. 1780 (14 March 1936), p. 225.

Includes the following comments:

'In order to emphasize sharp contrasts of social conditions which can scarcely be peculiar to England Mr Brandt has hammered his point till it is in danger of being blunted, while he has almost ignored the life of maritime and country folk, and of middle-class business people whose week-end search for fresh air and exercise in suburban gardens, on bicycles, or on foot is surely a feature worth recording.'

205 G.W. Stonier. 'London Night'. *The New Statesman and Nation*, vol. 16, no. 386 new series (16 July 1938).

This review of Brandt's second book, *A Night in London* (1938) includes the following assessment:

Most of the photographs of *A Night in London* are street scenes – theatre queues, glimpses of the river, deserted alleys, traffic jams, the prostitute on her corner, the workers at Billingsgate in the early morning. Other photographers have done these as well – or nearly as well – as Mr. Brandt. Where Mr. Brandt excels is in the naturalness of his interiors, many of which must have been carefully posed. Sometimes, looking through a window, he catches a family at dinner or sitting by the fire – it is the sideglance anyone might give from the street; but then, without loss of spontaneity, he goes inside one of these houses and shows us a bridge party in a Kensington drawing-room or a working-class bedroom where five children lie huddled together asleep. "At Half-past ten Mr. and Mrs. Smith prepare for Bed" is a triumph of this interior snapshotting; Mrs Smith, an old lady in an old dressing gown, is cleaning her teeth, glass in hand, while Mr, Smith with his back to us prepares to pull his shirt over his head: it might be a moment from *Sous les Toits de Paris*. Mr. Brandt has, indeed, something of Clair's genius in choosing human types for his camera; his old people are especially striking. As an artist he is quick, sardonic, ruthlessly interested. To any foreigner – or any Londoner for that matter – who wants to slip behind the scenes of London life I can recommend *A Night in London* as being as good in its way as *Sous les Toits* or Cavalcanti's *Rien que les Heures* – curiously enough there is no English film which does for London what they have done for Paris. And, though Mr. Brandt does not underline his sympathies, his book might well be intended as propaganda for social-

ism. The contrasts it illustrates between wealth and poverty are striking.' [excerpt]

206 Anon. [Review of *A Night in London*]. *The Times Literary Supplement*, no. 1910 (10 Sept. 1938).

The anonymous reviewer compares Brandt's second book with a Country Life collection, *London. A Pictorial Survey*, Introduction by Philip Tomlinson, 1938. It includes the following comment on Brandt's work:

'His photographs, with their heavy shadows and skilful lighting, are very clever, though even his cleverness cannot make a restaurant scene anything but a repetition of the photographs in the society paper. Nor has he succeeded in concealing his artifice. Many of his figures are waiting for the photographer. For that reason the best are the photographs without figures, and the best of all the pictures of roofs at dawn.' [excerpt]

207 Anon. 'Modern Photography at Marx House'. *New Statesman and Nation*, vol. 20, no. 492 (27 July 1940), p. 87–88.

An anonymous review of a London exhibition of several photographers' work in London. It includes the following assessment of Brandt's contribution to the exhibition:

'Bill Brandt gets straight to the core of the reality of an industrialised world, of life on the dole, in a series of magnificent documentaries. One peers down at an angle into a slum backyard in Jarrow where the family are huddled together in scabby confinement beneath the clothes-line, a rotting saucepan full of scum hanging on a decaying wall, a broken kitchen chair, a ruined tub … an intolerable picture of a miner's child standing in a sunken yard where nothing but the upturned rim of an enamel basin holds the light. He shows, too, a furious photograph of a Spanish beggar gesticulating against a sun-bitten building. All this is first rate and is, together with the work of E.T.H., photography with a vengeance, in every sense of the word.' [excerpt]

208 L.A. Mannheim. "London" – Ein Photobuch von Bill Brandt' [in German] *Camera* (Lucerne, German edition), vol. 28, no. 2 (Feb. 1949), p. 48–51. 4 illus.

209 L.A. Mannheim. 'Bill Brandt, London' [in English, German and French] *Camera* (Lucerne), vol. 28, no. 4 (April 1949), p. 98–109. 8 illus.

210 Tom Hopkinson. 'A Photographer as Critic'. *The Spectator* (27 July 1951).

In this review of *Literary Britain* Hopkinson, who had been editor of *Lilliput* and of *Picture Post*, describes the book as 'the most distinguished book of photographs that has appeared in this country for some years'. It includes the following astute assessment of Brandt's photographic art:

'But beyond all qualities of literary enjoyment, humour, technical ability, the outstanding impression the book makes is one of beauty. Brandt's gift as a photographer is that he goes straight for the essential, discarding everything not directly connected with his vision. His pictures are almost always simple, sometimes startlingly so, though the means by which he achieves them include a complete understanding of what his camera will do and a quite unusual mastery of printing technique … The negative, however, has been only the beginning. Holding back one part of the picture, stressing another, forcing the sky to lower, folding in darkness some detail that would have made the picture fussy, Brandt must have spent as much as a whole day making a single print – the work of minutes. The result is a severe and moving commentary, exactly adapted to the book form. The book is not a collection of loosely-associated artistic products. It is the work of art itself, and out of it, long after, rise images to haunt the memory.'[excerpt]

211 John Hadfield. 'Book Box'. *The Sunday Times* (London), (29 July 1951).

A review of *Literary Britain*.

212 Naomi Lewis. 'Storied Ground'. *The Observer* (London), (12 Aug. 1951).
Literary Britain is the subject of this review.

213 Willard van Dyke. 'Presentation: a Whale of a Difference'. *American Society of Magazine Photographers News* (Sept. 1951), p. 4–5. 1 illus.
A discussion of the effect of good presentation of photographs. A caption to Brandt's photographs at the Museum of Modern Art, New York is briefly mentioned.

214 Geoffrey Grigson. 'The Nail-File of Henry James'. *New Statesman and Nation* (1 Sept. 1951).
The poet Geoffrey Grigson sums up *Literary Britain* as follows:
'For sheer photography Mr. Brandt scores about thirty-five winners out of a hundred. The best of them are the ones least opposed to the stock ways of composing a landscape from Turner or Constable down to Munnings or Lamorna Birch. But such stock composition is what pictorial editors demand.'

215 J.P.T. 'Pilgrimage by Proxy'. *Punch* (London), (5 Sept. 1951).
A review of *Literary Britain*.

216 John Betjeman. 'Only an Idea'. *Time and Tide* (London), (13 Oct. 1951).
This is a review of *Literary Britain* by the distinguished British poet. It includes the following comment:
'. . . Bill Brandt is an impressive photographer. He sees things as an artist, not as some dud aspirer to the Royal Academy of 1908 which is the standard of most photographers of Britain Beautiful. He knows how to compose a picture on a page. He does not use the dreary camera-club technique – tree in the right foreground, sky two-thirds of the background, long shadows and a title like "It Ringeth Eventide". He owes

much to those serious documentary and abstract photographers of the 'thirties like Man Ray and Moholy-Nagy. But he has his own vision.' [excerpt]

217 Tom Hopkinson. 'Nudes in a New Dimension through the Lens of Bill Brandt'. *The Observer* (London), (2 May 1961), p. 61. 4 illus. 1 portrait.

218 Tom Hopkinson. 'The Perspective of Nudes'. *The Observer* (London), (21 May 1961), p. 17–27.
Hopkinson's review of *Perspective of Nudes*.

219 Georges Boudaille. 'Perspectives sur le Nu'. *Les Lettres Françaises*, no. 894 (28 Sept. – 4 Oct. 1961), p. 12. 2 illus. [In French].
A review of *Perspectives sur le Nu*, the French edition of Brandt's book.

220 Ralph M. Hattersley Jr. 'Perspective of Nudes'. *Infinity* (New York), (Dec. 1961), p. 8–11, 13–15. 9 illus.
Perspective of Nudes is the subject of this review.

221 Les Barry, Bruce Downes, John Durniak, H.M. Kinzer, Charles Reynolds, James M. Zannutto. 'Art, Pornography or merely Shocking?'. *Popular Photography* (Chicago), (March 1962), p. 42–43, 66–67.
A symposium review of *Perspective of Nudes* which provides an interesting insight into early reactions to Brandt's nude photography.

222 Jean Mohr. 'Bill Brandt – Perspectives sur le Nu'. [in French] *La Tribune* (France), (2–3 June 1962), p. v. 1 illus.
A review of *Perspectives sur le Nu*.

223 Robert Doty. 'The Photographs of Bill Brandt'. *Image* [The Bulletin of the George Eastman House of Photography, Rochester,

New York], vol. 12, no. 2 (1963). 4 illus. bibliog.

> This is an exhibition review of Brandt's work which was exhibited at George Eastman House (15 April – 17 June 1963).

224 Cyril Connolly. 'Poet with a Camera'. *The Sunday Times Magazine* (London), (11 Sept. 1966), p. 36–37. 6 illus.

> Reprints extracts from Cyril Connolly's introduction to *Shadow of Light*.

225 Norman Hall and Ralph Hattersley. 'Critics at Large: *Shadow of Light* by Bill Brandt: Views from Two Sides of the Ocean'. *Popular Photography* (Sept. 1966), p. 101–3. 12 illus.

226 Albert Plecy. 'Le Salon Permanent de la Photo – Bill Brandt'. [in French] *Point de Vue – Images du Monde*, no. 971 (20 Jan. 1967), 7 illus.

> A brief comment about Brandt's photography on the occasion of the publication of *Ombres d'une Île*, the French edition of *Shadow of Light*. The 'Île' [Island] in the French title is Britain.

227 Michel Tournier. 'Le Regard Génial de Bill Brandt'. [in French] *Nouvelles Littéraires* (9 Feb. 1967), p. 9. port.

> The French novelist reviews *Ombres d'une Île*.

228 Jean A. Keim. [in French] *La Quinzaine Littéraire* (France), no. 23 (1 March 1967) p. 17.

> A review of *Ombres d'une Île*.

229 Anon. 'Gallery: The Surrealistic Vision of Bill Brandt'. *Life* [US edition], vol. 67, no. 15 (10 Oct. 1969), p. 8–11. 4 illus.

> This is a review article based on Brandt's exhibition at the Museum of Modern Art, New York.

230 Robert Frank. 'Letter from New York'. *Creative Camera*, no. 66 (Dec. 1969), p. 414.

> A letter from the photographer Robert Frank on the occasion of the exhibition at the Museum of Modern Art, New York. Frank stresses Brandt's influence: 'the spell of Brandt's work holds more power than ever for me'.

231 Oswell Blakeston. 'Bill Brandt'. *Arts Review*, vol. 22, no. 9293 (9 May 1970).

> This is a review of Brandt's exhibition at the Hayward Gallery, London.

232 Anslie Ellis. 'Bill Brandt'. *The British Journal of Photography,* vol. 117, no. 5730 (15 May 1970), p. 472–76. 12 illus.

> A review article about the Hayward Gallery, London exhibition.

233 Jean A. Keim. 'Un Ermitte de l'Effroi'. [in French] *Nouvelles Littéraires* (4 June 1970).

234 C. Faraldi. 'The Brandt Collection'. *Observer* (London), (9 June 1974).

> Brandt's collages, reviewed here, were exhibited at the Kinsman Morrison Gallery, London (17 June – 12 July 1974).

235 Mark Haworth-Booth. 'Bill Brandt Collages'. *The Connoisseur*, vol. 187, no. 751 (Sept. 1974), p. 74. 1 illus.*

> A review of the exhibition at the Kinsman Morrison Gallery, London.

236 'The Land'. *Aperture*, no. 77 (1976), p. 66–77. 7 illus.

> This consists of a selection of writing from the catalogue of the exhibition of the same name (Victoria and Albert Museum, London) a quotation from Brandt's introduction to *A Camera in London*, a portfolio of images, and a selection of reviews from the following critics: Toni del Renzio (*Art and Artists*), Ian Jeffrey, John

Naughton (*New Statesman*), Richard Cork (*Evening Standard*), Christopher Drake (*The Tatler*), Fenella Crichton (*Studio International*), John McEwen (*Spectator*).

237 Sarah Kent. 'Bill Brandt'. *Time Out* (10–16 Dec. 1976). p. 40. 1 illus.
A brief comment on the exhibition at the Marlborough Art Gallery, London (Nov.–Dec. 1976).

238 Karsten Fricke. 'Ausstellungen'. *Fotgrafie*, no. 3 (1977), p. 45.
This is a review of the exhibition at the Rheinisches Landesmuseum, Bonn.

239 David Reed. 'Viewed: Bill Brandt at Marlborough Fine Art'. *British Journal of Photography,* vol. 124, pt. 1, no. 6067 (7 Jan. 1977), p. 14–16. 3 illus.

240 Richard Ehrlich. 'Bill Brandt'. *Art and Artists*, 131, vol. 11, no. 10 (Feb. 1977), p. 28–31. 3 illus.
A review of the Marlborough Gallery exhibition, London.

241 William Feaver. 'London: Retouching the Past'. *Art News*, vol. 76, no. 3 (March 1977), p. 106–8.
The Marlborough Gallery exhibition in London is the subject of this review.

242 Ian Jeffrey. 'Photography'. *Studio International*, vol. 193, no. 986 (March/April 1977), p. 139–40. 1 illus.
In this review of the Marlborough Gallery exhibition, London, Jeffrey mentions Brandt's fascination with his childhood books.

243 David Reed. 'Recent Books'. *British Journal of Photography*, vol. 124, no. 6100 (24 June 1977), p. 522–27. 4 illus.
A review of the second edition of *Shadow of Light* is included.

244 Anon. 'Bill Brandt – In Black and White He's a Genius'. *Practical Photography* (Aug. 1977).
An appreciative review of the second edition of *Shadow of Light.*

245 Joan Murray. 'Brandt Rediscovered . . .'. *Artweek*, vol. 8, no. 29 (10 Sept. 1977), p. 11. 3 illus.
A review which re-examines Brandt on the basis of the second edition of *Shadow of Light.*

246 Jack Schofield. 'Bill Brandt: Shadow of Light'. *Photo-Technique*, vol. 5, no. 9 (Oct 1977), p. 51–57. 16 illus.

247 Lyliane Boyer. 'La Vie en Images: Bill Brandt'. [in French] *Le Nouveau Photo-cinéma*, no. 61 (Oct. 1977) p. 14–15. 3 illus.
A review of *Ombre de Lumière*, the French edition of the second edition of *Shadow of Light.*

248 Jean Leroy. 'Bibliographie Photographique'. [in French] *Photo Revue* (Nov. 1977), p. 636. 3 illus.
Reviews *Ombre de Lumière.*

249 Katherine Tweedie. 'Second Shadow'. *Afterimage*, vol. 5, no. 5 (Nov. 1977). p. 15. 3 illus.
Shadow of Light reviewed.

250 C.L. 'Expositions'. *Zoom*, no. 48 (1977) p. 112–13. 1 illus.
This is a review of an exhibition, 'Ombre et Lumière', Fnac, Montparnasse, Paris.

251 Hans Christian Adam. 'Bucher'. *Fotografie*, no. 5 (1978), p. 51. 1 illus.
A short review of the second edition of *Shadow of Light.*

252 Petr Tausk. 'Navstevou u Bill Brandta'. *Fotografie 78*, vol. 22, no. 2 (1978) p. 69. 4 illus.

253 O.C. 'Knihy (Books)'. *Fotografie 78*, vol. 22, no. 2 (1978), p. 80–82. 9 illus.

A brief review of the second edition of *Shadow of Light*.

254 Lanfranco Colombo. 'Libri'. *Fotografica Italiana*, no. 236 (April 1978), p. 14. 1 illus.

This includes a review of the second edition of *Shadow of Light*.

255 Joe Novak. 'Books in Review'. *Camera 35*, vol. 23, no. 9 (Oct. 1978), p. 28–29. 3 illus.

Shadow of Light is reviewed.

256 Joan Murray. 'Photography: Bill Brandt, Pictorial Novelist'. *Artweek*, vol. 9, no. 41 (2 Dec. 1978), p. 13. 2 illus.

A review of an exhibition at the Simon Lowinsky Gallery, San Francisco.

257 Sarah Putnam. 'Shows'. *Views,* 1, no. 3 (Spring 1980), p. 24. 1 illus.

Exhibition review of 'Bill Brandt', Kiva Gallery, Boston, Mass.

258 'Bill Brandt: A Bagatelle: Nus Dans Le Style Faits Divers'. [in French] *Photo* (Paris), no. 158 (Nov. 1980), p. 104–11, 150. 7 illus. port.

A review of an exhibition at the Petit Trianon Bagatelle, Paris.

259 Anon. 'Books'. *Camera* (Lucerne), vol. 60, no. 3 (March 1981), p. 47.

Includes a review of *Bill Brandt: Nudes 1945–1980*.

260 Anon. 'Books Received and Noted' *History of Photography*, vol. 5, no. 2 (April 1981), p. 175.

This is a brief review of *Bill Brandt: Nudes 1945–1980*.

261 Giuliana Scimé. 'La Galleria dell'Imagine; Libri'. *Il Diaframma*, no. 255 (April–May 1981), p. 38. 1 illus.

Includes a review of *Bill Brandt: Nudes 1945–1980*.

262 Ricardo Gomez-Perez. 'Books and Catalogues'. *European Photography*, vol. 2, no. 2 (April–June 1981), p. 35–36. 1 illus.

Bill Brandt: Nudes 1945–1980 is reviewed.

263 Mark Haworth-Booth. 'Bill Brandt: A Retrospective Exhibition'. *Creative Camera*, no. 199 (July 1981), p. 140–43. 5 illus. 1 port.

The retrospective exhibition at the Royal Photographic Society, Bath is the subject of this review.

264 Hilton Kramer. 'Art: Bill Brandt: Nudes 1945–1980'. *New York Times*, (11 Sept. 1981) [part lll], p. 18.

A review of the exhibition 'Nudes 1945–1980' at the Marlborough Gallery, New York. It includes the following comments: 'In submitting his figures to the syntax of abstraction, Mr. Brandt has gained something and lost something. The element of artifice that has always been his forte in photography is elevated to an extraordinary level of invention, but the sense of mystery and the erotic glow that were in these pictures at the outset have been emphatically diminished.'

265 Ben Lifson. 'Lines, Angles, and Curves'. *Village Voice* (New York), vol. 26. no. 3 (23–29 Sept. 1981), p. 108–9. 2 illus.

'Bill Brandt: Nudes, 1945–1980' at the Marlborough Gallery, New York (8–29 Sept. 1981) is reviewed.

266 Ilene Fort. 'Bill Brandt'. *Arts Magazine*, vol. 56, no. 1 (Sept. 1981), p. 19. 1 illus.

Reviews the exhibition 'Bill Brandt: Nudes, 1945–1980, at the Marlborough Gallery, New York.

267 Abigail Solomon-Godeau. 'Bill Brandt'. *Arts Magazine* (USA), vol. 56, no. 1 (Sept. 1981) p. 5. 1 illus.

This is a review of the exhibition 'Bill Brandt: Nudes, 1945–1980' at the Marlborough Gallery, New York (8–29 Sept. 1981).

268 Bryn Campbell. 'World Photography'. *Popular Photography*, vol. 88, no. 10 (Oct. 1981), p. 89–99, 124–25, 129–32, 140–41, 172, 184. illus.

A book review of *World Photography* by Bryn Campbell including excerpts from the book: a statement by Brandt and one photograph.

269 Andy Grundberg. 'Books in Review'. *Modern Photography*, vol. 45, no. 10 (Oct. 1981), p. 188.

In the course of his review of *Bill Brandt: Nudes 1945–1980*, Grundberg remarks of *Campden Hill, London 1978* (plate 91) that 'the woman's hair seems to have been drawn on by a magic marker'.

270 Duane Stapp. 'Bill Brandt'. *Arts Magazine*, vol. 56, no. 3 (Nov. 1981), p. 19. 1 illus.

An exhibition review of 'Bill Brandt: Nudes, 1945–1980, at the Marlborough Gallery, New York.

271 Calvin Bedient. 'Flesh and Filigree'. *Art in America*, vol. 69, no. 10 (Dec. 1981), p. 27, 29.

A review of several recent books of nude photographs, including Brandt's *Bill Brandt: Nudes 1945–1980*, which is discussed on page 29.

272 Pari Stave. 'New York Reviews: Bill Brandt'. *Art News*, vol. 80, no. 10 (Dec. 1981), p. 180. 1 illus.

Reviews 'Bill Brandt: Nudes, 1945–1980' at the Marlborough Gallery, New York.

273 Anon. 'Bill Brandt'. *Architectural Design*, vol. 52, no. 7–8 (1982), p. 52.

274 A. Berman. 'Photographs by Bill Brandt'. *Artnews*, vol. 81, no. 3 (1982), p. 92–98.

275 Adrian Knowles. 'Bill Brandt Portraits'. *Amateur Photographer*, vol. 166, no. 7 (8 May 1982), p. 110–12.

276 Ainslie Ellis. 'Dark Resonance: the Portraits of Bill Brandt'. *British Journal of Photography*, vol. 129, pt. 22, no. 6356 (28 May 1982), p. 560–63, 567.

277 Richard Cork. 'The Stalker Behind the Lens'. *Evening Standard* (London), (3 June 1982).

This is a review of an exhibition of Brandt's portraits at the National Portrait Gallery, London (7 May – 22 Aug. 1982).

278 Marina Vaizey. 'Bill Brandt Portraits'. *Art Book Review*, vol. 1, no. 2 (July 1982), p. 69–72. 1 illus. plus cover.

A substantial review of the book *Bill Brandt: Portraits*; it also mentions the portraits exhibition at the National Portrait Gallery.

279 Tom Evans. 'Brandt: The Grand Inquisitor'. *Art and Artists*, no. 190 (July 1982), p. 26–27. 4 illus.

This is a review of an exhibition at the National Portrait Gallery, London.

280 Mark Holborn. 'Bill Brandt Portraits'. *Aperture*, 90 (1983), p. 3–5, 3 illus.

Reviews the exhibition at the National Portrait Gallery, London.

281 Andrew Motion. 'Bill Brandt: Literary Britain'. *The Times Literary Supplement*, no. 4231 (1984), p. 498.

282 Ainslie Ellis. 'The Best of Brandt'. *British Journal of Photography*, vol. 131, pt. 18, no. 6456 (4 May 1984), p. 457–61. 5 illus.
A review of the exhibition 'Literary Britain' at the Victoria and Albert Museum, London.

283 Tom Goodman. 'Bill Brandt's Balancing Act'. *Afterimage*, vol. 13, no. 7 (Feb. 1986), p. 8–10.
This is a review of the book *Bill Brandt: Behind the Camera* and of the exhibition of the same name at the Philadelphia Museum of Art.

284 Mark Alice Durant. 'The Hand of the Photographer'. *Artweek*, vol. 18 (12 Dec. 1987).

285 Richard B. Woodward. 'Bill Brandt'. *Art News*, vol. 87, no. 5 (May 1988), p. 183.
A review of an exhibition at the Anthony Ralph Gallery, New York.

286 Peter Conrad. 'A Documentary Lens Turns to the Surreal'. *Observer* (London), (3 June 1990) [Review section].
In this review of an exhibition of Brandt's collages at the Zelda Cheatle Gallery, London, Conrad points to analogies between Brandt's collages and the work of Hans Bellmer, Paul Klee, Pablo Picasso and Joseph Cornell.

287 Denis Baudier. 'Bill Brandt, Lewis W. Hine'. [in French] *Art Press* (France) [Special edition] (1990), p. 103–7. 6 illus.
Briefly considers Brandt's and Hine's documentary photography in relation to an exhibition at the Espace Photo des Halles, Paris (23 Nov. 1990–3 Feb. 1991).

288 J.R. Arnaud. '*Bill Brandt* par Patrick Roegiers'. [in French] *Cimaise* (France), vol. 38, no. 210 (1991), p. 94.
This is a book review of Patrick Roegiers' *Bill Brandt*.

289 Liz Wells. 'A Month in Paris'. *British Journal of Photography*, vol. 138, no. 6811, (14 March 1991), p. 14–15. 3 illus.
Discusses the Mois de la Photo festival in Paris including an exhibition of Brandt's work.

290 Lucinda Bredin. 'A New Brandt of Denim'. *The Sunday Telegraph*, (11 April 1993). 9 illus.
An interview with Bill Brandt's widow, Noya Brandt, on the occasion of Brandt's nudes being used to advertise Levi jeans.

291 Michael Wood. 'Reflections in a Golden Eye'. *Arena* (Sept. 1993), p. 30–1. 5 illus.

292 Richard Edmonds. 'Artist of the Camera Lens'. *Birmingham Post* (8 Sept. 1993). 4 illus.

293 Mark Haworth-Booth. 'A Clear Eye'. *The Independent on Sunday Magazine*, (18 Sept. 1993), p. 30–7. 9 illus.

294 Julian Rodriguez. 'Brandt Awareness'. *British Journal of Photography*, no. 6942, (30 Sept. 1993), p. 14–16. 7 illus.
A discussion of Brandt's career on the occasion of the Barbican Art Gallery's retrospective exhibition.

295 Tiffany Daneff. 'Beachcomber's Other Life'. *The Sunday Telegraph*, (25 Sept. 1993). Review Section, p. 7. 1 illus.
Examines Brandt's assemblages which were exhibited at the Reed's Wharf Gallery, London.

296 Ian Jeffrey. 'Levi's Brandt Name'. *Creative Camera* (October/November 1993), p. 43–4. 1 illus.
Jeffrey considers Levi's use of Brandt's photographs in their advertising campaign.

297 Richard Cork. 'Snapshot of a Nation's Soul'. *The Times* (1 October 1993). 1 illus.
Cork reviews the Barbican retrospective.

298 Terry Hope. 'Best of Brandt'. *Amateur Photographer*, vol. 185, no. 40 (2 October 1993), p. 22–7. 7 illus.
A discussion of Brandt's career.

299 James Hall. 'An Inner Violence'. *The Guardian* (5 Oct. 1993) Arts Section p. 4–5. 3 illus.
A review of the Barbican exhibition.

300 Tom Lubbock. 'Every Picture Tells Half a Story'. *The Independent on Sunday* (10 October 1993), p. 34.
Lubbock reviews the Barbican exhibition.

301 Jonathan Meades. 'Funny Peculiar'. *The Mail on Sunday* (10 Oct. 1993), p. 34.
This includes a review of the Barbican exhibition.

302 William Feaver. 'A World of Moody Lies and Darkest Truths'. *The Observer* (10 Oct. 1993).
Feaver reviews the Barbican exhibition.

Television and Radio Programmes about Bill Brandt

Television Films

303 Peter Adam. Director/Producer. *Bill Brandt*. (1983), 35 mins. BBC production in association with Chanowski Productions and Andreas Lanshoff Productions. [Distributed by Arts Council of Great Britain Film Library].

See also Bibl. **165** on the making of this film.

304 Stephen Dwoskin, Writer/Director. *Shadows from Light*, (1983), 59 mins. Produced by Robert Jaffé and Kathie Conn.

Production agency: Urbane Ltd; Arts Council of Great Britain. [Distributed by Arts Council of Great Britain Film Library; Concord Films Council Ltd. U.K.].

Radio Programme

305 Tom Hopkinson interviewed on Bill Brandt's photographs. Interviewer Paul Vaughan from *Kaleidoscope* (BBC Radio 4) 23/05/75. [British Library National Sound Archive Reference LP 36600 b 03].

Index

In this index, numbers printed in light type refer to page numbers and those in bold refer to bibliographical entry numbers as indicated in the Bibliography section.